STEP BY STEP ART SCHOOL

WATERCOLOUR

STEP BY STEP ART SCHOOL

WATERCOLOUR

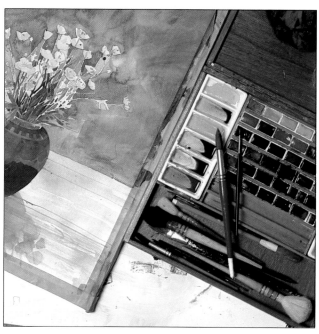

BY PATRICIA MONAHAN

HAMLYN

Published in 1987 by
The Hamlyn Publishing Group Limited
a division of The Octopus Publishing Group plc
Michelin House, 81 Fulham Road
London SW3 6RB

Copyright © First Editions/Patricia Monahan 1987

Second Impression 1988

ISBN 0 600 55196 2

Designed, edited and produced by
First Editions (Rambletree Limited)
27 Palmeira Mansions
Church Road, Hove
East Sussex
BN3 2FA
England

Phototypeset by Adelphi Graphics, London.
Origination by Contemporary Litho, London
Printed by Mandarin Offset in Hong Kong

Contents

Chapter 1
Introduction

Watercolour has a fresh, glowing translucency which many artists, including beginners, find irresistible. It is a demanding, irritating but fascinating medium. It is also full of contradictions, for though undoubtedly a difficult medium to master, the basic techniques are really very simple. Most beginners fail because they do not understand the medium or the materials and therefore insist on treating watercolour as they would oil or poster colour. As a result their paper cockles, the wet paint runs and forms muddy puddles and, convinced of their own lack of ability, they give up.

We assume no knowledge of watercolour. In this chapter, for example, we look at some general topics – colour, composition and selecting a subject. In Chapter 2 we look at the materials and give you some pointers as to what you should buy. The remaining chapters start with an introduction to the concepts which underlie watercolour painting and the techniques which you will need to master if you are to become a proficient and confident watercolourist. Each topic is illustrated with simple exercises which you are encouraged to practise, for only by handling paint, putting brush to paper – and making mistakes – will you become familiar with the medium and learn to handle paint with confidence. Make sure you have lots of paper to hand, preferably of various weights and qualities so that you get to know the way different surfaces affect and modify the behaviour of the paint.

Each chapter also contains a series of carefully structured projects which become increasingly ambitious as the book progresses and as your skills and confidence increase. The demonstrations in Chapter 3 are very simple indeed – the first one uses only one colour! There are two ways of using the book – you can either copy the paintings or you can find similar subjects and paint your own picture using the same techniques. A word of warning here. One of the attractions and pitfalls of watercolour is its unpredictability. The paint sometimes dries unevenly and wet colours bleed and run creating accidental effects which you will not be able to replicate, so your picture will never be an exact copy of the demonstration picture. However, by working through the project with the artist you will gain invaluable insights into his method of working, you will see how the techniques you have learned may be applied and learn how to overcome the limitations and exploit the randomness of the medium. In time you will develop your own unique approach.

Introduction
COLOUR

Primary colours

These are colours that cannot be created by mixing other colours. For the artist the primary colours are red, yellow and blue. In theory every other colour can be obtained by mixing these colours in varying proportions.

Secondary colours

The secondary colours, green, orange and violet, are created by mixing two primary colours in equal proportions. It is difficult to create true secondaries using pigment primaries because they tend to contain traces of other colours. Thus cadmium yellow pale which contains a slight trace of red can be used to mix good oranges, but tends to dull greens. To achieve a good green use lemon yellow instead. Cobalt blue has a tendency towards yellow and dulls the blue-red mixture which produces violet. A better violet can be mixed from ultramarine and alizarin crimson which has a bluish tinge. On the right the secondaries have been produced by mixing primary pigments produced by the French company Pebeo.

Tertiary colours

Here we show tertiary colours which are produced by increasing the proportion of one of the primaries in the mixture. The tertiaries are red-orange; yellow-orange; yellow-green; blue-green; blue-violet; red-violet.

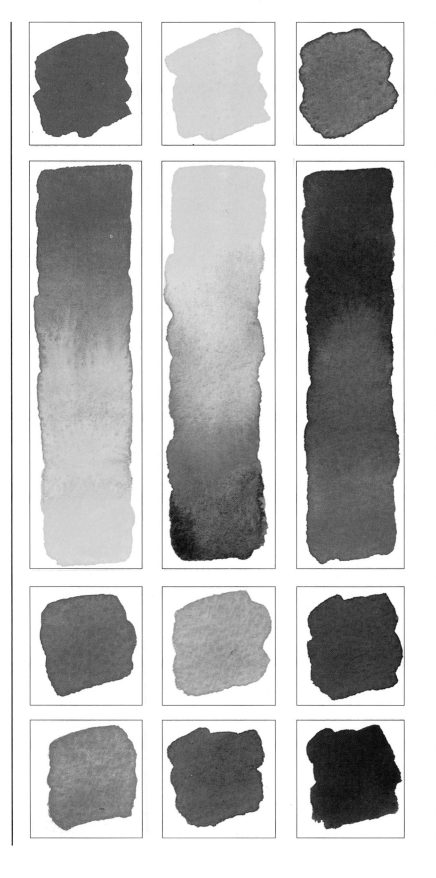

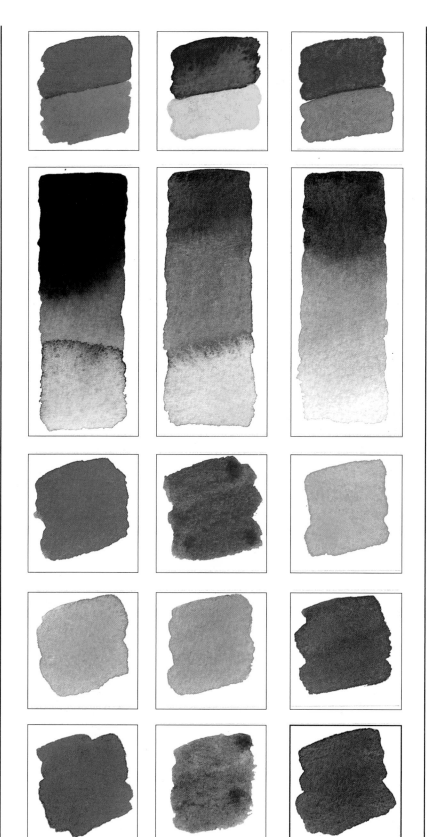

The complementaries

The complementaries are pairs of pure colour such as red and green, violet and yellow, blue and red. When placed side by side they enhance each other – red looks redder and green looks greener.

Neutral greys

The term 'pure' is used to describe a primary or any mixture of two primaries – the secondaries and tertiaries which we have looked at are all pure colours. If a third primary is introduced into the mixture a duller, less saturated colour is produced. This is a neutral grey – a grey with a colour-bias. Here the artist has created neutral greys by adding: red to green; yellow to violet; blue to orange.

Suggested palette

You can start painting in watercolour with a very modest selection of colours. Here we show you nine colours which together with ivory black are really all you need. As you progress you may find that you need additional colours. If you paint a lot of landscapes, for example, you may find that you need more greens – sap green might be a useful addition. However, you will find that most professional artists actually work with a very limited palette. The colours illustrated here are *(left to right, top to bottom):* cadmium red, alizarin crimson, cadmium yellow, yellow ochre, cobalt blue, Prussian blue, viridian green, burnt umber, Payne's grey.

13

CHOOSING A SUBJECT

A frequent cry from inexperienced painters is 'I don't know what to paint'. The answer is simple, paint whatever you see. It may be the view through the window, a 'landscape'; the clutter of coffee cups and biscuits, a 'still life'; or the questioner, a 'self-portrait' or 'figure study'! Lack of subject material is the thinnest of all excuses for not taking up your brush.

What you paint will depend on your interests, your circumstances and the type of image you want to produce. If you are particularly interested in vivid colour you will naturally gravitate to flower studies, if you find the complexities of tone more interesting you might concentrate on still life groups with simple arrangements of local colour. Those of you who live in the countryside, or visit regularly, will feature landscapes in your output. If you find your fellow human beings fascinating and you enjoy a challenge you may well concentrate on life studies and portraits.

In many ways still life is the simplest and most convenient subject of all. Unfortunately, many of us have been put off by memories of unrewarding school days spent slaving over a boring collection of broken crockery. But if you look around you, particularly in the kitchen, you will find an almost unending supply of material – bottles, jugs, pots and pans, bread, fruit and vegetables, the list goes on and on. But the special joy of still life is that you are in control – you select the shapes and colours that interest you, then you arrange and light them as you want. The group can be large or small and you can generally leave the set-up for several days. Still life is an infinitely fascinating source of inspiration, and a wonderful way of studying a particular theme such as

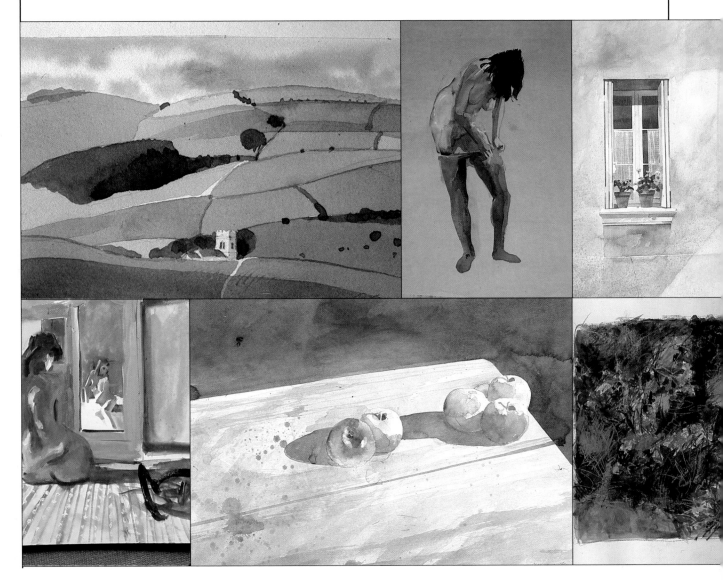

colour, shape, composition or tone.

When you take up painting you start to see the world in an entirely new way. You begin to see with the eyes of an artist and everything is potentially the subject of a painting.

The three main subject areas are landscape, still life and figure and portrait. Which you choose will depend on your interest and circumstances. Here we show a selection of images by different artists which will give you some idea of the range of subjects and approaches.

1 *Landscape* Ronald Maddox
2 *Figure* Stan Smith
3 *Window* Ian Sidaway
4 *Landscape* Stan Smith
5 *Figure* Stan Smith
6 *The Fall* Sue Shorvon
7 *Figure* Stan Smith
8 *Apples* Ian Sidaway
9 *Garden* Sue Shorvon
10 *Flowers* Stan Smith
11 *Gateposts* Ian Sidaway
12 *Portrait* Ian Sidaway

	1	2	3	4	5	6	
7		8	9	10		11	12

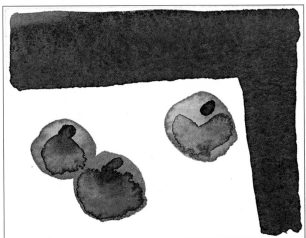 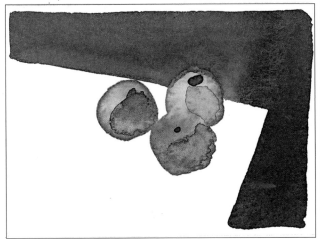

The illustration above shows different arrangements of three apples on a table. The artist has considered not just the apples, which are the subject of the painting, but also the shapes made by the background space and the table. In many ways it is much easier to 'see' a composition if you don't 'see' the apples, if you see abstract shapes instead. The apples then become circles rather than spheres, the table becomes a rectangle, the space behind it an L-shape. The background is seen not as an empty, 'negative' space, but as a series of interlocking shapes of which the apples are a part.

A picture must be made. The raw material is there but as an artist you take that raw material and process it, and by editing, rejecting and sorting produce something which is original and uniquely your own. People tend to assume that the creative process starts when the artist puts brush to support, but a great many of the important decisions have already been made. This process of assembling and designing a picture is called composition. We also talk about the composition of a painting meaning the way the various elements are dispersed about the picture surface, the way the image is cropped by the edge of the support, and the rhythms and stresses within the picture.

There are lots of 'nevers' in painting, many of them formulae for 'good' and 'bad' composition, and like most of these rules they can be ignored if they don't suit you. They do, however, fulfil a useful function in that they force you to make a decision rather than leaving the composition to chance. In fact, many of them are quite sensible and, often, practical, but have been learned by rote and are sometimes applied with little understanding of the underlying reasons.

You can either compose the subject or the painting. With a still life or a figure painting, for example, you can decide where the subject should be, select the background and

colours, and arrange the lighting as you wish. The process is taken further when you start to work on the painting or drawing, for then you decide which part of the picture area the subject should occupy, how much of it should be included and how much emphasis should be given to the different elements.

If you are painting a landscape you have less control and a lot of decisions to make. For a start you have 360 degrees to choose from, but usually there will be one particular view which attracts you. Many beginners find landscape daunting because they do not know where to begin. You can make things a little easier by framing the scene – either with your hands or with a frame cut from card. This simple device isolates a section of the landscape and by holding the frame close to your eye you increase your field of vision, by holding it further away you isolate a smaller section of the landscape.

When you paint a picture you usually want to engage the attention of the viewer, and there are various devices for keeping the viewer's eye

within the picture area. For example, in a figure study you would avoid having an important figure looking out of the picture as this would lead the eye away from the main part of the composition. Similarly, strong directional lines, such as an outstretched arm, would not normally point towards the edges of the picture. It is also sensible to avoid emphasizing the corners of the composition: imagine a circle or oval within your rectangle, touching it at the edges, and try to keep all the main activity within this area.

The shape and size of a painting is an important component of the composition of a picture. Most paintings are rectangular, a shape which relates to the walls on which our pictures hang, rather than our field of vision which is an ellipse. In most instances, therefore, your picture will be rectangular – should it be an upright rectangle known as 'portrait', or a horizontal rectangle which is called 'landscape'? The choice will depend on the subject and the way you want to treat it. For example, a broad sweeping

landscape with a wide horizon would obviously sit well within a landscape format, whilst a landscape which included a tall building or a high mountain peak would suggest a portrait format.

1 *Flower shop* by Ian Sidaway. Here the artist has opted for a landscape format. The line of the pavement and the awning give the composition a dominant horizontality which is balanced by the verticals of the shop front.

2 *Lighthouse* by Ian Sidaway. The artist draws attention to the striking shape and strong verticality of the lighthouse in two ways. He has chosen a portrait format which draws the eye upwards. He has also devoted more than half the picture area to the sky, which acts as a foil to the rest of the painting. The sky is not, however, a negative area, it is a bold important shape cut around, and drawing attention to, the outline of the lighthouse.

1

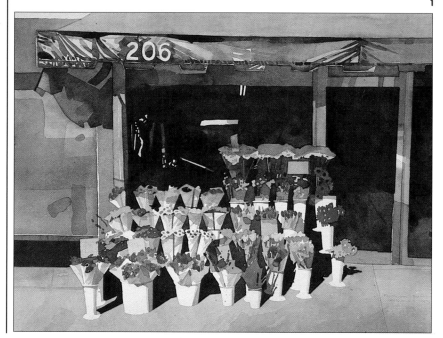

2

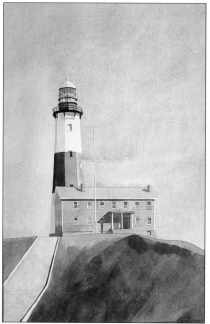

STARTING TO PAINT

Watercolour is an exciting, flexible and richly rewarding medium. It can be used for several purposes – for rapid sketchy notes, for finished paintings or for highly finished illustrations. It also responds well to different approaches so if your natural inclination is for bold splashy colour, you will enjoy it, but it can also be used in a tighter more controlled way. It is entirely up to you.

The projects in this book are carefully structured, simple and uncomplicated to start with, but becoming progressively more ambitious throughout the book. The artists have combined a controlled use of the medium with a willingness to incorporate accidental effects. When you have mastered the techniques and feel happy using the medium, you will be able to develop your own personal style. This book is intended to help you over the first hurdles and to encourage you to use the medium, it is not intended to impose a particular style. When you have worked your way through it your introduction to watercolour will only have begun, for there is no substitute for experience and you never stop learning.

One of the many myths which surround the art of watercolour is that it is fast, but the opposite is true. Watercolour washes use a great deal of water. Colour is built up by laying down one wash over another, but in order to achieve certain effects and prevent the painting from turning into a puddle of muddy colour, the painting must be allowed to dry between washes. This, of course, takes time, involving a lot of waiting round, and if you are out of doors you will probably resent the time spent twiddling your thumbs. One of the solutions is to work on several paintings at once. This may sound complicated but once you get into the habit it is quite easy. The three paintings of sweet peas on these pages were all completed at one sitting. The artist set up the still life, started working on one painting and once it became too wet, set it aside, and started on another, and then on to a third. By the time the third was unworkable the first was ready to be worked on again.

Watercolour is ideal for rapid, on-the-spot paintings. The paints are small and light, conveniently carried in a box which incorporates a palette and, sometimes, a waterbottle and reservoir. The paper is also light and easy to carry, whether it is in a block or stretched on a board. You do not necessarily need an easel, but if you take one it will be light and collapsible. To use your time most efficiently work on several studies at once, these need not be on separate sheets for you can paint several images on a single sheet – on these pages we show several examples of watercolour used in this way. The medium is ideal for studying transient effects such as the changing shapes of passing clouds, or the way that light changes with the weather. If your painting expedition is cut short by inclement weather you can make a rapid pencil sketch and touch in dabs of colour as an *aide memoire*. You can then take the sketch home and produce a painting at leisure.

The three studies of *Sweetpeas* by Sue Shorvon were painted at the same time, the artist moving from one painting to the next. This method of working allows each painting time to dry and avoids the painting becoming overworked.

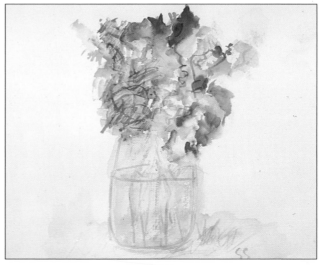

INTRODUCTION

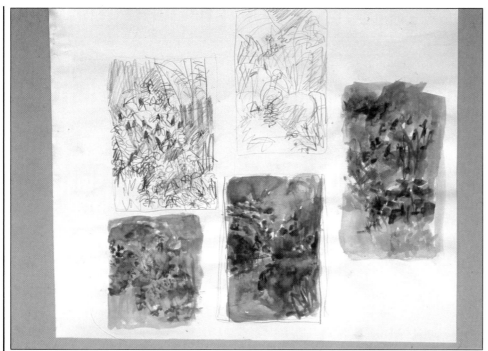

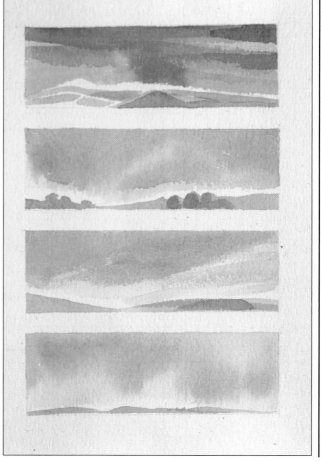

The sketches on the left are also by Sue Shorvon and were completed in a garden in Canada. Below, we see four studies of skies by Ronald Maddox. The artist worked quickly to capture the rapidly changing effects. The sketches of sand dunes are also by Ronald Maddox. Again they were painted on the spot and are part of a large collection to which he constantly refers for inspiration and for reference.

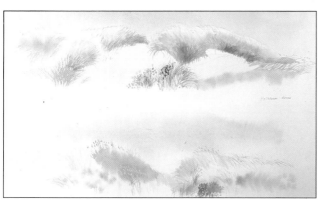

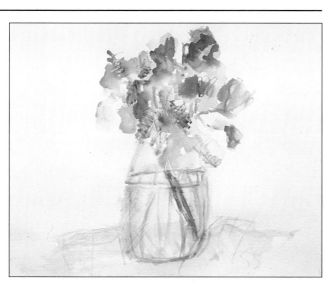

Chapter 2
Equipment

Watercolour is a thrilling and extremely flexible medium, with something to offer everyone. The extrovert can work boldly, enjoying the brinkmanship of working with fluid paint, while the meticulous can use a more controlled and minutely detailed technique. Unfortunately, watercolour has, over the years, acquired a mystique which leads the uninitiated to believe that the medium is not for them, assuming that only a trained, gifted or experienced painter could possibly cope with a medium so difficult and demanding. We set out to dispel those myths, and in this chapter tackle the first hurdle which you will have to overcome – purchasing your equipment.

The materials required for watercolour painting are simple: paints, paper, brushes and water. But that list belies the complexity of the subject. If you have already visited an art shop to buy paints you will be aware of the bewildering range of materials and the apparent impossibility of making a selection.

With watercolour more than any other medium you should buy the best you can afford – you will be getting extremely good value for money and the expenditure will be more than repaid by your pleasure in the result. The materials used for watercolour are a delight in themselves – small, exquisite and very desirable. The pans of paint, for example have a jewel-like quality, each with its own neatly printed paper band, under that a foil wrapping which peels off to reveal the glossy cubes of paint in their individual white plastic containers. The best brushes too are elegant objects, beautifully crafted from the finest materials with costly sable bristles and glossy, black lacquered handles. The paintboxes are ingenious master-pieces of economy and efficiency which combine paints, palettes, and often, waterbottles and reservoirs.

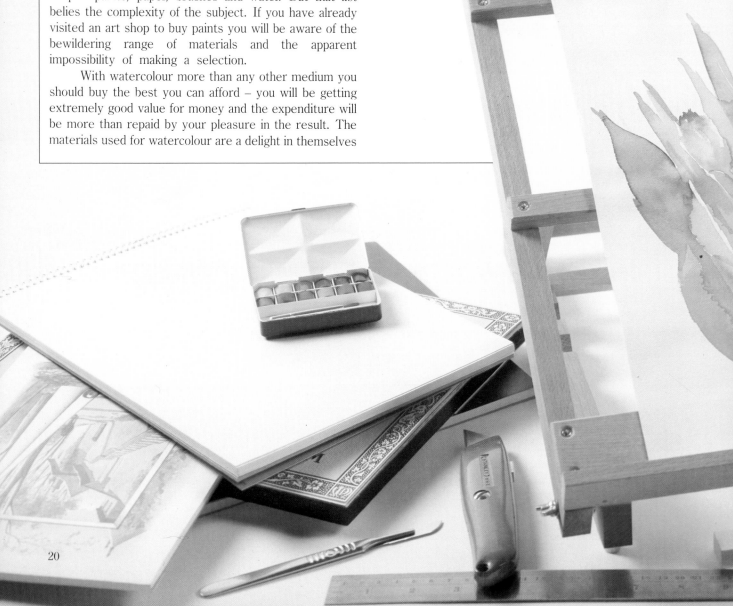

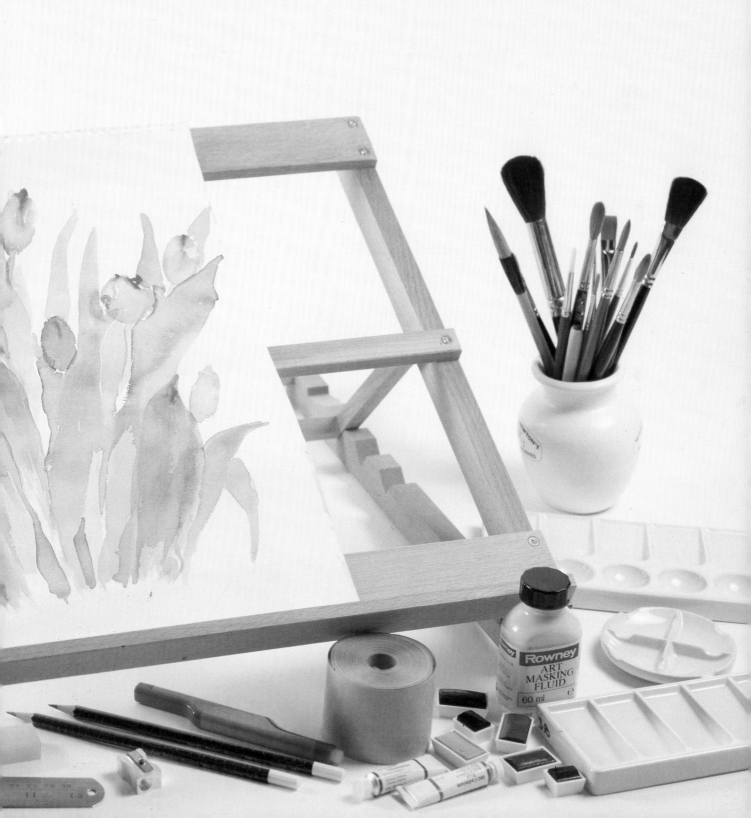

Equipment

SUPPORTS/PAPER

A 'support' is any surface which an artist uses for painting or drawing on – canvas, hardboard or even a wall can used as a support. The support for watercolour is paper which is cheap, available and portable.

The range of papers available is bewildering – they vary in colour, texture and the materials from which they are made. The best are expensive but worth the investment. The quality of the paper you use is important, for it plays a significant part in painting, affecting the way the paint is accepted. Generally the papers used for pure watercolour are white or only slightly tinted – this is because the paper itself will establish the lightest area of the painting, and the white of the support shows through the layers of transparent paint imparting a special brilliance to the colours.

Watercolour paper is sold in a range of weights which are expressed as pounds per ream (480 sheets) or grammes per square metre. Weights vary from 90 lb (185 gsm) for lightweight paper to 300 lb (640 gsm) for the heaviest. Most paper needs to be stretched – this prevents the wet paper from cockling. The heavier the paper the more readily it accepts water, so the heaviest papers – above 140 lb – need not be stretched unless they are going to be flooded with water.

Papers can be bought in spiral bound pads, blocks in which the paper is bound on all four sides and loose sheets. Pads are useful for sketching especially if you don't use a lot of water. Separate sheets can be torn from the pad and stretched if necessary. The blocks are useful for working out of doors, the sheets are firmly attached and therefore do need to be stretched – and they do not blow about. If you look carefully you will find a small area where the sheets are not attached – remove them by slipping a blade in at this point and gently work it around the edge of the

sheet. Do not use the sharp edge or you will cut the paper.

The Cotman paper used for most of the demonstrations in this book is a new paper developed for Winsor & Newton by Canson. It has two, different, Not surfaces and is available in two weights, 90 lb and 140 lb. It is a particularly good paper for the beginner as it is strong, offers a choice of surfaces and allows you to lift colour from areas very easily.

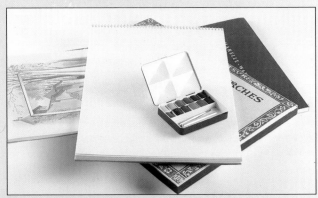

Here we show a selection of pads and blocks. The largest paper sizes are available only as loose sheets. The tiny watercolour box is a Bijou Box by Winsor & Newton. It contains 12 quarter pans of artist's quality paints and a sable brush pocket brush.

The papers shown on these pages are, from left to right: Bockingford 70 lb Not; Montval by Canson 90 lb Not; Cotman 140 lb Not; Arches 140 lb Rough; Arches 90 lb Not; Bockingford 140 lb Not; Arches Rough 300 lb; Saunders 90 lb H.P.; Watmough 140 lb H.P.; Watmough 140 lb; Rough Saunders 72 lb Rough.

PAPER TEXTURE

The type of surface a paper has is important. There are three basic finishes: Hot-Pressed (H.P.); Cold-Pressed or Not; and Rough. Hot-Pressed has the smoothest surface because during the manufacturing process it is rolled between hot metal rollers. Its smooth surface is ideal for drawings in pen or pencil. The paper has less tooth than other watecolour papers and some artists like the way

paint responds to the slippery surface. However, it is not very absorbent and is difficult to use for wet, washy techniques. Its most important use is for tight, detailed work – illustrators often use H.P. papers.

Not paper, so-called because it is 'not' hot-pressed, has a medium textured surface. The Cotman paper used for many of the projects in this

book has a Not surface, in fact, it has two Not surfaces.

Rough paper has a distinctly textured surface. Many artists like the way that paint responds to the irregular surface, sitting on the raised areas whilst the recesses remain white, giving washes a luminous sparkle. It is probably best to avoid Rough papers until you are more experienced.

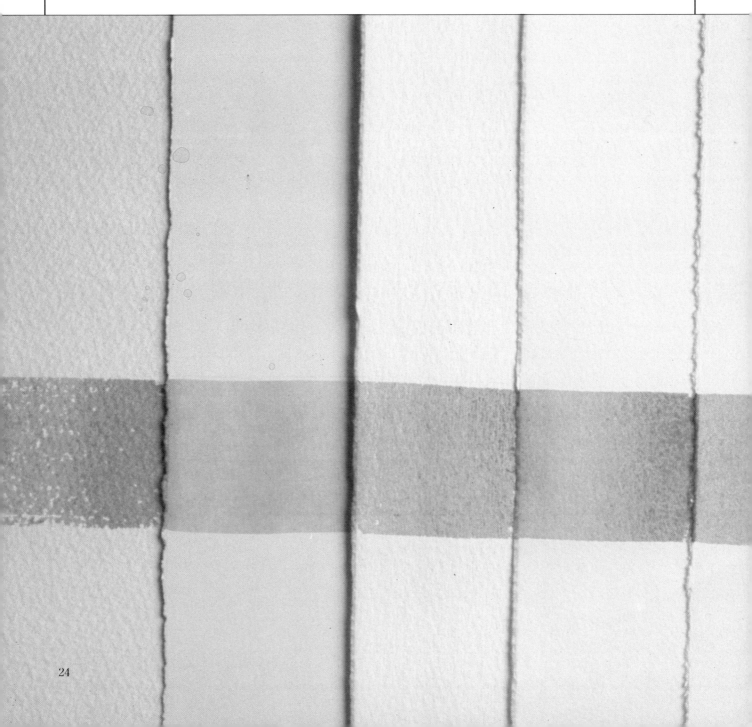

Paper is a subject which is apparently simple, but the more you go into it the more complex it becomes. To start with you will be safe enough if you buy any paper which says it is suitable for watercolour and stick to a Not surface. You should also get into the habit of stretching your papers, especially if you buy the lighter weights.

As you become more experienced you may experiment with different surfaces and weights and will soon discover what sort of surface you prefer. You will find that what one manufacturer describes as Not another calls H.P. You will also find that some papers are considerably more expensive than others. The most expensive papers are handmade and are really not for the beginner.

Here we have laid a band of watercolour across a selection of papers to show how the colour is received. *From left:* Green's pasteless board; Saunders 90 lb H.P.; Arches 140 lb Rough; Saunders 200 lb Not; Arches 140 lb Not; Arches 90 lb Not; Bockingford 200 lb Not; Saunder's Waterford 90 lb; Cotman 140 lb Not.

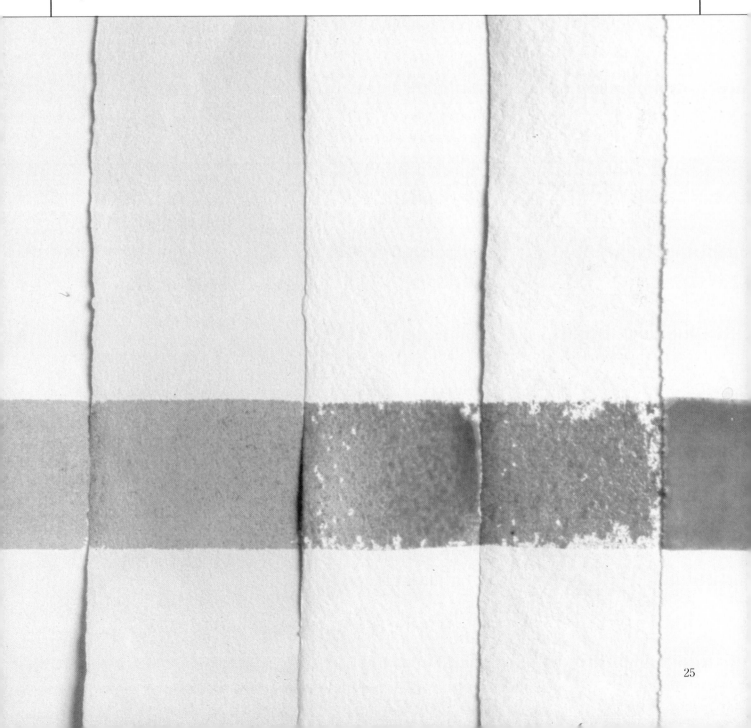

PAINTS

Watercolour paint consists of pigment bound with gum, a naturally occurring watersoluble substance. Gum arabic, the most common binding medium for watercolour is produced, by several species of North African and North American acacia trees. Gum tragacanth comes from a thorny shrub native to Greece and Turkey. The manufacturer mixes pigments with various components, such as gum and glycerin, in order to produce paints which will mix with water, and produce an even glaze of colour when diluted. The pigments come from many sources, some occur naturally, others are artificially produced.

Pigments are idiosyncratic – some, like viridian and alizarin crimson, are naturally transparent and therefore ideal for glazing. They also differ in their staining qualities, thus viridian is non-staining and is easily removed from paper while alizarin crimson will leave a mark. You can test the staining power of pigments by laying down patches of paint, allowing them to dry then washing off the colour under running water. You will find that some colours stain the paper quite strongly whilst others leave no mark at all. Colours also vary in their transparency, some colours like cerulean blue, oxide of chromium and Naples yellow are naturally opaque, and although the manufacturers try to overcome this by adding glycerin, you should use these colours with care if you are not to lose the translucency which is such an attractive quality of watercolour. Some pigments have a tendency to granulate when used in a wash – in fact some are so prone to this that they are not used in watercolour at all. Learning about pigments is not a purely academic exercise, for if you are aware of the way a particular colour behaves in certain circumstances, you will be able to use it in a more informed way – you will not, for example, obliterate a subtle passage by putting down too much of a particularly intense colour like viridian, or an opaque colour like yellow ochre. The more knowledge you have the more you can control the medium.

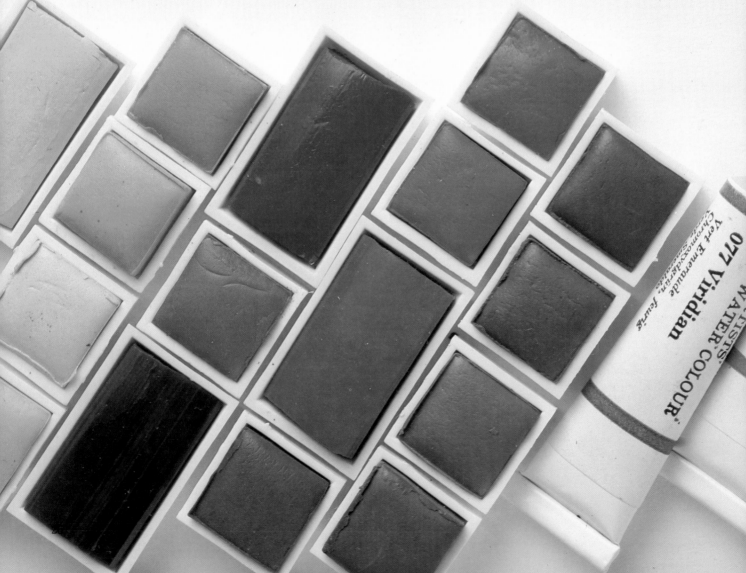

Watercolour is available in various forms: dry cakes, pans, half-pans, tubes, cakes and bottles of concentrated colour. You may already be familiar with the disks of dry colour often used in children's paint boxes. They contain very little glycerin so the colour is very concentrated. It is difficult to wet the paint so you must work the brush vigorously in order to lift the colour. If you do use paint in this form drop a little water onto each cake at the beginning of a session – this will soften the paint and make it easier to lift.

Pans and half-pans contain more glycerin and are semi-moist so it is easier to wet and lift the colour. Each cube of colour has its own container: pans measure 19×30mm and half-pans 19×15mm. The smallest boxes contain quarter pans – to replace these you will have to cut the larger pans to fit. Watercolours in pans are both economical and convenient. All the colours are available for immediate use, you take off colour as you need it and in exactly the quantities you need. With tube colours you must either decide which colours you are going to use and squeeze them out at the beginning or, alternatively, stop and squeeze out colour as you go along. You either waste paint or interrupt your work at intervals. Pan colours are particularly useful for sketching out of doors, where the nature of the subject and the working conditions mean that you need all your colours to hand, and you also want to keep your equipment to a minimum.

A disadvantage of pan colours is that once you have removed the wrapper you have no record of the colour. This can be confusing for dark colours look remarkably alike in solid form. You must therefore be very organized, laying out your paintbox in a particular way so that you know where each colour is. You should also make a colour chart, laying down a blob of each colour and labelling it – this will help you identify the colours when you are working and will also be useful when you want to replace the paints.

Tube colours contain even more glycerin than pan colours and are very soft. They are especially useful when you are working on a large scale and need to mix large quantities of wash –

Here we see a mixture of pans, half-pans and tubes. Pans will probably be more economical and useful, but you might need tubes for large washes – ultramarine or cobalt blue for skies for example.

PAINTS

it is easier to squeeze out colour and add water than to work up a pan and carry colour brushload by brushload to the palette.

The fourth form of watercolour is liquid and is sold in bottles. These colours are particularly vivid and are popular with graphic artists and some illustrators. They tend to be more fugitive than other forms of watercolour.

There are two grades of watercolour – artist's quality and student's quality. Student's quality colour is cheaper – usually all the colours are the same price – artist's quality are made from better pigments and this is reflected in the price. Artist's colours are coded by series which indicate the price

bracket. Some colours are extremely expensive so you should check the series number before you buy. Manufacturers aim their student's quality materials at beginners and the difference in price between these and the artist's quality certainly make them attractive. However, there is a lot to be said for starting with the best: artist's quality paints are better, and the colour is more intense and goes further.

Tubes of watercolour can be bought individually or in boxed sets. The boxes range from the tiny Bijou sketchers set shown below to large wooden chests of colour. The watercolour box fulfils several functions. Not only does it contain paints and possibly a brush, it

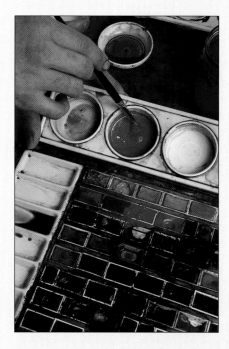

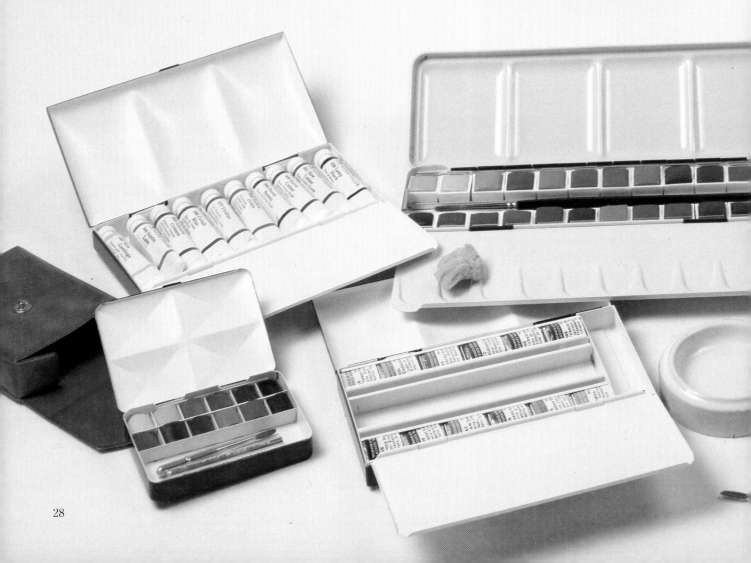

On the *left* we see a 'working' paintbox. Compare this with the pristine examples below!

Here we see a selection of watercolour boxes. They vary in the number and type of colours they contain – tubes, pans or half-pans. The smallest box contains quarter pans. The small ceramic saucer is for mixing washes.

protects the paints, preventing them from drying out and the lid functions as a palette for mixing colours. Some boxes have an extra leaf which folds out providing another mixing surface. You can buy an empty box and select your own colours – just a few to start with, adding others as necessary and as you can afford them.

You will also need separate palettes – these may be plastic or ceramic, but are usually white so that

you can see the colour of the wash. Plastic palettes with deep wells are ideal for mixing large washes. Alternatively you can use ceramic dishes often sold in nests of about five. Tile palettes are rectangular, usually ceramic, sometimes divided into five or six slanting divisions, or with a combination of circular and slant recesses. But ordinary household saucers and yogurt pots will do just as well. Many professional artists have very odd assortments of containers.

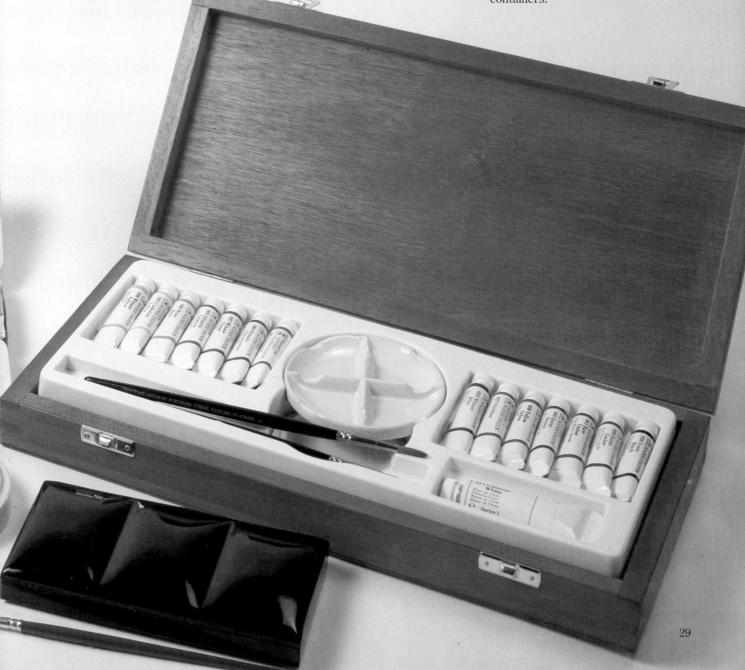

BRUSHES

You will need a small selection of brushes to start with, ideally a large flat brush to lay on washes, a medium sized brush for broad areas and a small brush for detailed work. The size and type of brush you use will depend on the type of painting, the size and your technique. A botanical illustrator, for example, might have a selection of very small sable brushes, whilst a painter with a freer, more gestural style might have a large selection of brushes, some not obviously appropriate for watercolour. Thus you will find brushes intended for DIY, toothbrushes and nailbrushes in many artists' collection.

Brushes are made from different materials, the most expensive being red sable made from the tail of the Siberian mink. They are extremely expensive especially in the larger sizes, but they are lovely to work with and properly cared for will last for a long time. Sable brushes have qualities which make them ideal for watercolour. They have a pleasing springiness, which makes for lively brushwork, yet they are responsive, allowing you to control the paint. The sable hairs have special qualities which allow the brush to absorb and hold paint, so that you can work with a loaded brush. With a less expensive

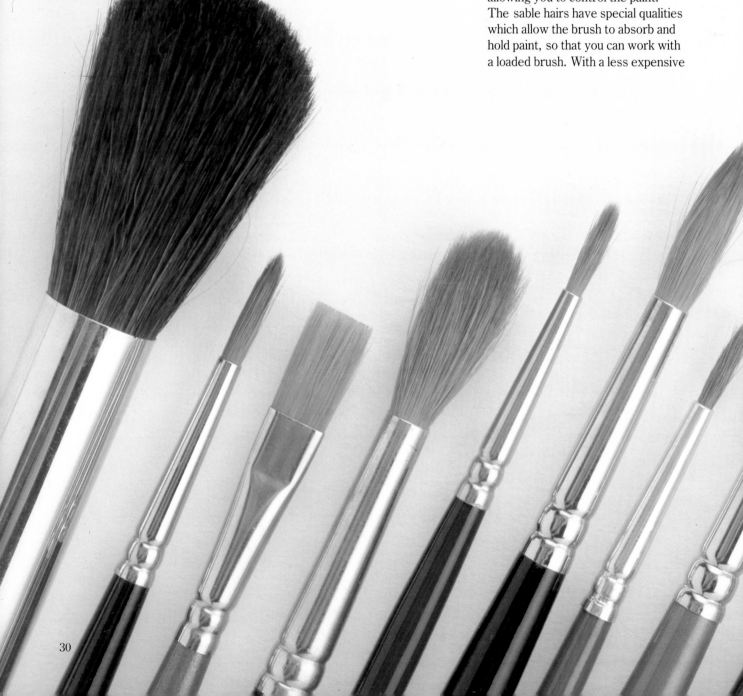

brush you would have to return to the wash several times, making a number of strokes where a sable would allow you to make one. Less expensive brushes are made from sable mixed with squirrel, ox hair or other fibres. The Sceptre range produced by Winsor & Newton are extremely good, though they are not cheap. Cheaper still are the brushes made without sable. Soft synthetic brushes are also used for watercolour, some of them are very good indeed.

Your brushes are expensive and should be looked after. Wash them thoroughly in water after use, gently reshape the bristles, or better still,

flick them briskly and you will find that they resume their correct shape. Round brushes should come to a point and if you lose this they become difficult to use. Store brushes bristle end up in a jar. When you go out painting take your brushes in a container which will protect the bristles. Art suppliers sell tubes, but you can roll them up in card or a cloth, anything which will protect their bristles from damage. Never leave brushes standing on their hairs or bristles – in a jar of water for example. If you do the brush head will lose its shape and can become so distorted it is entirely unusable.

Here we show a selection of brushes suitable for watercolour. Unless otherwise indicated they are Winsor & Newton brushes. They are, from left to right:
series 14A, extra large, round wash brush, imitation squirrel;
series 7, number 3, sable;
Sceptre series 606, 6mm, mixed fibres including sable;
series 7, number 8, sable;
series 33, number 3, a cheaper sable;
series 16, number 8, sable;
series 35, number 3, ox and sable;
Sceptre, series 101, number 8 mixed fibres including sable;
series 33, number 8, sable;
Rowney, series 43, number 3 Kolinsky sable;
series 35, number 8, ox and sable;
Sceptre, series 101, number 2;
series 608, 8mm. sable;
Sceptre, series 202, number 3;
series 14B, large, domed wash brush, imitation squirrel hair.

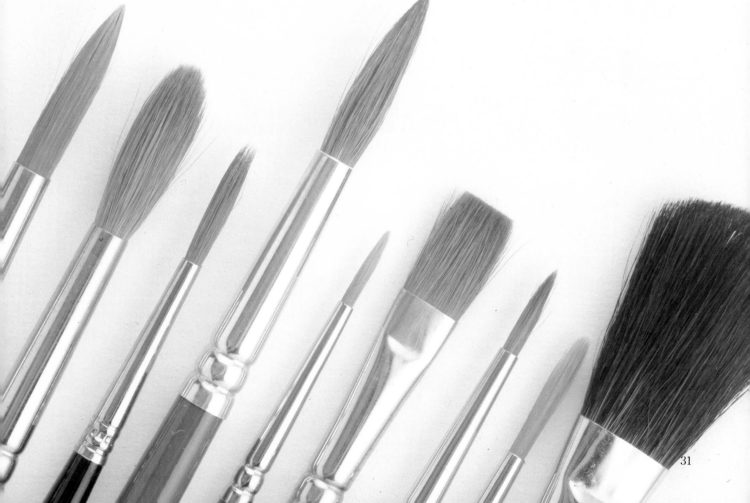

HANDLING WATERCOLOUR

How do you actually get the paint from the tube or pan to the support? Beginners sometimes get in a muddle because they squeeze paint onto a palette and then apply it directly to the support, or work directly from the pan to the support. If you do that you end up with a thick, opaque layer of paint rather than the thin washes which allow the white of the support to show through and give the medium such brilliance. Pan colours are semi-moist and get very soft and sticky if you work directly from the pan. And whichever form of watercolour you use you will get through it far too quickly. Using the paint correctly will give you a better and a more economical result.

The secret of watercolour is washes – these are solutions of paint and water. To prepare a wash with tube colour, squeeze a little colour into a saucer or one of the recesses of your palette, then dip your brush in a jar of water and work up the paint with the brush. Add more water until the colour is the right intensity – test it on a scrap of paper. Use your brush to add more water as required.

If you are using pan colour put a little water in a saucer or a recess in a palette. The paint must then be moistened with a wet brush and the brush used to work up the colour. When the brush is loaded with paint transfer it to the palette. Again, test the intensity of the colour and add more water or paint as required.

There are occasions when you will want to work directly from the unmixed paint or the pan, if for example you are working wet-in-wet and want to add more colour, or if you want to introduce intense, opaque colour for fine details. In general, though, you would dilute the colour first.

1 This is a working artist's paintbox. There are two tile palettes, a plastic palette with ten deep recesses and two saucers and a mixture of pans and half-pans. If you favour large brushes you should use pans – it is much easier to use a large brush on a large paint surface.

2 Here the paint is transferred to a dish in which there is a little water. Test the strength of the solution on a scrap of paper. Remember that watercolour looks much darker when wet than when it is dry.

1

2

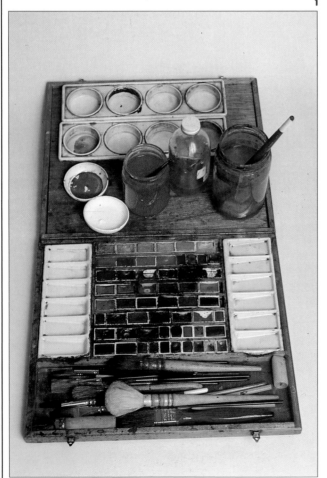

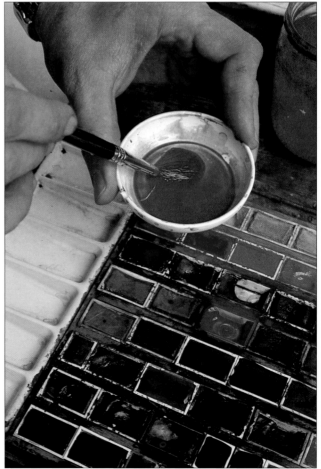

A great deal of water is used for paintings in watercolour and paper responds to water in different ways depending on how thick it is and how much size it contains. Nevertheless, most papers abosrb water causing them to stretch when wet, and then shrink as they dry. Unfortunately, they don't generally dry flat, but buckle and wrinkle. Many an aspiring watercolourist has started by painting on unstretched cartridge paper, and has ended up with a sadly wrinkled piece of paper covered in puddled colour. But even cartridge paper can be used for watercolour if it is first stretched. Stretching paper is very, very simple. And if you have a watercolour on which unstretched paper has cockled you can still flatten it. Simply follow the instructions here, but wet only the back of the paper and stretch the painting face down.

1 You will need: a sheet of watercolour paper; a drawing board or a similar flat surface; gummed tape; scissors or a scalpel; water and a sponge or a brush. Trim the paper so that it is slightly smaller than the board. Cut four strips of gummed paper – two to the length of the short side, two for the long side.

2 Lay the sheet of paper on the board. Here water is being squeezed onto the paper from a sponge.

3 Working quickly but gently to avoid damaging the paper surface, spread the water over the paper – it should be damp rather than soaking wet. If the paper is thin you only need to wet one side, if it is thicker you should wet both sides. If it is a really thick paper you may have to soak it in the bath for a minute or so, but be careful not to tear it when it is wet.

4 Wet the strips of gummed paper.

5 Use them to fix the paper to the board, making sure the paper is as flat as possible. You do not need to exert any pressure – the forces set up by the drying and contracting paper are quite enough to flatten it.

6 Don't worry if the paper looks bubbly when you leave it. Have faith, when you return it will be beautifully flat!

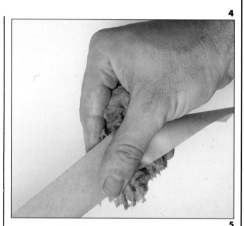

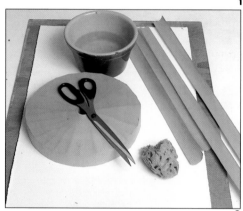

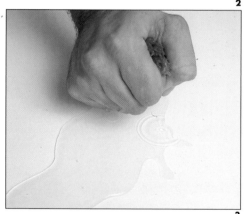

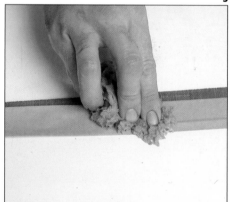

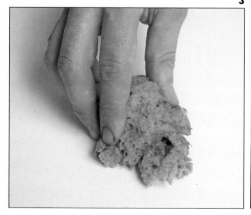

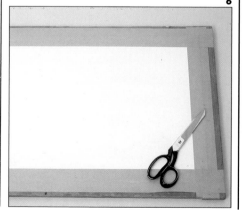

Chapter 3
Washes

Watercolour is entirely different from any medium you have used so far. First of all, it is transparent, the white of the paper giving it a special luminosity and brilliance which is unmatched in any other medium. Its transparency does, however, impose limitations which make it difficult for the beginner to handle watercolour without a little tuition. You cannot, for example, apply a light colour over a dark colour and in this chapter we look at the concept of 'working light to dark', which means that you lay down your lightest colours first and then build up the colour layer upon layer, adding the darkest tones last. To do this you must plan your approach carefully – you cannot suddenly decide to add a highlight at a late stage of the painting. Another important point to remember is that the only white available in a true watercolour technique is the white of the paper so this must be carefully guarded. In this chapter we look at ways in which you can create a range of tones, highlights and local whites without white paint.

Washes are the basis of all watercolour painting, for in a wash you see watercolour in its truest and most beautiful form. In a wash paint is diluted with lots of water and applied to the support in solution, so you will have to learn to control fluid paint and wet paper. There are all sorts of things you can do with a flat wash. First of all it allows you to cover large areas very quickly. Then if you allow the paint to dry you can apply another wash of the same colour and so build up the intensity of tone, or change the colour by applying another wash of an entirely different colour. Tones can also be built up by adding more colour, thus increasing the ratio of paint to water.

Working with wet paint and paper is thrilling, demanding and fun. The most successful watercolours are produced by artists who 'know' the medium, and can work with, and exploit, its unpredictability. In this chapter we lead you through the very first steps, explaining what you should do, but also explaining why. Make sure you have lots of paper and work your way through the exercises at the beginning of the chapter. Then try the three simple projects – copy them or find similar subjects of your own. Good luck!

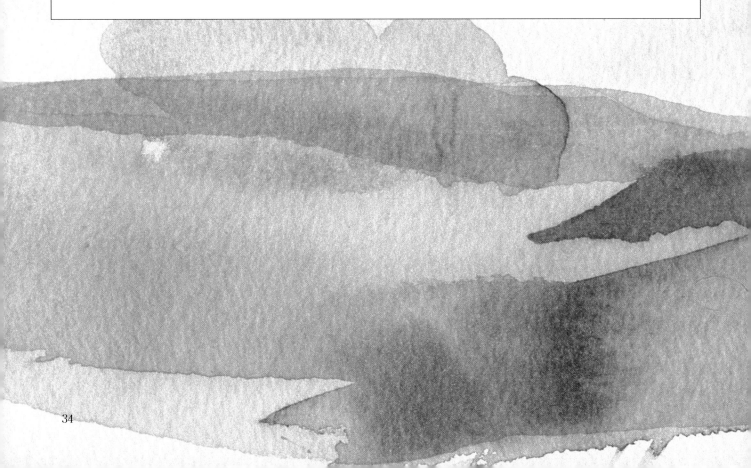

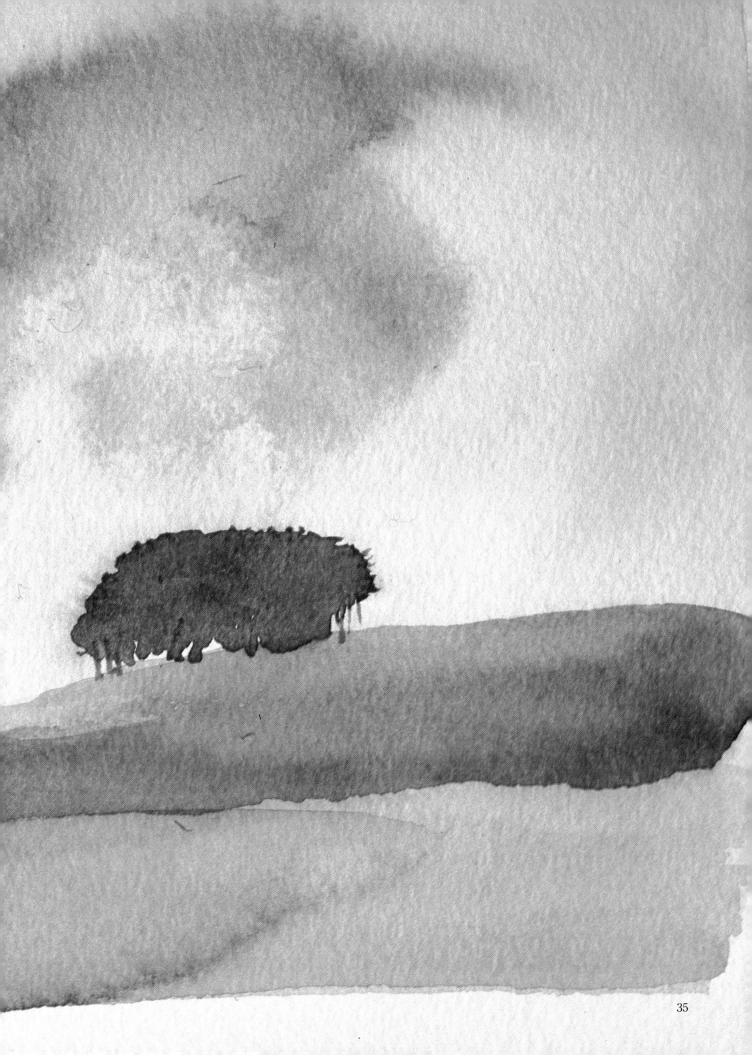

Techniques
LAYING A FLAT WASH

In a wash watercolour paint is diluted with considerable amounts of water and applied to the support in a very fluid state. The technique highlights both the attractions and difficulties of the medium. In a wash watercolour is revealed at its most transparent and subtle, but the quantities of water involved, the unpredictability of the reaction between paper and paint, and the uncertainties introduced by variables such as room temperature, add an edge of excitement whether the artist is an accomplished exponent or a struggling beginner.

You will need lots of clean water, at least two jars – one for cleaning your brushes and the other for mixing paint. Clean your brushes between applications of colour, otherwise tiny amounts of paint will stray into your wash and spoil the purity of colour. Some pigments have particularly powerful staining qualities and a minute amount will contaminate an entire wash. You will need a palette or dishes to mix the wash in – their size will depend on the area you intend to cover. The recesses in the lid of your watercolour box may be adequate but a saucer will do if you need something larger. The secret of successful washes is to mix plenty of colour – otherwise you will run

1

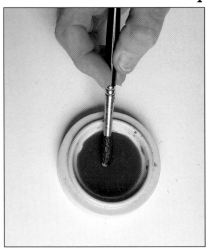

2

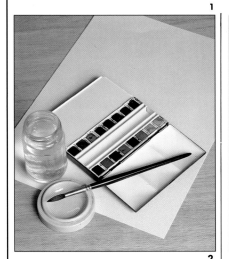

3

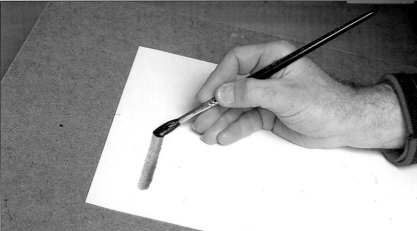

4

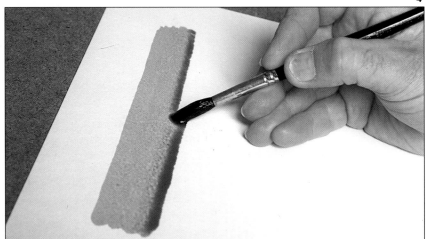

1 You will need paints, tube or pan, a palette, stretched paper, a brush, lots of water and a board of some sort.

2 Mix the paint and water in a dish. Use plenty of water and make sure that you have enough wash to cover the area.

3 Fix the paper to a board – the wet paint can then be controlled by tilting the board. Here the artist used Cotman 140 lb unstretched. Start by loading the brush with the dilute colour and lay a band of colour across the top of the tilted board.

4 Now, working in the opposite direction, lay a second band of colour making sure that you pick up the fluid paint along the base of the previous stroke. Here the artist lays a third band of colour – the tilted board has caused the stream of colour to gather along the bottom.

out half-way through and will have to stop to mix more. Not only will it be difficult to get just the right intensity of colour the second time, but whilst you are mixing it, your first application will have dried, leaving ripples and tidemarks.

You will need something to paint on – ideally you should stretch a sheet of good quality paper. Large quantities of water cause most unstretched papers to cockle – not only does this look unsightly, it causes the paint to puddle so that it is impossible to achieve a flat wash. Some heavy papers do not need stretching, but, just

to start with, you should stretch all your paper. Start by doing things by the book and you will avoid disappointment and make rapid progress.

Here we describe laying a wash with a brush, but you could also use a sponge, especially if you want to cover a large area. The method is otherwise the same. Make sure that you have lots of paper, and experiment with both techniques. Use different colours; this will help you become familiar with the colours in your box and with their peculiarities. Keep all your practice sheets, as you can use them to practise the techniques described later.

5

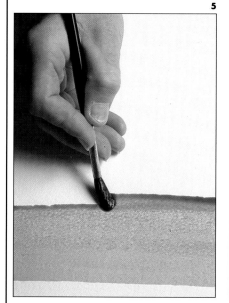

6

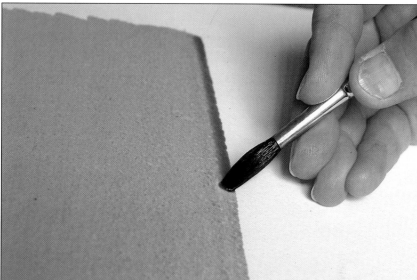

7

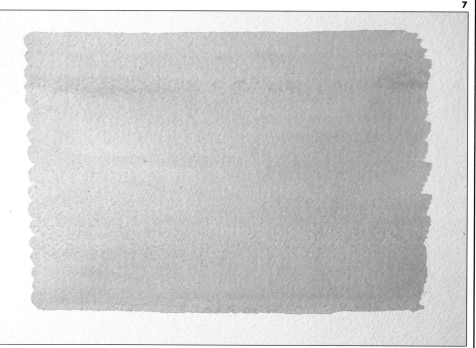

5 The secret of a good wash is to mix plenty of colour, work quickly, tilt the board and keep the front edge wet. Keep the brush loaded with colour to avoid running out of colour in the middle of a stroke. Reload, when necessary, at the end of a stroke.

6 When you have finished, use a dry brush to pick up the stream of fluid paint which has gathered along the bottom of the wash.

7 When the wash is dry the colour should be even in tone, though it will be lighter than when wet. If your wash is uneven, practise until you can get it right. You may never want to lay a completely flat wash but you will need this degree of control over the medium.

WET-IN-WET

The term wet-in-wet describes the application of paint to a wet surface – this may be paper dampened with water, or paper on which there is already wet paint. You will have to master wet-in-wet techniques if you are to exploit watercolour to the full and, like the wash on the previous pages, the only way to learn about wet-in-wet techniques is to put paint to paper and experiment for yourself. You will soon find that watercolour is unpredictable and exciting, but the more you practise the more familiar it will become and the less alarming it will seem. To succeed you must be decisive and prepared to take risks – watercolour is definitely not a medium for the timid.

Wet-in-wet techniques have many uses. In the projects in this book, for example, the artist uses a very simple wet-in-wet technique to lay in skies. To do this, damp the paper, either with a large brush or a sponge. The paper should be damp rather than wet – the amount of water you need will depend on the type of paper, the room temperature and humidity. As you get more used to handling watercolour you will be able to judge exactly the amount of water required. Mix a solution of paint in a palette, load a large brush and touch the colour on to the

1

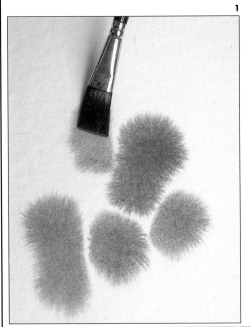

2

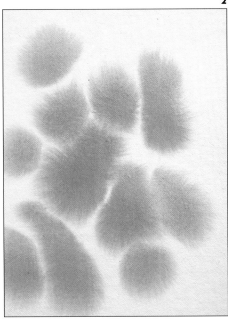

One colour on damp paper

1 Experiment first with a single colour. Dampen the paper with a large brush or a sponge. Mix a solution of colour – here the artist has used ultramarine – and lay the colour on to the damp paper with a large brush. Notice the way the colour spreads into the damp paper.

2 The colour continues to spread, but more slowly as the paper dries. When completely dry the colour will be paler and the edges softer than when wet. Practice with different papers and colours.

1

2

Two colours on damp paper

1 Now try the same exercise, but this time use two colours – here the artist has used ultramarine and vermilion. Mix solutions of the two colours and then dampen the paper as before with either a brush or a sponge. Use a brush to touch-in one colour, clean the brush and then dot in the other colour.

2 The paint will continue to bleed into damp paper – the amount will depend on the type of paper, how damp it is and the temperature and humidity of the room. The colour is paler than when wet, and the two colours have blended in places to create a third.

damp paper with the tip of the brush. You will see the colour being drawn off the brush and spreading over the paper. If you have not worked in this way before you will find the effect quite startling. The colour will continue to spread as long as the paper is damp, but more and more slowly as the paper dries. When dry the edges will be softer and the colour will look considerably lighter. Again, only with practice will you be able to look at the wet paint and know what the dry paint will look like.

Wet-in-wet techniques can also be used to blend colours. You can start by laying a flat wash of one colour and drop a second one into it. Alternatively, you can mix solutions of two colours and drop one colour on to the damp paper, then clean the brush and do the same with the second colour. In both cases the colours will bleed into each other, creating a marbled effect with blurred edges at the margins of each colour. The final effect will depend on the dampness of the paper, the concentration of the washes, and the amount of colour solution used.

Wet-in-wet

1 Try this experiment. Lay a flat wash of colour – here the artist has used chrome yellow on a sheet of very heavy handmade paper. Then while the wash is still wet brush in two strokes of another colour – here the second is cadmium red.

2 The second colour spreads into the wash, the two colours blending to create orange. The mark of the brush enlarges, the edges blurring, but the broad form of the original mark is still discernible.

Wet-on-dry

1 Now using the same colours as above try this experiment. Lay a wash of the first colour, but this time allow it to dry completely – it must be absolutely dry. Now, using the second colour, lay two brush strokes on to the dry wash.

2 This time the colour does not spread and the integrity of the mark is maintained with crisp, clearly defined edges. This highlights yet another resource of the watercolour artist – the ability to create different types of edges – softly blurred edges using wet-in-wet techniques and crisp edges using wet-on-dry.

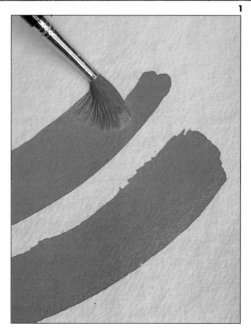

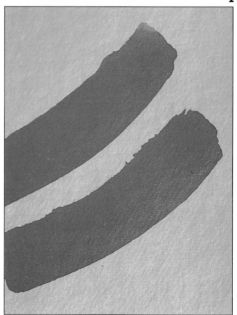

PAINTING WITHOUT WHITE PAINT

For the newcomer to pure watercolour the lack of a white paint presents both an intellectual and a practical problem, yet it is essential that this concept should be grasped if you are to use watercolours correctly. Those of you used to working in oil or poster colour will be quite stumped. How on earth are you to represent something white and how do you create lighter tones of a colour? The answer is twofold: paper and water. In true watercolour the white of the paper is the only white and your lightest colour. This means that you must plan your paintings carefully, allocating the whites at a very early stage and carefully guarding them. With many other media, white is created at a late stage by overpainting with white paint and you can make a last minute decision about where the whites should go. With watercolour, once you have lost a white area it is almost impossible to retrieve it. (There are certain exceptions which are discussed in Chapter 4).

But what about pale tones? To understand this you must remember two important things about watercolour. First, it is a transparent medium and, secondly, the support is white. The vehicle for carrying the paint to the paper is water and as you increase the proportion of water to paint so you increase the transparency of the paint. What you are really doing is increasing the extent to which the white paper is allowed to show through the paint layer.

We look at this concept more closely in the following pages when we discuss the ways in which you can create tones.

To understand watercolour you really must understand the implications of the lack of white. If you don't, you will constantly work yourself into corners from which you will find it difficult or impossible to extract yourself. You will start by making an area too dark, and in order to maintain the correct tonal relationships you will have to make the rest of the painting much darker than you had intended. Which brings us to the concept of working 'light to dark'. This describes the classical watercolour method in which the artist starts with a white sheet of paper onto which he lays very pale tones, making sure that the white areas are left untouched. The darker tones are built up as layers of colour, the darkest tones being added at the end.

The illustrations on these pages are intended to reinforce these concepts by demonstrating two different ways of creating whites. In the picture at the top of the facing page the pattern is created by painting around the shapes, leaving the white of the paper to show. But below, the pattern is created by laying down a strip of red paint and then using white gouache to paint the pattern. If you look at the strips below you will see that the final effect is much the same, but the approach required is entirely different.

BUILDING UP TONES BY OVERLAYING WASHES

In order to describe form you need to be able to create a range of tones – here we are looking at one of the ways of creating a range of tones with watercolour. If you were asked to create a blue tonal scale – a range of tones of a single colour, from lightest to darkest – how would you go about it? Your first reaction would probably be to reach for the white paint, and develop the scale by progressively adding more white to the blue. But there's the rub – you have no white! And because watercolour is transparent, it is not possible to overpaint and obliterate one colour with a lighter colour. The method of creating tonal variations which is illustrated on this page, exploits the transparency of watercolour by overlaying washes of the same colour. Start by laying a flat wash of your chosen colour. Allow the first wash to dry and then lay another wash over the first, leaving a strip of the original showing. As you can see, each additional layer of colour darkens the tone. See how many layers you can put down before the wash starts to break up. When you have finished you will have a tonal scale of the colour. Experiment with different colours and try different types of paper. You will find that the transparent colours give you a greater range of colours

1 Start by laying a flat wash of colour – you can use your sample washes. Make sure that you have enough colour to complete the exercise. Here the artist has used rose madder alizarin. Before progressing to the next stage allow the wash to dry.

2 When the first wash is dry, load a large brush with the same colour and start to lay a flat wash of colour over it. Use the same method as before, laying one band of colour under the next, working briskly from left to right, then right to left, keeping the front edge wet and picking up the stream of colour on each return stroke. Take the colour two-thirds of the way down.

3 Allow this second layer of colour to dry completely – if you don't, the overlaid wash will pick up the underlying colour and the flat, even tone will be disturbed. Load a brush with the same colour and lay the colour in exactly the same way as before, this time taking it down only one-third of the wash. Allow the colour to dry and you will see that you have achieved three tones of the same colour from a single solution of colour.

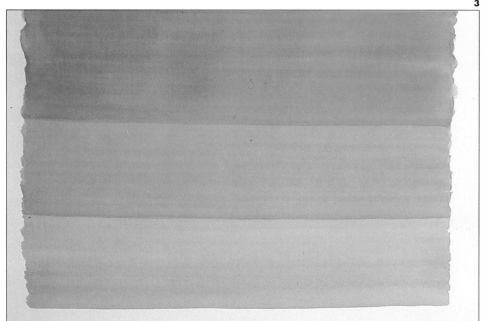

than the more opaque ones. You will also find that some papers can take more layers of colour than others, but eventually the wash will begin to break up. Make sure that each layer is completely dry before the next one is applied.

This technique of overlapping washes is very important in watercolour, and is exploited in the monochrome painting – the first project in this chapter. However, you will also overlap washes of different colours, each colour modifying the other to create a third colour, and all of them affected by the white of the paper which shines through the transparent paint layers.

1 To emphasize our point we have repeated the exercise with a different colour – ultramarine. Again we have started with a flat wash.

2 The first wash is allowed to dry completely and then a second wash of colour is laid over the first, taking it over two-thirds of the original wash.

3 A third layer of colour is laid over the other two, this time taking it down over the top third of the wash.

4 When the colour is dry you can see that again three different tones of the colour have been created by overlapping washes.

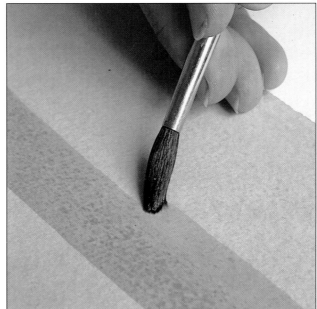

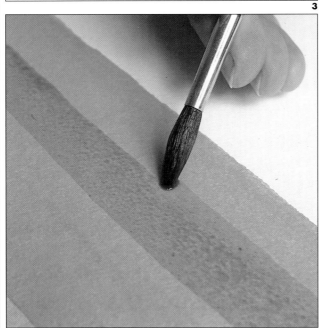

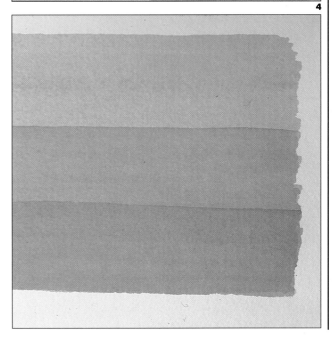

CREATING TONE BY DILUTING PAINT

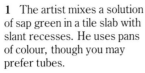

1 The artist mixes a solution of sap green in a tile slab with slant recesses. He uses pans of colour, though you may prefer tubes.

2 Below we see three bands of sap green. The artist mixed the darkest tone and laid the first band. He then added more water and laid the next band and so on.

On the previous pages we discussed the concept of painting light to dark and the building up of increasingly dark tones by overlapping washes of the same colour. So we now have a white – the white of the paper – and a limited range of tones created by overlaying washes. Here we look at another way of varying tone – this involves controlling the degree to which the paint is diluted. It is quite obvious, once you think about it, that the more the paint is diluted with water, the paler the colour will be. But if you are to use watercolour effectively and with confidence you need to know exactly how much water to

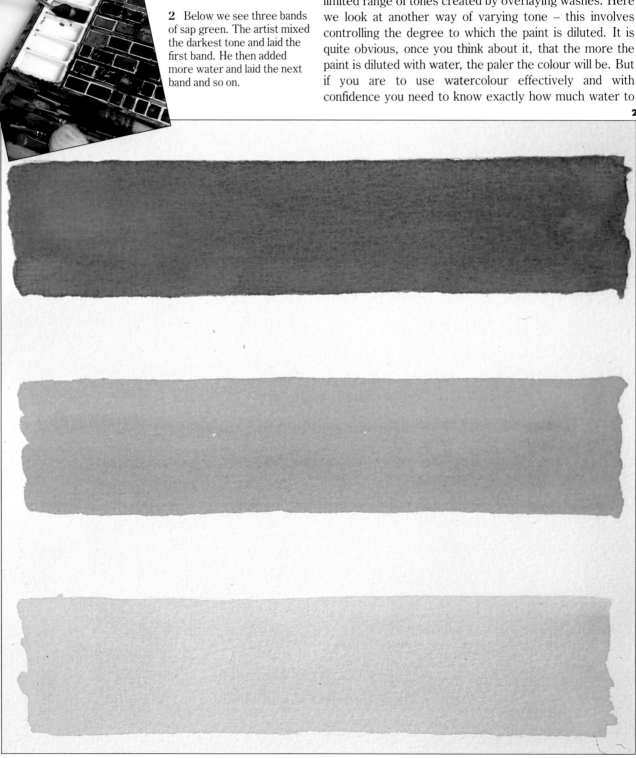

add to the paint, how a colour will look on a particular paper and what range of tones you can get from a particular colour. Here we suggest that you experiment with two greens: sap green which is rather transparent and oxide of chromium which is much more opaque. We have produced only three tones of each colour – when you have tried this simple exercise, see if you can create a continuous tonal scale by painting a square of the most intense shade of the colour you can get, then add a little water and paint another square beside the first. Continue until you have a shade so pale it barely tints the paper.

3 Here the artist has used exactly the same approach, but this time he uses oxide of chromium, a less transparent colour than sap green. This is particularly evident if you compare the middle bands of each sequence. Experiment with different colours – it will help you become familiar with the paints in your box. Each has special qualities, and it is very irritating to find that you have spoiled a subtle effect by using a colour which is too opaque or too strong.

You could darken your wash by adding more paint but it is easier to control and predict the effect of adding a certain amount of water.

3

LAYING A GRADED WASH

Graded wash on dry paper

1 Mix a solution of colour and load a brush with this full-strength mixture. Lay a band of this colour across the top of the paper.

2 Lay several more strokes of the same full-strength colour as you would for a flat wash.

3 Dip the brush into water and lay a band of colour, picking up the wet front.

4 Continue in this way, gradually increasing the ratio of water to pigment to achieve a gradual lightening of the tone.

5 The finished wash dries lighter than it looked when wet and you must allow for this.

A graded wash is one in which the colour is dark at the top progressing through carefully controlled tonal gradations to the bottom of the wash, where it merges into the colour of the paper. Graded washes can be laid in one of two ways. In both cases you will need stretched paper which is fixed to a board. The board should be tilted at about 30 degrees. For the first method you mix a solution of colour, and with this full-strength mixture and a loaded brush lay a band of colour across the top of the sheet. Keep the board tilted so that the colour runs down. Dip the brush into clean water and then lay another band under the first,

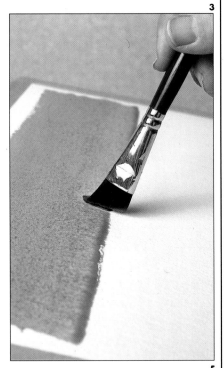

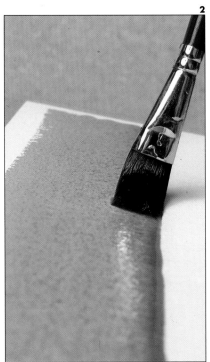

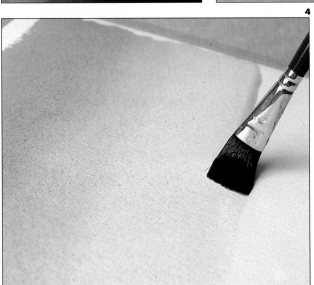

picking up the wet front. Continue in this way and you will find that the colour gradually becomes lighter in tone. You can achieve the same effect by adding water to the original wash before each stroke. You can also lay several bands of one strength before diluting the wash.

For the alternative technique you should damp the lower part of the paper where you want the pale colour to be. Mix the solution of colour as before and lay a band of paint across the top of the paper. Then working quickly take the colour down into the damp paper, where it will become paler.

Laying a wash into a wet area

1 Now try to achieve the same effect in a different way. Start by damping the paper with a sponge or water – blot off excess water.

2 Start with the full-strength solution in the same way, laying the colour with a loaded brush and picking up the wet edge of the wash.

3 Eventually you will take the colour down into the damp area and, as the paint solution meets the wet paper, it will become lighter in tone.

4 The final effect is much the same as that achieved using the previous technique. Nevertheless this method is useful when you want to establish a pale area in a particular part of a painting.

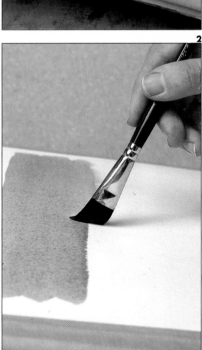

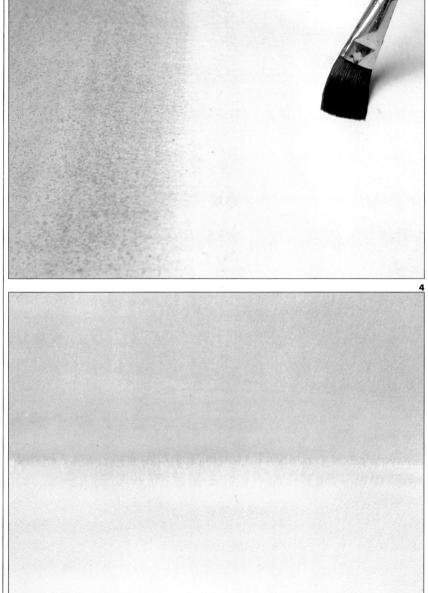

Rain Clouds 1
MONOCHROME

For this, your first watercolour painting, you will need only one colour, lamp black. The word monochrome is used to describe a drawing or painting in which only one colour is used. The exercise will give you practice in judging and mixing tones, laying and controlling wet paint and creating form and space with only one colour. It will also allow you to apply the knowledge you have gained by doing the exercises on the previous pages.

You may use either pan colour or tube colour. When mixing large quantities of a single colour it is probably easier and quicker to use a tube – you squeeze a little colour onto a palette and add water. With pan colour you have to pick up colour from the pan with a wet brush, take the loaded brush to the palette and add water. You may have to return to the pan several times in order to take up sufficient colour. However, the decision to use pan or tube colour is finally a question of personal preference. The type of ceramic palette with both slab and circular recesses is probably best for tube colour. The colour can be squeezed into the circular recess and water added when mixing small quantities, or larger amounts can be mixed in the slab recess.

Make sure that you mix plenty of colour – it is very irritating to run out half-way through a wash. If you do have to stop to mix more colour the wash will have started to dry by the time you return, creating ugly tide-marks when you wanted a smooth, even finish. This can sometimes be remedied by applying more water to the area and allowing it to dry thoroughly. The success of the remedy will depend on several factors: how dry the paint is, the type of paper and the staining power of the particular pigment. Only with experience will you be able to judge these accurately, but forewarned is forearmed, so we will try to alert you to the pitfalls which lie in wait for you. In most of the paintings in this book the artist has used Cotman paper, a new paper produced by Winsor & Newton Ltd which is particularly suited to the requirements of the beginner. One of its qualities is the ease with which colour can be lifted from its surface.

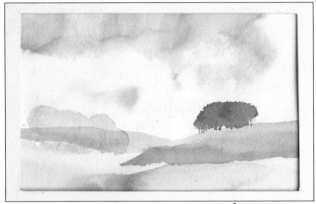

The subject of our first watercolour demonstration is a rolling landscape beneath a brooding sky. The painting evolves in a series of simple steps. Study the captions and pictures carefully and then have a go yourself. Good luck!

1 The artist used a sheet of unstretched 140 lb (300 gsm) Cotman paper 10¾ in × 14¾ in (22.5 cm × 37.5 cm). He used only one brush – a number 8 Kolinsky sable; a little piece of natural sponge; a jar of water; and a plastic palette.

The artist uses a sable brush loaded with water to dampen the paper. This is not as easy as it sounds for the amount of water on the paper is critical: too much and the colour will spread too rapidly and you will not be able to control it; too little and the paper will dry before you have run in the colour, creating tide-marks.

2 You must work quickly. The artist creates the sky using a wet-in-wet technique. He mixes a large quantity of colour in a plastic palette and, with a loaded brush, works across the damp paper touching in the colour with the tip of the brush. The colour spreads quickly across the paper, the variegated tones creating the impression of a cloudy sky.

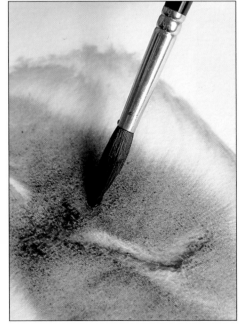

3 The artist softens the edges of the wash by dabbing the wet paint with a small piece of damp sponge which lifts out some of the colour. When you first start working wet-in-wet the effect can be startling – everything is wet and apparently uncontrollable. Many things can go wrong – the paper can get too wet, there may be too much colour on the brush or your colour mixture can be too light or too dark. But there's no need to panic because as long as the paint is wet, there is hope. Here for example, the artist kept the edges soft by picking up excess colour from around the edges with a brush. He used the sponge to blot off colour to give greater transparency to the underside of the clouds.

4 Below we see just how effective and dramatic watercolour can be. We've actually done very little, but a great deal has been achieved by working with the paint and paper, and to a certain extent, by allowing the medium to dictate the outcome. Once familiar with the water, paint, paper and other materials, you can better handle the elements of risk and randomness inherent in the medium. With a few touches of the brush and by lightly controlling the wet paint, the artist has created an atmospheric sky. Notice the way in which the colour has been contained within the original wet area.

3

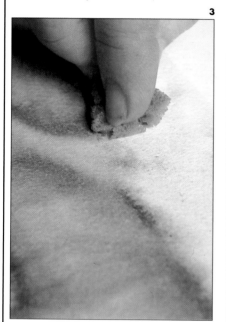

4

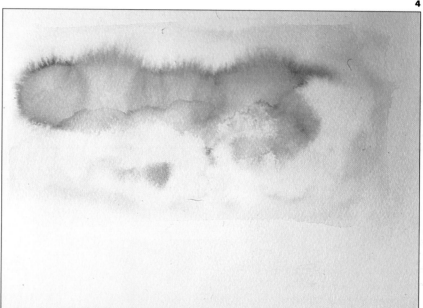

5 Here we have the artist working wet-on-dry in order to achieve crisp edges. It's important to make sure that the painting is absolutely dry before proceeding to this stage. The artist mixes a darker solution of lamp black and, using the same number 8 sable brush, lays down a swathe of colour to describe the distant hills. Notice how dark the colour looks and compare this with the tone in the final painting.

5

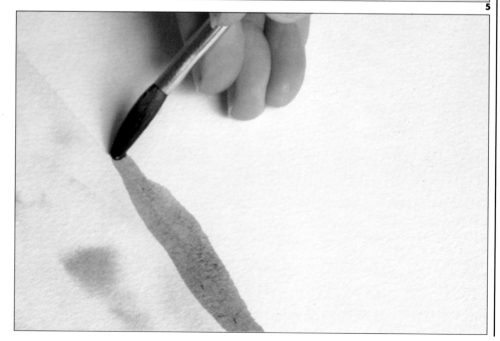

6 The artist adds more lamp black to his mixture and lays down a broad band of colour to describe the nearer hills. The darker tone creates the impression that these hills are nearer. This is the principle of aerial perspective, which states that objects in the distance are lighter in tone and less clearly defined than those closer to the observer. As you can see, with a few simple areas of a single colour the artist has already managed to create a sense of space and distance.

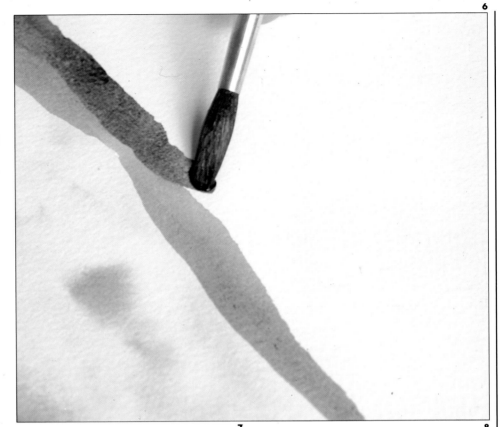

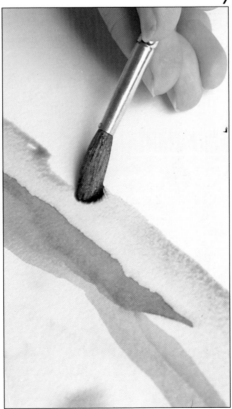

7 Next the artist uses a very light wash to establish the foreground. He works rapidly, keeping a wet edge to avoid streaking and takes the colour down the page. Where this wash overlaps the previous washes darker areas are created, adding interest to the middle distance.

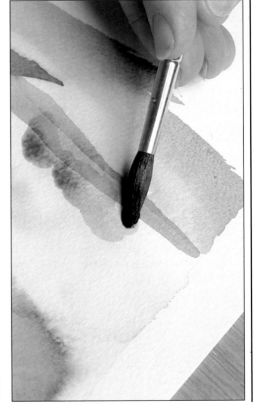

8 Using the same mixture and a loaded brush the artist now defines the clump of trees on the hillside. In this detail you can see quite clearly the transparent quality of watercolour and the effects created when one wash is overlapped by another.

At this stage the artist stood back from the painting and viewed it from a distance to see if it was 'coming together'. He decided that a final wash was required in the foreground to establish this area and bring the whole painting into focus.

Here we show two versions of the final painting. In one we see the uneven edges of the paint areas, in the other we have dropped a mount over the painting. This has the effect of delimiting the boundaries of the picture, concentrating the viewer's attention. Cut yourself a mount to the correct size and use this to mask off the painting. Doing this at various stages as you work will allow you to 'see' the painting more clearly. Areas that are too dominant will jump out at you and those areas requiring more work will become apparent. While in these exercises the end product is less important than what you learn in the process of creating the painting, it is sometimes helpful for beginners to have their early works framed as they are able to see them as 'real' paintings. You will probably be pleasantly surprised to find that your picture is better than you thought... 'It's amazing the different a mount and frame makes.'

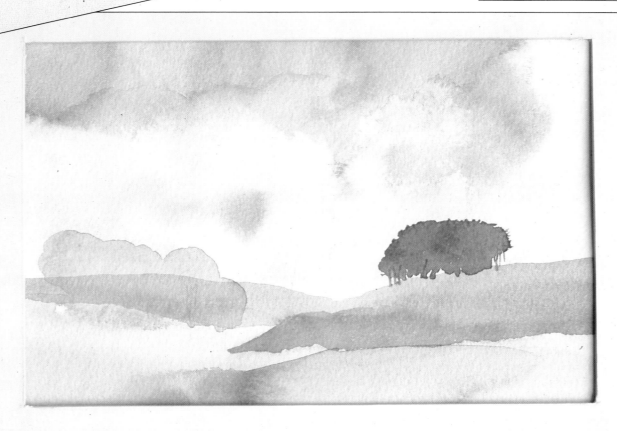

Lamp black

9

Rain Clouds 2
MONOCHROME WITH WASH

I hope that you will have been agreeably surprised by the range of tones and the variety of effects you were able to achieve with only one colour. It is a good idea, especially when you start painting, to limit your palette and concentrate on becoming familiar with the techniques and the possibilities of the medium. You will find that most experienced artists use a fairly limited range of colours. Certain basic colours crop up again and again in their work, but this basic palette may be supplemented by other colours introduced for particular purposes.

One of the special qualities of watercolour is its transparency. This means that the white of the paper glows through the layers of paint, giving it a special brilliance. It also means that you can overlay one colour with another, one modifying the other to create either a third colour or a darker tone. Here the artist demonstrates this quality by laying tints over the original monochrome painting. The effect is rather like that of a hand-coloured print. Try this yourself, but remember to make sure that the first washes of paint are completely dry before you start work. Otherwise the first washes will lift off and taint the top layers.

1

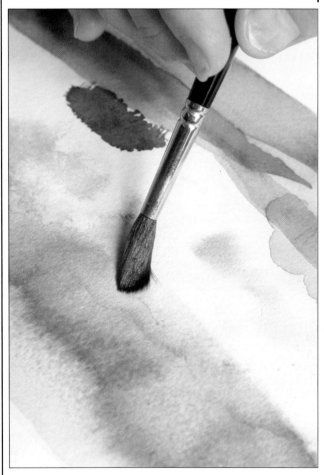

2

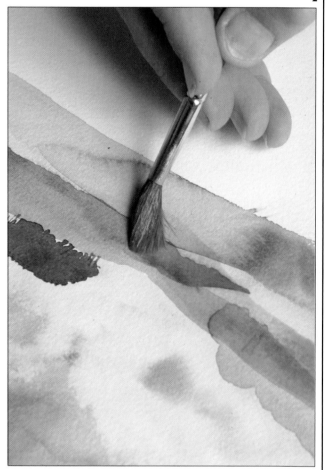

1 The artist used a number 8 sable brush and two colours – Winsor blue and yellow ochre. He mixed a quantity of Winsor blue wash in a ceramic dish. He used a number 8 brush and worked up the surface of the colour in the pan by going over it briskly with a wet brush.
The success of this exercise depends on speed and decisiveness. You must decide exactly where the colour will go before you start and make sure you have enough colour to complete the wash. The artist laid blue wash over the sky area with a loaded brush and you'll see that the tonal underpainting shows through the transparent colour.

2 Next the artist laid a wash of yellow ochre over the foreground. Again he mixed plenty of colour and worked quickly, the transparent wash adding a hint of colour to the foreground.

3 Here we have masked the painting again so that you can see it as a 'finished' object. Cut yourself a set of masks to fit the sizes that you work with. Drop them over your paintings to judge your work as it progresses.

Watercolour is unlike any other medium. Other water based points such as gouache, poster colour or acrylic are opaque, and the lightest tones are created by the addition of white, while darker tones are created by adding more of the same colour, or black. Working in watercolour is entirely different: you add more water to create a light tone – the thinner the wash the more the white of the paper will show through. The support – the painting surface – thus becomes extremely important, the texture and colour having a significant influence on the final image. In this painting, for example, the palest tones are in the sky just above the horizon where the white of the paper is overlaid by a subtle wash of Winsor blue.

Another way of creating dark tones is by overlaying several washes of colour as the artist has done in the middle distance. In most other media one colour will obliterate an underlying colour. Here, though, the ochre and monastral washes do not obliterate but rather modify the underlying tonal painting.

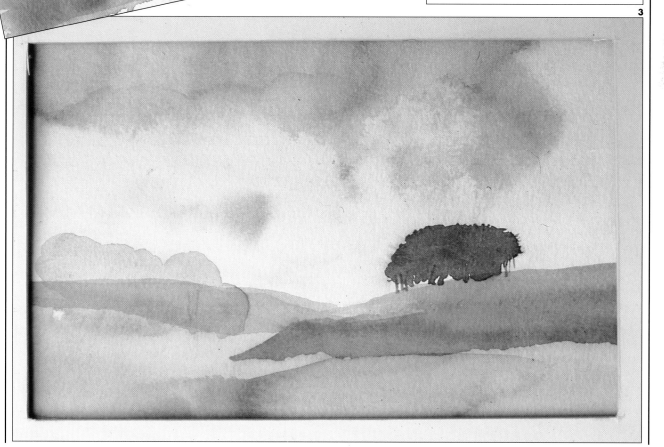

Lamp black *Yellow ochre* *Winsor blue*

3

The Beach
GRADED WASH

In this simple painting you will be applying a graded wash. This is a wash in which a colour grades from an intense shade, through gradual changes of tone to a very pale tone of the same colour. Here it is used to describe a clear, cloudless sky which shades to pale blue at the horizon – this is typical of a hot summer's day when the bright blue of the zenith is modified nearer the ground by heat hazes. This grading of colour helps to create a sense of space: the deepest blue is overhead, above the viewer, the paler colour is perceived as being further away.

Remember that there are two ways to lay a graded wash. You can damp the paper in the area you want to be palest and then take the colour down into that area. The other technique is to dilute the wash as you come down the paper, you can do this by dipping your brush into water and going directly to the paper. Alternatively, you can add a little more colour to your wash. Practise until you are confident that you can complete the wash without dithering – if you stop the wash will dry or will begin to run back. Laying a graded wash should take only seconds.

The painting is simple – a few bands of colour with details added in the foreground and in the distance, but it is, nevertheless, effective. Try and keep your painting simple so that you can concentrate on getting to know watercolour. When you are more familiar with the medium you can be more ambitious with your choice of subject.

1 The paper for this painting was Cotman 90lb (185 gsm) and measured 10¾ in × 14¾ in (22.5 × 37.5 cm). The artist used two sable brushes, a number 3 and a number 8.

The artist mixed a solution of Winsor blue and Payne's grey. Tilting the board and using a number 8 sable brush loaded with colour and working left to right, the artist laid a broad band of colour across the top of the picture area. When he reached the edge he lifted his brush, picked up more colour, then made the return stroke, making sure that he picked up the 'wet edge'. He diluted the wash by adding more water, then loaded his brush with this paler colour and laid another band across the paper, continuing in this way to the bottom.

1

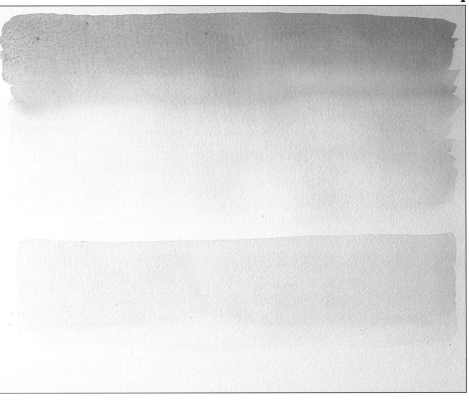

2

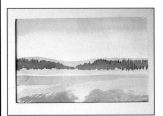

Here the artist has chosen a simple subject – a sandy beach backed by a strip of vegetation, and low hills.

2 The second wash of ochre and Payne's grey was laid down in the same way. Here you see the two areas of colour.

When laying any kind of wash it is important to work quickly and keep the board tilted, so that the swathes of colour blend evenly and do not run back into the wet area. The wash would not be smooth if that happened and you would end up with puddles of colour and tide-marks.

3 The graded washes were allowed to dry and, working wet on dry with a mixture of sap green and Payne's grey, the artist laid down the broad forms of the vegetation which borders the beach. Try to simplify your work as much as possible by concentrating on the broad forms rather than bothering with details.

It is important that you become familiar with watercolour and the way it reacts in different circumstances – only in this way will you gain confidence, allowing you to experiment and develop your own style.

4 In this detail the tip of the brush handle is being used to draw strands of colour out of the still-wet paint, effectively breaking up the smooth contours of the colour so that it suggests the spiky outlines of mixed vegetation.

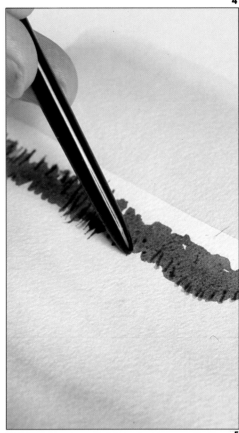

5 So far you have laid down only three areas of colour: two graded washes for the sky and sand and a band of wet-on-dry textured with the brush handle for the strip of vegetation. Yet, as you can see, the broad forms of a convincing landscape are already beginning to emerge. At this stage stand back from your painting and study it carefully to see which areas need more work. This is particularly important with watercolour, which is generally small scale and often painted on a flat surface. You tend to work close to the painting, either hunched over or even sitting down to it. This means that you do not tend to step back from the work at frequent intervals as you do with easel painting.

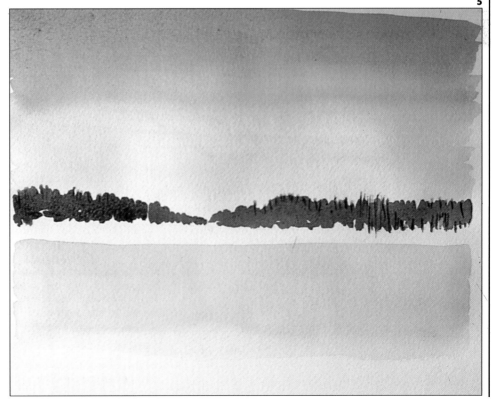

Techniques
LIFTING COLOUR

In the previous chapter we talked about the lack of white in the watercolourist's palette and the limitations this imposed on the artist. As we said, the white of the paper then becomes the only white available, and pale colours are created by diluting the paint with water. It is obvious therefore that you must plan carefully to retain white and light areas, because they cannot be lightened by overpainting at a later stage. However, there are exceptions to every rule and artists are ingenious at overcoming the limitations of a particular medium.

Watercolour is a very fluid medium and takes a little while to dry. While the paint is still moist it is possible to lift the paint and thus lighten an area. The success of this process depends on several factors: how dry the paint is; the staining power of the paint; and the type of paper. As we have mentioned, different paints have different staining powers. The paints with high staining power are extremely difficult to lift once they are laid down. Winsor blue and alizarin crimson fall into this category and, under most circumstances, they will leave a stain on the paper. The paper's capacity to release colour depends on texture and the size used. The Cotman paper, which we have used

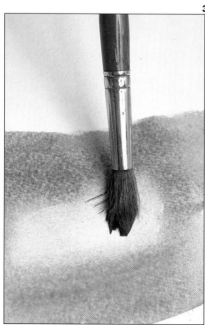

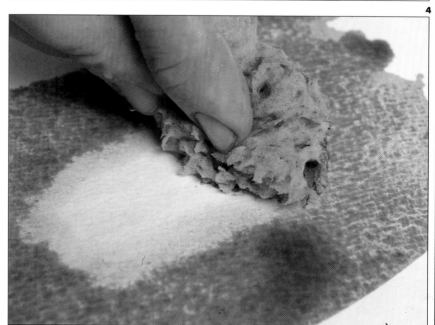

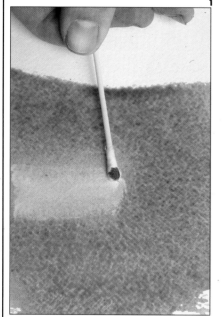

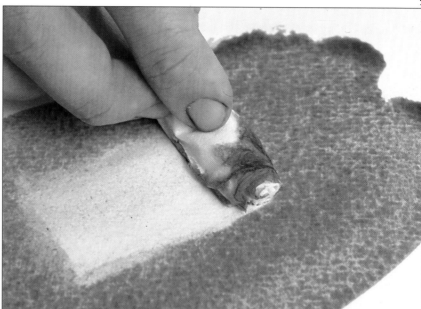

for many of the projects in this book, is particularly good for this purpose and you should try if possible to get some for these exercises.

Wet colour can be lifted from paper, usually with tissue, a brush or a soft cloth. This can be useful to correct mistakes or when you have flooded the paper and simply want to remove the excess. But it can also be used for more positive reasons, to create a light area for a particular purpose – clouds in a blue sky, ripples on water, or highlights on a vase, for example. In many ways it can be thought of as 'drawing back' into the paint.

Even when the painting is dry there are things that you can do – again, you may wish to correct a mistake or achieve a more positive aim. Here we illustrate the use of sandpaper or a blade to scrape off the surface of the paint – obviously this damages the paper surface. However, if you are interested in texture you may wish to incorporate this scuffed effect in your painting.

Now lay a flat wash and experiment with the following suggestions.

1 These cotton wool buds are extremely useful. The cotton wool absorbs the colour while the stick and the small size and neat shape of the bud gives considerable control. See how many patterns and shapes you can create.

2 Tissue paper is another useful absorbent material. Here a tightly rolled wad of tissue is used to lift colour from a still-wet wash.

3 A brush can be used to lift wet paint. Wash it thoroughly in clean water, then dry it by blotting it with cloth or tissue. Dab the brush into the colour and you will find that some of the paint is absorbed. Wipe the brush on tissue and repeat the process. If you want to lift a large area of colour you may need to rinse the brush in water at intervals.

4 A small sponge is an essential piece of equipment for the watercolourist. Sponge is an absorbent material, ideally suited for this purpose. It is particularly useful for lifting colour from large areas and for blotting sky washes to create cloud effects. Sponges are sold in art suppliers, but you will find it cheaper to buy one elsewhere and cut pieces from it as you need them. Use either natural or synthetic sponge.

5

5 The examples on this page are all applied to dry or nearly dry paint surfaces. Here a fine sandpaper is used to lighten an area. The sandpaper should be handled lightly, but even so the surface of the paper will obviously be damaged. However, if your painting is dry and there is something you feel you must remove, this may be the only way.

6

6 Here a sharp blade is used to remove paint. Again, the paper surface is damaged, but the technique allows you to remove very small amounts of colour or create very fine details. It could also be used to introduce texture to an area.

7

7 This technique is known as a backwash, and it sometimes happens by mistake! The paint is almost dry and water is dropped on to the surface. Leave it for a few minutes and the colour will lift and separate, the colour particles tending to accumulate at the edge of the wet area. This technique is used to add texture to a painting, but it also shows that some colours *can* be lifted once they are dry.

LOOKING AT EDGES

Watercolour is a simple medium, based on a few principles but capable of almost infinite possibilities. Here I want to draw your attention to the different qualities of edges that can be achieved using wet-in-wet and wet-on-dry techniques. You may never have considered edges in isolation before, but they give you important clues to the visual world – at a distance, edges become blurred and ill-defined, while those close to you appear crisp and sharply defined. This allows you to imply distance in a painting and is exploited in aerial perspective. Crisp edges can also be used to suggest brightness. On a bright sunny day there will be a lot of contrast between the areas in full light and the shadows, which will be dark with clearly delineated outlines. So if you want to suggest brilliant sunshine introduce a few contrasty shadows.

The quality of edges is also important in the description of form. To describe a rounded object in certain light conditions you will need to create subtle changes of tone, one colour gradually blending into another. This effect can be achieved in several ways. You might, for example, use small dots of broken colour which blend in the eye, so that seen from close to the changes are far from subtle, but when seen from a distance the eye is deceived into reading them as a subtle gradation. You may decide to use a tighter, more meticulous technique,

blending the colours into one another so that there are no sudden changes of tone. In that case you would apply the paint wet-in-wet, allowing the colours to run into one another. To learn more about edges, and the way paint reacts under different conditions, we suggest you practise the exercises on these pages – no amount of reading can replace the experience of putting brush to paper.

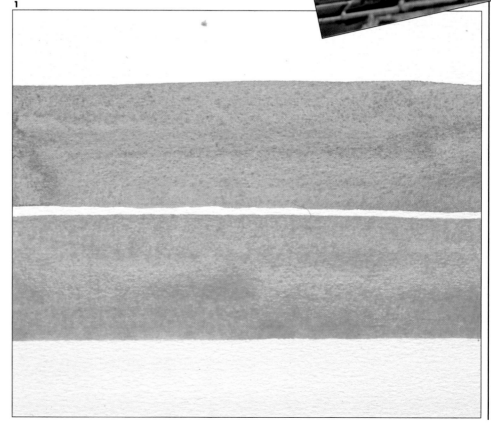

Collect jam jars and coffee jars – they make excellent water containers. As a watercolour painter you will soon find all sorts of alternative uses for household objects.

1 Lay two bands of colour side by side on to a dry sheet of paper, leaving a small gap between them. The colours used here are permanent mauve and prussian blue. Leave the paint to dry.
The first point to notice is that the blocks of colour dry with a crisp edge – because they were applied wet-on-dry. The other point is that although they are laid fairly close together they have not run into one another. This can be exploited when you are painting in a hurry – out of doors for example. If you want to paint a sky and hills along the horizon and do not have time to let the sky dry first, you can lay in the sky and then, leaving a slight gap between the two, lay in the hills, filling the gap at a later date. The size of gap required will depend on the type of paper; on some papers paint bleeds more than on others – again, only experience will tell you which.

2 Next, using the same colours and working wet-on-dry, lay two bands, but this time allow them to just touch. Again leave it to dry. You will find that the colours merge into one another at the junction, creating a softer edge between the two colours. The wetter the paint, the more they will run into one another.

3 Finally damp some paper and lay two bands of colour onto it, leaving a reasonable gap between the two colours. As you see, the colours flow into the wet area, creating a soft edge – which should be compared with 1 and 2. Again, practise laying colours wet-in-wet varying the distance between them.

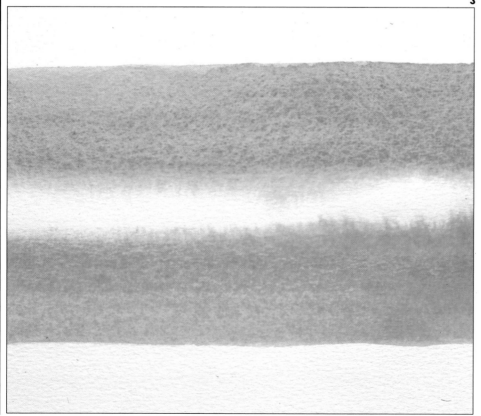

BRUSH MARKS

The brush is not just a means of getting paint on to the paper in the way that a decorator applies paint to the wall. For the artist, the brush is a means of expression, a subtle instrument to be exploited in just the same way as a flautist exploits his flute. The brush works in conjunction with the paint, the water and the paper, and you must be prepared to let these various elements do the work for you. So sometimes you will leave the brush on the paper for a moment and allow the colour to bleed off, rather than brushing it on. There are a great many different kinds of brushes and we have looked briefly at some of these in

Round number 9 Kolinsky sable
The marks were made as follows *(left to right, top to bottom):*
Regular hatching marks, moving from the wrist.
Brisk vertical marks, again from the wrist.
Vigorous hatching, moving from the elbow.
Stippling, using the tip of the brush and moving from the elbow.
Rolling the brush.
A stippling movement, but applying pressure so that the ferrule is near to the paper surface.

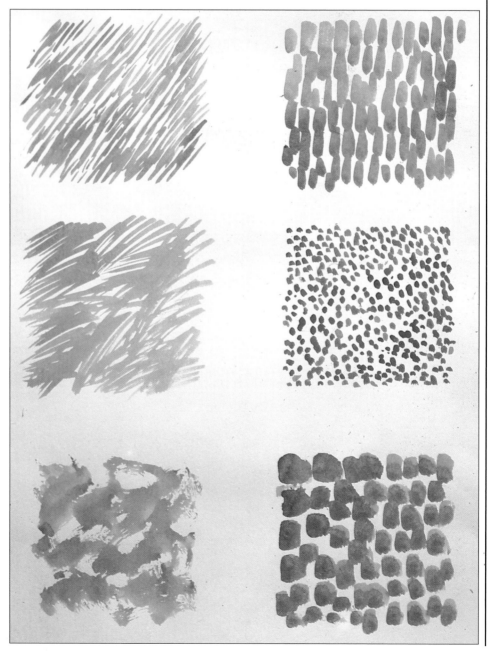

Chapter 2. However, don't think that you need a huge selection – most of the paintings in this book were painted with just one or two at most. To start with, choose a couple of brushes and really get to know them. Start by holding the brush in different ways, close to the ferrule, part way up the handle, and at the very top of the handle. Each grip gives you a different range of movements and a range of marks. Except for close detailed work you will normally find that holding the brush in a fairly relaxed way will give you the best results. Now look at the range of movements that can be used. Depending on the scale of the work you can use wrist movements, movements from the elbow or, on really large works, movements from the shoulder. Experiment with all these gestures and try making a variety of long strokes and short strokes. Now do as we have here and take a flat brush and a round one of the same size, and see just how many different marks you can get from single brush. Use the tip of the brush, the centre, and the base near the ferrule. Make short stabbing strokes, long sweeping strokes, and rolling movements. Practise these marks and movements whenever you can, and you will acquire greater control over your brush.

Flat, ¾in ox hair
The marks were made as follows *(left to right, top to bottom)*:
The flat of the brush, left to right gesture from the elbow, with a stiff wrist.
Stippling with the tip of the brush.
Stippling with the corner of the brush.
Brisk hatching marks from the wrist, changing direction.
Flat of the brush with a loose wrist.
Stabbing gesture with the side of the brush.

DRY BRUSH

Dry brush is a delicate technique which employs, as the name suggests, a brush which is only barely damp. The brush is dipped in the paint solution and surplus fluid is removed by squeezing the brush between thumb and forefinger – alternatively, the surplus can be blotted off on a piece of tissue. If you experiment with either of these techniques you will find that the fibres of the brush spread and become separated, and when applied to the paper surface create a light feathery effect. To create this effect in any other way you would have to use a very tiny brush and spend a great deal of time building up the delicate marks. Dry brush can be used for a variety of effects; in this book it has been used to describe grasses and shadows of grasses on a track. It could also be used to suggest wintry trees seen from a distance, the tiny twigs of a tree seen from close to, or feathers or fur. Practise dry brush techniques on a variety of papers and with different brushes. Also explore the range of marks that can be created with a stiffer brush than is usually used for watercolour.

1 Mix a quantity of the colour you intend to use, in a dish. Test the colour on a sheet of paper – if it is too pale, the technique will not show to advantage.

2 Now remove excess moisture from the brush by blotting it on tissue, or by pulling the bristles through your thumb and forefinger. This not only removes moisture, it also causes the fibres to separate into pointed groups.

3 Using the tip of the brush make a series of marks on a sheet of dry paper. You will find that the brush leaves not one but several marks.

4 Here the artist has built up a complex mesh of marks to show you how the technique might be used.

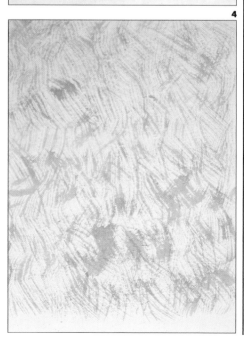

In Chapter 2 we looked briefly at different types of watercolour paper and their qualities. Here we again look at paper and how you can get the most from it. For the beginner a Not surface will probably be most useful – its texture is smoother than Rough and rougher than H.P. The surface of the paper, whether smooth or textured, makes a great deal of difference to the painting. Look at the work of other artists and you will find that generally those who use a tightly rendered technique go for a smooth paper, whilst those who apply the paint rather freely like a more textured surface. Illustrators, for example, favour smooth papers as these allow them to render fine detail and are much easier to reproduce from – the pits and shadows on a textured paper are picked up by the camera in the reproduction process. The texture changes the feel of the paper, and this in turn affects the sort of gestures you make and the way you handle the brush. Textured paper has tooth, takes up a lot of paint and resists the brush. On a smooth paper, on the other hand, the brush slips over the surface with very little resistance.

Scumbling

1 This term, which is usually applied to oil painting, describes the application of paint so that coverage is uneven, allowing the support or underlying paint layers to show through. The result is broken colour. Here the artist takes up the colour on his brush, blots off the excess and applies the paint, brushing briskly.

2 Here you can see the uneven paint surface which allows the white of the paper to show through. The texture of the paper contributes to this effect – a smoother paper would produce a less broken effect.

Rolling

1 Here the artist has loaded a brush with paint and then rolled it over the paper surface.

2 As you can see the paint takes to the paper surface unevenly, catching on the high parts and leaving the recesses paint-free. The effect is heightened on this highly textured paper.

Mill in Winter
USING THE WHITE OF THE PAPER

One of the aspects of watercolour which many beginners find difficult to grasp is the concept of working light to dark. They also find it difficult to reconcile themselves to working with a medium that provides no white paint. The overriding characteristic of watercolour is its transparency which means that colour is built up as a series of transparent washes. White pigment is always opaque, so it covers any underlying colours. If white paint were mixed with watercolour, the watercolour would lose its translucency – it would in fact become gouache. So for all intents and purposes white paint is 'banned' from the palettes of pure watercolourists. At this stage it would be best if you could avoid the use of white. When you are more expert with the handling of pure watercolour you may well decide to mix your media and incorporate gouache, but that is really a more 'advanced' technique. Like most new concepts, once you understand and accept it, the principles of watercolour are not particularly difficult. But, especially if you have been used to a medium such as oil, gouache or poster colour, you will find it difficult to plan your work. The snow scene which we now demonstrate forces you to address this particular problem. The white snow is obviously the lightest part of the painting, so from the very beginning you must decide to avoid putting any colour in these areas. The shadows on the snow are the next lightest areas and these too must be reserved. Once a dark tone has been laid down, the only way it can be lightened is by physically removing it – with a tissue or sponge, for example. Particularly when you are new to watercolour it is probably best to build up your painting as a series of very light washes. Remember that in watercolour you can always get darker but you cannot (with certain exceptions) get lighter.

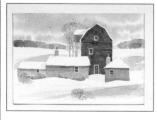

This snowcovered landscape will help you to understand one of the basic principles of watercolours – the paper is the only white you have to work with!

1 The paper is Cotman 140 lb (300 gsm) Not, 10¾ in × 14¾ in (22.2 cm × 37.5 cm). The artist used a 4B pencil for the initial drawing and then worked with sable brushes numbers 3 and 6.

He started by making a simple outline drawing of the subject. He did not put in too much detail, just enough information to tell him where the main elements of the composition were located. He uses very light pressure to avoid indentations in the paper surface.

2 The artist mixes a wash of Winsor blue and Payne's grey, making sure he has plenty of colour to complete the wash. Using a number 6 sable brush dipped in clean water he carefully 'paints in' the area of the sky, working along the horizon line up to and around the roofs of the tall gabled buildings. The area of the wash has been shaped by the water. In the detail below the artist is adding in the Winsor blue/Payne's grey mixture to the wet area.

3 The wet-in-wet technique is capable of almost infinite variety. You may be exclaiming, 'Not another Payne's grey/Winsor blue sky!' but if you examine the picture on the right you will see that the effect achieved is quite different. The artist laid down the colour by working across the painting from left to right then right to left. Near the horizon he has let horizontal strips of white paper show through the wash, creating a crisp cold mackerel sky.

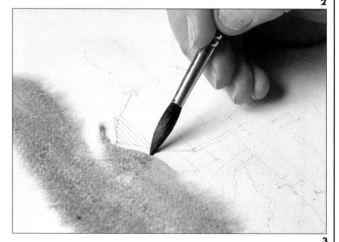

4 The artist mixes raw umber with a touch of Payne's grey and starts to block in the gabled end of the weatherboarded building. Stripes representing the boards were laid on in a slightly darker tone while the paper was still damp. The edges of these stripes are slightly softer than they would have been had the paper been completely dry.

5 The trees in the background are laid in very simply and directly with broad strokes of a burnt umber/ Payne's grey mixture. The buildings in the foreground are blocked in with a very dilute wash of burnt sienna.

6 The painting has progressed remarkably quickly for several reasons. The subject is simple and the snow on the ground and roofs makes the white of the paper a positive element in the composition. The white areas become more significant as you define other areas of the picture. Another factor in the speed with which the painting develops is the scale at which the artist is working. The artist tends to work on a fairly small scale especially when he is working from life. He does however work on a larger scale on other occasions, when the subject appears to demand it or when he has a particular commission to fulfill. You will soon find the scale you prefer to work on – you may even like to vary the scale quite often.

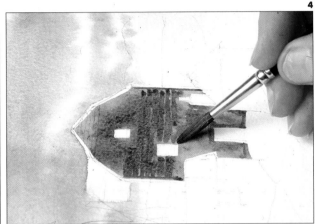

4

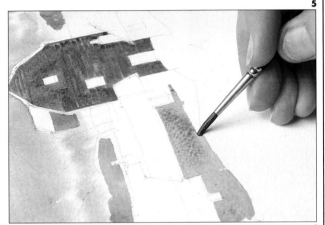

5

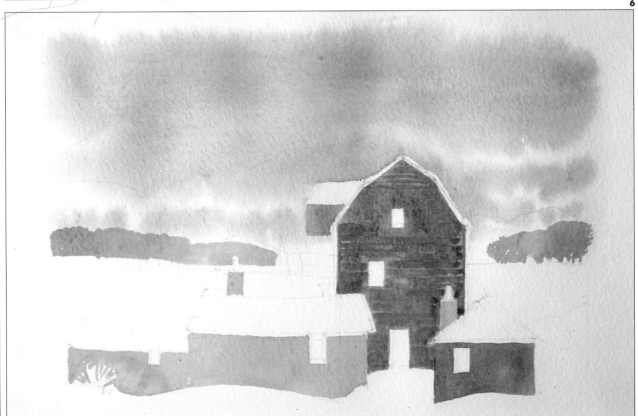

6

USING THE WHITE OF THE PAPER/MILL IN WINTER

7 With a very pale tone of the burnt umber/Payne's grey wash, the artist lays in a band of colour along the horizon suggesting woods and coppices receding into the distance. Remember that pale colours and soft edges persuade the eye that the object is further away than a dark object with crisp edges. Now that the broad areas of the painting have been established the artist starts to add details. Below we see him putting in the glazed areas of the windows, using a mixture of burnt umber, Payne's grey and Winsor blue with the tip of a number 3 brush. Notice the way he has left the white of the paper to stand for the window frame and glazing bars.

8 A touch of cadmium red on the door adds a zest of colour. Payne's grey and burnt umber are used to draw in the skeletal forms of the wintry trees behind the house. The artist again uses a pale tone to place the group of trees in their correct position in space. Below, he uses the same mixture to draw the spiky outline of the small bush.

9 Snow is not white and flat, it is a reflective surface which picks up colour from its surroundings and in most instances the surface will be broken by humps and hollows which we see as subtle changes of tone. Here the artist uses a pale blue wash mixed from Winsor blue and Payne's grey to suggest the tones of the snow.

7

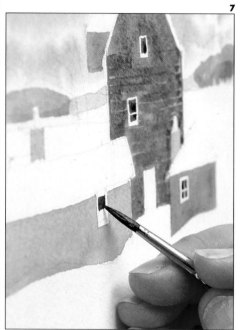

8

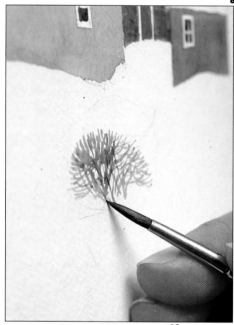

10 Here the artist lays a dark band of colour along the eaves of the roofs to describe the shadow cast by the overhang.

11 In this detail the artist adds interest and texture to the wash on the building. With a more concentrated mixture of the same burnt sienna he puts in dashed lines which very simply but precisely evoke the brick pattern.

9

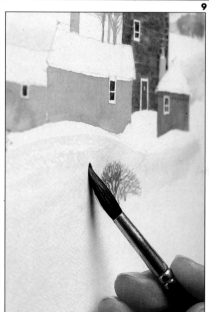

10

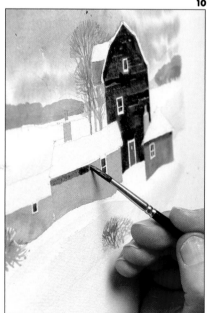

11

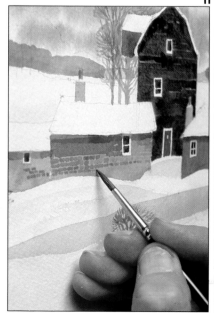

Detail
Watercolour is a flexible medium. Its transparency can be seen by the way in which the background shows through the skeletal forms of the tall trees. The soft modulations in the sky can be contrasted with the crisp edges of the blobs of colour which suggest the texture of the brickwork.

12 At this stage the artist carefully appraised the work so far. He decided he needed to define the various buildings because white on white is difficult to read. He chose to intensify the darker tones of the snow behind the roofs of the foreground buildings and removed any visual ambiguity. He also washed in some light directional shadows on the roofs where one shadow is cast by the chimney pot and where another is cast by the taller building.

This painting was created with a very limited palette but the effect is satisfying and convincing. It demonstrates in a very simple way the importance of the white paper in a watercolour painting – the white paper is the lightest tone you can achieve and must be carefully guarded when, as here, you require a pure white area. In almost any other medium white areas could be retrieved at a late stage by applying an opaque white pigment.

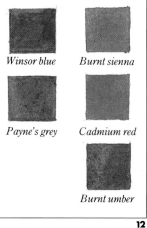

Winsor blue *Burnt sienna*

Payne's grey *Cadmium red*

Burnt umber

12

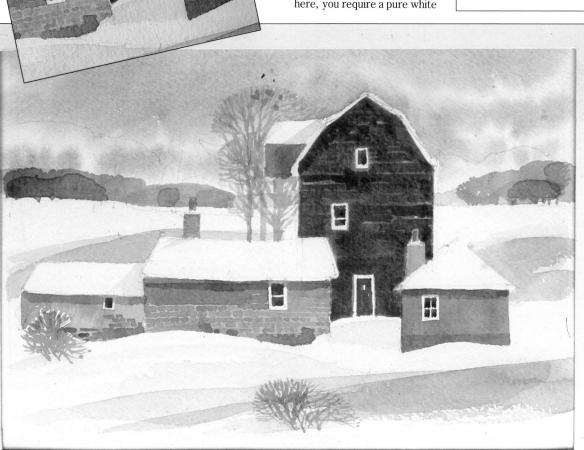

Child with Panda

MIXING FLESH TONES

In this book we have deliberately avoided subjects which appear difficult, for first and foremost we want you to learn to use and love watercolours. You can set yourself more ambitious projects when you are able to handle paint with enough confidence to really enjoy it. Portrait painting has always interested artists for it is one of the most challenging subjects, infinitely varied and full of expressive possibilities. We have chosen a portrait of a young child, an apparently difficult subject which the artist has treated simply and directly. You will find that watercolour is a particularly appropriate medium for describing the subtleties of flesh, especially the glowing translucency of youthful skin. Here the artist uses a series of pale washes, studying the child closely to get just the right colour. The

subject requires a direct approach for the colours must be fresh and lively. If skin tones are overworked they look dull and dead, not at all like real, living flesh. The artist uses a combination of wet-in-wet and wet-on-dry to create subtle blending of tones and crisp shadows.

One of the particularly striking aspects of this painting is the composition. The child and panda group occupy an unusually low position within the picture area, leaving a large empty space at the top of the painting. This creates a sense of balance and tension within the painting – the large, rather still background space providing a foil and a contrast for the small, busy area at the bottom. The large space around the group also draws attention to the youth and small size of the child.

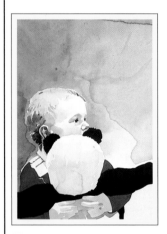

Watercolour is ideal for capturing the freshness of a young child's skin tones.

1 For this painting the artist stretched a sheet of Bockingford 140 lb (300 gsm), Not, watercolour paper, 30 in × 22 in (750 cm × 550 cm). The brushes were sable, numbers 8, 6 and 3.

The artist started with a very simple but detailed drawing using a 2B pencil. He had considered the subject carefully and knew exactly how he was going to approach it. He uses the pencil to define the outlines of the form and to delimit areas of tone.

2 It is often difficult to identify areas of tone, especially when the subject is made up of very close tones. One way of identifying the tones is to study the subject carefully through half-closed eyes. The artist mixes a mid-tone from cadmium orange and brown madder alizarin, washing this into the area around the eye sockets and another touch of the same tone under the nose. These are usually the darkest tones on the face in normal lighting. The lightest tone is washed in with a dilute solution of cadmium orange. The same two tones are used to define the hands.

3 Next he starts to work on the hair by laying down a very pale wash of yellow ochre. Without allowing the paint to dry, he creates darker and more intense tones by adding more yellow ochre using a wet-in-wet technique rather than by introducing a new colour. Notice the way the pencil drawing helps him to identify the darker areas and the way in which he has simplified the subject. There is a great temptation to regard hair as a mass of separate strands but from an artist's point of view it is a single object with a particular texture. For example, if you were painting a rope you would 'see' the whole rather than the fibres.

4 Below we can see the progress made so far. The forms are beginning to build up very gradually as the artist lays down each subtly modulated wash. The subject requires sympathetic handling – crude brash colours would not be appropriate.

The artist's method of working is the classic watercolour technique. He establishes his lightest tones first, then gradually adding the mid and dark tones. Obviously the subject demands light colours but do remember that the colour will dry lighter than it appears when wet – but by now you are probably much better at making these judgments.

3
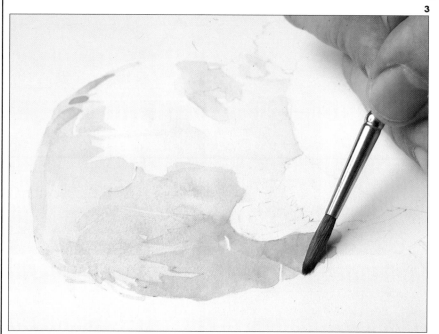

4
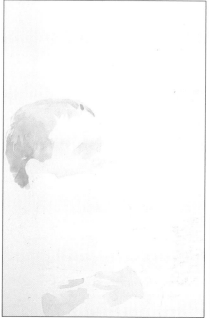

5
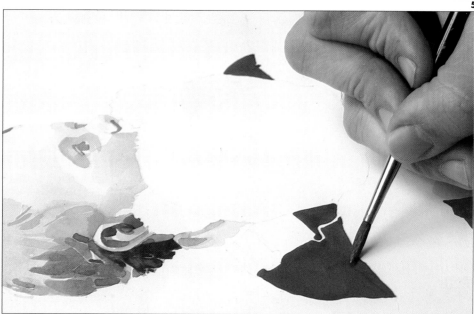

5 The artist continues working in this way, establishing the forms by laying in darker tones. He uses sepia and yellow ochre for the darker tones where the back of the head is cast in shadow. The very darkest tones are created by adding Payne's grey to the previous mixture. He develops the tones on the face with a warm shadow colour mixed from brown madder alizarin and chrome orange. The eyes are treated very simply by creating a dark colour from ivory black and Payne's grey. Pure black would look too heavy. The child's garments are laid in with a brown madder alizarin.

79

House by the Shore
WET ON DRY DETAILS

There are many ways to 'start' a watercolour. In almost all the examples shown in this book, the artist begins with a pencil drawing. The drawing serves several purposes including allowing the artist to see how the composition will work. If you are painting a bowl of flowers, for example, you can place the image at any size or position on the paper surface. Each combination of scale and location creates an entirely different composition. The pencil drawing also helps the artist organize his colour areas; thus, when he is laying down a blue wash for the sky, a light pencil line indicating the horizon will tell him where the colour should finish.

For beginners, deciding what to include and what to leave out is the first of many dilemmas. A simple homemade viewfinder can help. This is simply a sheet of card with a small rectangular window cut in it which is held to the eye to frame the subject. Hold the viewer close to your eye and it will frame off part of your surroundings. As you move it away from your eyes the field of vision will get smaller. As the different elements come into view your composition changes. Choosing which view you will use is the first step in the composition of the picture.

There are several subjects which strike fear into the heart of most people when they begin to paint. Any architectural subject is regarded as difficult because the artist has to cope with the perspective of a three-dimensional geometric shape. In a landscape painting, the soft lines of the contours blur the problems of perspective but as soon as a building is introduced it must be shown to stand squarely and convincingly in its own space. The architectural details such as windows, doors, bricks and roofing tiles also present problems, for there is a temptation to attempt too literal an interpretation when a few lines could be used to imply a texture or pattern. In this painting the artist has made things easy for you by avoiding these problems: the perspective difficulties are reduced by taking a square-on view of the house; and the architectural details are simplified by the use of representational rather than photographic effects.

1 The artist used a soft, 2B, pencil and three brushes – numbers 2, 6 and 8.

Here the artist uses a soft 2B pencil. It is important to use a light line and not to apply too much pressure. A dark pencil line will show through subsequent layers of paint and a heavy line will create indentations on the soft paper surface in which the paint will gather.

2 In this drawing we can see that the artist has made several decisions about the composition. He has chosen a simple straight-on view which avoids the perspective problems any other view would pose. About a third is allocated to the sky, the foreground occupies just under a third, while the house and the trees behind it occupy the remainder of the picture area. The house could have been higher up or lower down, it could have been larger but the artist has chosen to place it firmly in the picture area.

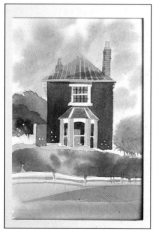

The artist has chosen a simple architectural subject and placed it in the centre of the picture area for maximum impact. Think carefully about the way you organise the elements of your painting, composition makes an important component to the final effect.

1

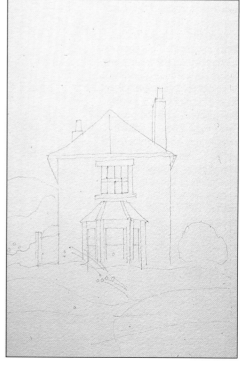

2

3 The artist started by wetting the paper in the sky area making sure that the paper was damp enough to allow the colour to flow without pooling or running back. With the wet brush he carefully traced the contours of the house and trees then, after mixing a wash of Payne's grey, he applied the colour using a number 8 Kolinsky sable. In this detail you can see him touching in the colour with the tip of his brush. Notice the way strands of colour bleed into the wet paper after the brush strokes have been made.

4 In this painting the artist has used the wet-in-wet technique from his previous paintings to create the sky. Here the effect achieved is quite different. By allowing the white of the paper to show through, he has suggested a billowing, moody and mobile sky. As we have said before, the techniques which the watercolourist needs to master are actually very few but the greater the skill and experience of the artist the more varied will be the range of effects he can achieve.

3

4

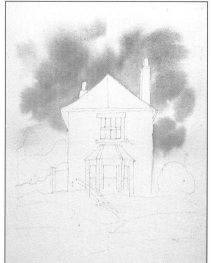

5

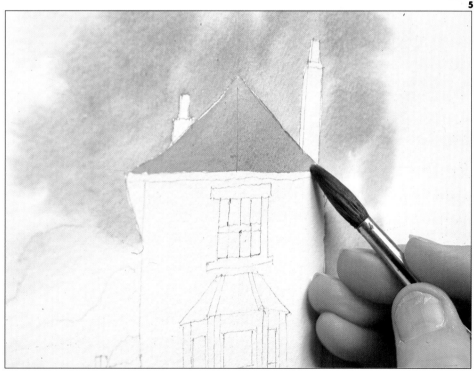

5 With a mixture of dilute burnt sienna the artist lays in flat areas of colour for the roof, the chimneypot and the brick columns between the windows. He works carefully using the same number 8 brush. Some of the details are small but by using the tip of the brush it is possible to create quite fine lines. He works wet-on-dry because he does not want the colour to spread. It is obviously important that the sky area should be dry before he proceeds to this stage for even if the paper were slightly damp the burnt sienna would seep into the Payne's grey.

6

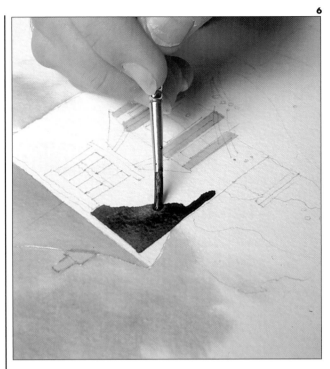

7

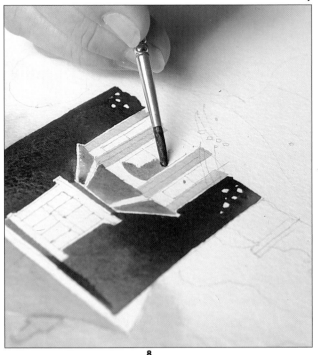

8

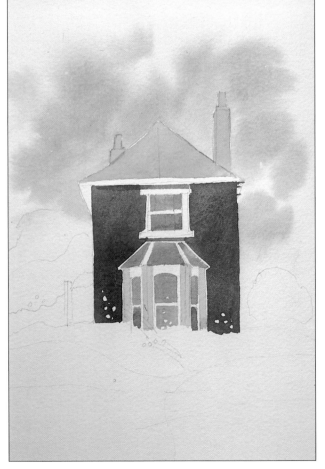

6 The dark tone of the house front is a mixture of Payne's grey and neutral tint. In the detail above, the artist applies this rich dark colour using a loaded number 3 brush. He works quickly starting from the top left-hand corner taking the paint down the page and keeping the painting edge wet, as he wants to create a fairly flat unmodulated area of colour.

7 In the detail above, the artist lays in a pale Payne's grey to describe the canopy over the bay window and the glazed areas of the windows. He works carefully with a number 6 brush making sure that he keeps the colour within the pencil lines since he wants to keep the window frames white and no paint must be allowed to stray into these areas.

8 On the left we can see the way in which the painting is developing. So far it has been treated as areas of flat untextured colour. The artist has simplified his subject as much as possible but nevertheless it is a convincing representation.

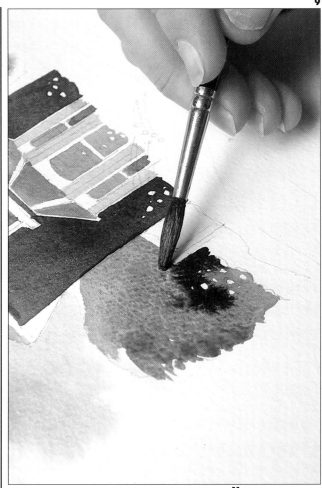

9 The artist now turns his attention to the canopy of trees in the background. With a mixture of sap green and Payne's grey, he blocks in the trees which stand behind the house. In this detail he bleeds Payne's grey into the still-wet paint to create a darker tone, carefully working round the white areas which he is reserving for the flower heads.

10 The tree on the right of the house is laid in using a wet-in-wet technique. The artist wets the area and then touches in Payne's grey so as to achieve a soft outline which contrasts with the crisp edge of the other clump of trees. A mixture of sap green and yellow ochre as a base colour for the hedge.

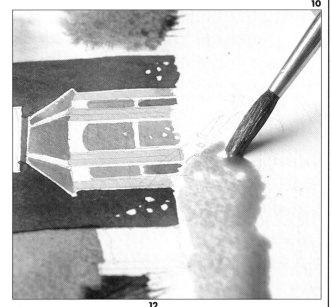

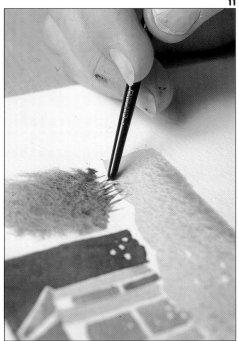

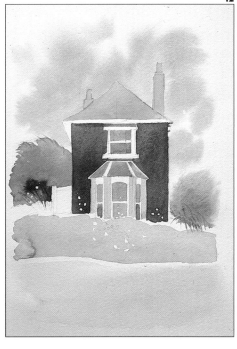

11 In this detail we see the artist pulling down wet paint from the Payne's grey. He uses the tip of the brush handle in order to create a crisp line which suggests the stems of tall ornamental grasses.

12 A very pale wash of the Payne's grey/yellow ochre mixture is laid into the foreground area and this is allowed to dry.

85

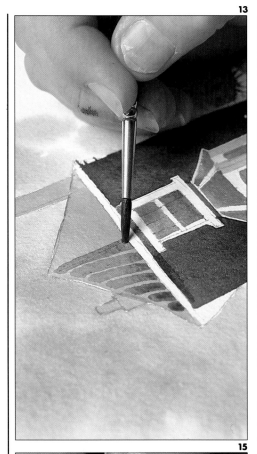

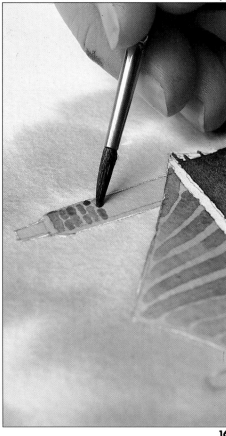

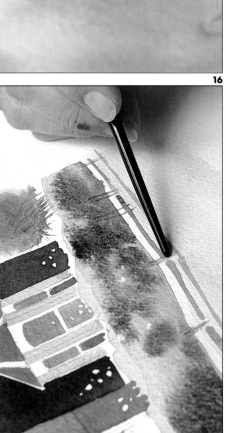

13 The artist wants to suggest the texture of the roof tiles. There is a great temptation to draw every single tile but the artist abstracts and simplifies what he sees and produces a shorthand representation of reality. When faced with a subject such as this, ignore your ideas about tiles but study the subject intently, half-closing your eyes if necessary, and paint exactly what you see. In this case, the artist interprets the tiles as broad dark stripes which alternate with thin lines of a darker tone. In the detail above, he lays down stripes of a Payne's grey/burnt sienna mixture using a number 8 brush, overpainting the lighter tone with a darker tone. He is 'working from light to dark'.

14 In the detail left, the artist applies the same technique to create a brick pattern on the chimney. He allows the colour to blob at the end of each stroke, creating a darker brick.

15 In the detail far left, the artist draws in the glazing bars of the top window using Payne's grey. As you can see, he can create a very fine line using a number 3 brush.

16 A mixture of burnt sienna and Payne's grey was used for the dark shadows between the white boards of the wooden fence. Once an area is dry, there is no reason why it should not be made wet again. Here the artist wanted to create the texture of foliage in the hedge which runs in front of the house. With a damp brush, he wets the area then bleeds in a dark green mixed from Payne's grey and sap green. Again he uses the tip of the brush handle to draw down wet colour.

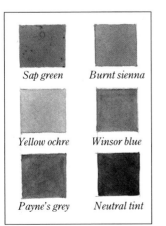

17 A few touches are added to complete the painting. A dark tone is laid on the shady side of the chimney and the same Payne's grey/burnt sienna mixture is used for the shadow it casts across the roof. Other details such as a light wash of Payne's grey on the guttering are added. The door on the left is painted with Payne's grey and Winsor blue and Payne's grey is used to create the dark areas in the windows. These suggest the space inside the house. The artist brings up the tone in the foreground by laying a wash of yellow ochre. Finally, a mixture of Payne's grey and burnt sienna is used to cast a shadow across the grassy foreground.

17

Detail
Here you can see the way in which the texture of the paper adds interest to an area of flat colour. The Payne's grey used for the front of the house is subtly modulated by the undulations in the paper surface. You can also see the way one colour is modified by a subsequent colour – in most cases the underlying colour shows through but when very dark tones are used, as in the darks within the windows, these completely obliterate the previous colours. This detail also shows you how free the initial drawing can be and how loosely the artist has followed the pencil line.

Sap green	*Burnt sienna*
Yellow ochre	*Winsor blue*
Payne's grey	*Neutral tint*

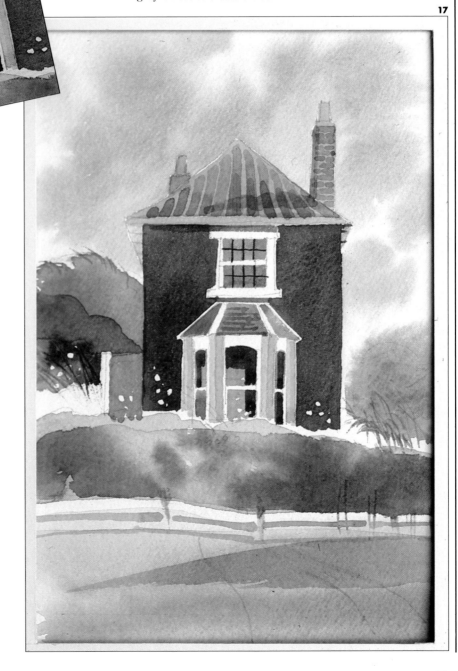

Chapter 5
Masking

Having started by persuading you that watercolour is really very difficult – we're now showing you little tricks of the trade which will make life a lot easier. By now you will have realized just how important the white of the paper is to the watercolourist and will undoubtedly have found how difficult it is to make sure that you retain your whites. You may have found the effort to make sure that you remember where the white areas are, and to ensure that you do not stray into them, very restricting. You may even have cheated and used white paint to rectify an apparently insoluble problem. Here we show you various ways of protecting the white of the paper. The first uses artist's masking fluid – a fluid which is applied to the painting with a brush or pen. It dries to a thin rubbery film, protecting the painting while you work, and allowing you to paint very freely. The mask is removed by gently rubbing it with your finger. It is very simple and allows you to handle projects which would otherwise seem entirely impossible – you'll wonder how you managed without it. There are other solutions to the problem too – wax can be used as a resist,

as can paper – each gives the finished image its own special quality.

In this chapter the projects are slightly more difficult and all use masking techniques to some extent. As before you are encouraged to work through the projects we show you here, though you may by now feel able to set up a similar project of your own. This is particularly the case with the study of anemones. Arrange a vase of flowers and set up a still life, thinking about the background and the lighting – you'll find that strong light emphasizes the tonal differences and may make the subject easier to tackle. Next think about your viewpoint – will you be looking down on the subject, up at it, or seeing it from straight on. Then decide whether you will be near the subject so that the image is seen in close-up, or will you view it from a distance, so that it looks smaller and you can see less detail. Will it fill the paper or will it be seen as part of the surroundings? You'll have done a lot of the work before you even put pencil or brush to paper – the time spent thinking is almost as important as the time spent painting.

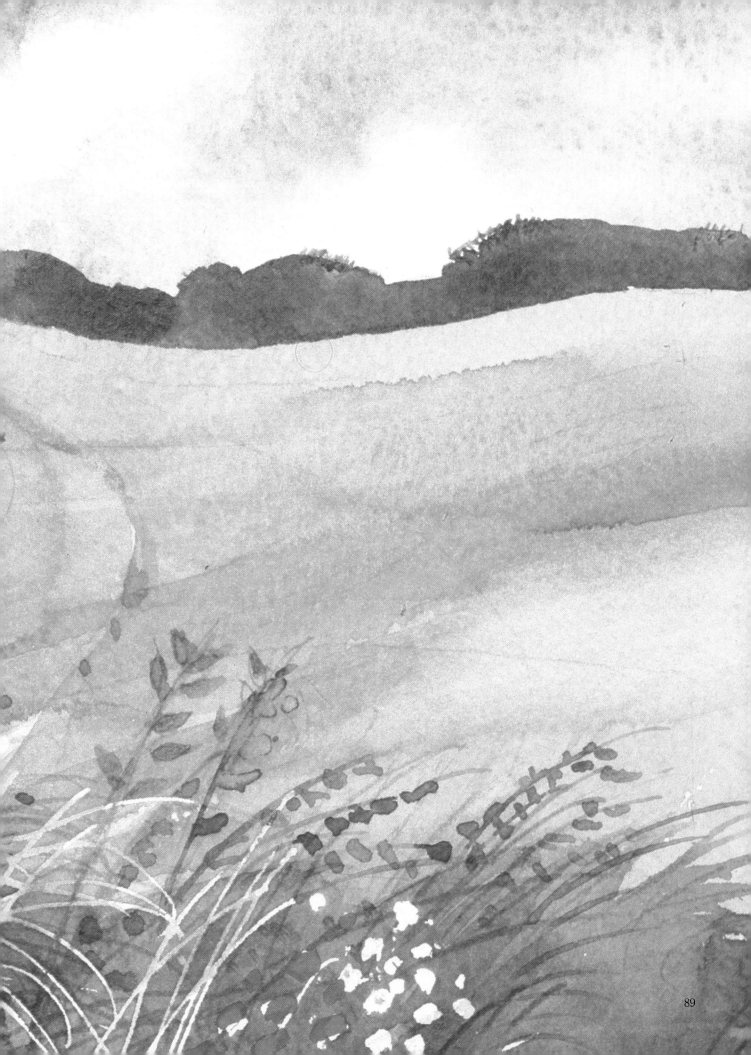

Techniques
MASKING FLUID

We're back to the white of the paper, only this time we shall look at ways of reserving the white. As you will no doubt have found by now, keeping your white areas white and the light areas light takes a great deal of organization. In some cases, the subject is so complicated that maintaining the white areas becomes very tedious if not impossible, and certainly forces you to curtail your more expansive gestures. Masking fluid can be applied at an early stage – this seals off the white areas with a thin rubbery film. You can then work over the masked areas with great freedom, confident that the white areas will remain intact. The masks can be removed at the end or whenever suits you. But make sure that the mask is absolutely dry before you start applying paint over it, and also make sure that the paint is dry before you remove the mask at the end. Masking fluid is removed by rubbing gently with your fingers – it comes away as little rubbery crumbs, revealing the clean white paper beneath. But beware, if the paint is not dry you will immediately smudge your crisp white paper.

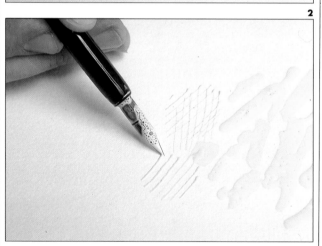

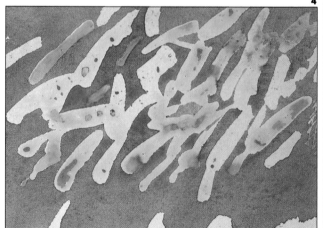

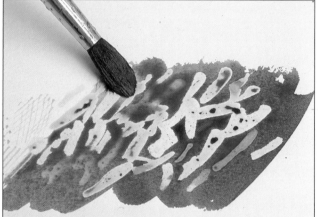

1 Masking fluid can be painted on to broad areas or it can be used in a much tighter way to define small details. DON'T use your best brush. DO clean your brush in water immediately after use – the rubbery fluid is almost impossible to remove from the hairs of a brush once it has dried.

2 Here masking fluid is being applied with a dip pen – having a stiff drawing point, it is much easier to control for fine details like stippling and delicate linear details.

3 Allow the masking fluid to dry before applying paint over it. You can test for this by touching it gently with your fingers. If you don't allow it to dry the mask will lift, mix with the paint, and your carefully masked areas will become confused.

4 You can work very freely over masking fluid, applying as many washes as you like, for example. Not only does masking fluid allow you to work very freely, it also, in many instances, allows you to work very quickly. BUT DO REMEMBER – allow the painting to dry before you remove the masking fluid.

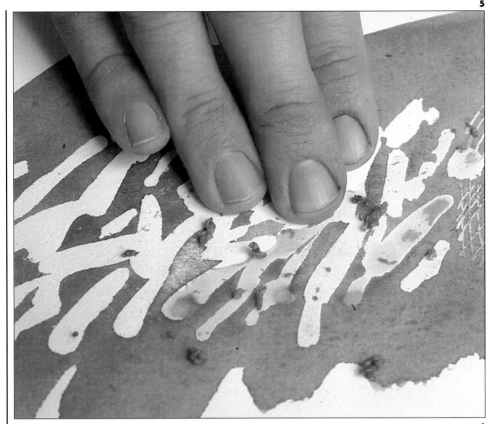

5 When the paint is completely dry you can remove the masking fluid. The method is very simple – just rub gently with the tips of your fingers. The mask will lift and come away from the paper as rubbery crumbs, revealing the pristine paper beneath.

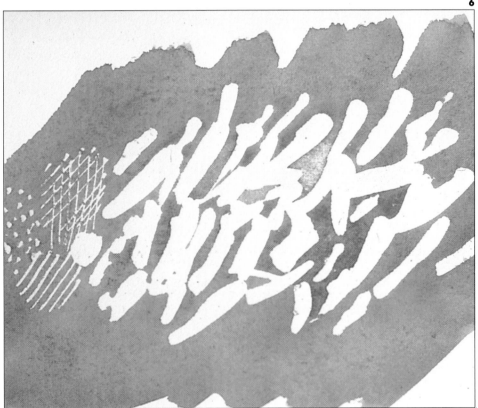

6 Areas that have been masked in this way have a special crisp quality, with very clearly defined edges. This is a quality which you may be looking for, though it will not necessarily suit all subjects. Here we have talked about masking white paper, but in the projects that follow you will find at least one instance where the artist has masked an area which has already been washed with a light colour. You will also find one instance where the artist decides to leave some of the mask, as he felt that it contributed to the final image.

WAX RESIST

Here we look at another way of reserving the white of the paper, or any colour. This time we are using a white wax candle. The intention, and the result, are different from the masking fluid method we looked at on the previous pages. This time we are exploiting the antipathy between wax and watercolour. The wax is laid down, then watercolour is applied over it. The waxy areas repel the water – or most of it, leaving them to show as white. The difference between wax resists and masking fluid is that the wax remains on the surface. It is also a much broader technique – a candle – or even a wax crayon is a much blunter drawing instrument than a brush or a pen. Some paint does stay on the waxy area, especially when the wax is applied over a large area. The water is shed by the wax, but some coagulates to form droplets which dry on top of the wax, adding another textural interest to the area. Wax resist tends to be used to add texture rather than for reserving white for details. Coloured candles and crayons can be used to add variety and texture to an area. Again, once the resist has been applied you can work with considerable freedom.

1

2

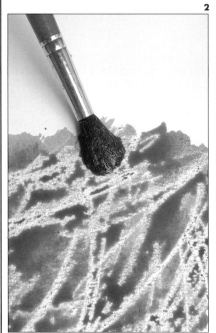

3

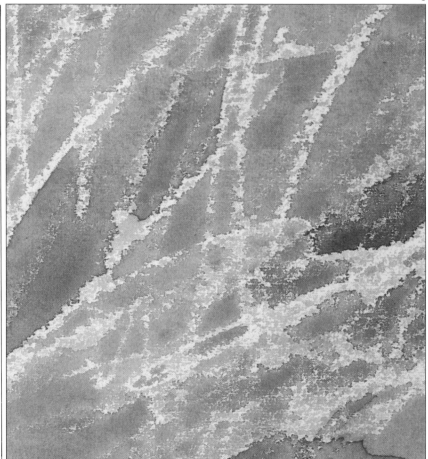

1 Here the artist uses a white wax candle, but you could use a wax crayon, even a coloured one depending on what effect you are trying to achieve.

2 Apply a wash of paint over the waxed surface and notice the way the water runs off – or forms droplets.

3 Here you see the effect when the paint is dry. A wax resist has a special textural quality which can add interest to a painting. Compare this with the masked areas on the previous page.

MASKING WITH PAPER

There may be occasions on which you want to reserve an area of white, but you don't want to use masking fluid – perhaps you haven't got time, or you haven't got any masking fluid to hand. A paper mask can be very useful – cheap, clean and quick to use – and has the added advantage that it gives you a choice of edges. By cutting the paper you create a crisp edge, by tearing it you create a softer edge. Different types of paper tear in different ways, depending on their thickness and strength. Experiment with papers and see just how many different effects you can achieve.

Torn paper mask

1 Tear a sheet of fairly thick paper and lay it on to the support. Fix it with bits of masking tape – you don't want the mask to shift as you work, or the paint will smear and destroy the effect.

2 Peel the mask back briskly. The edge which has been masked with torn paper has a pleasingly soft quality.

Cut paper mask

1 This time the paper mask is created by cutting rather than tearing – it is laid over the support as before. Apply the painting, working briskly.

2 Compare this with the type of edge produced by the torn paper mask.

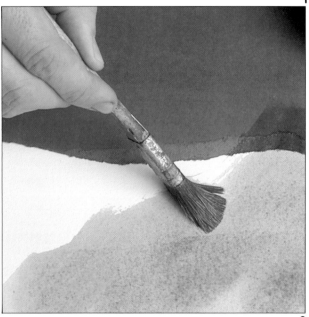

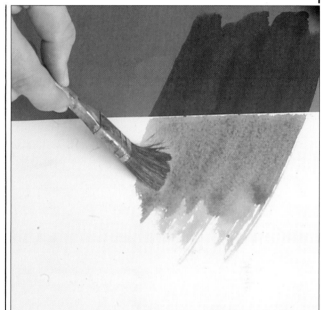

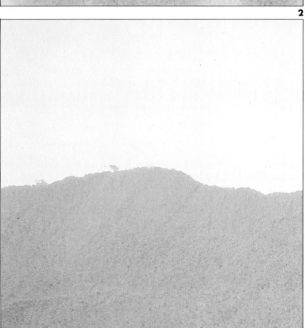

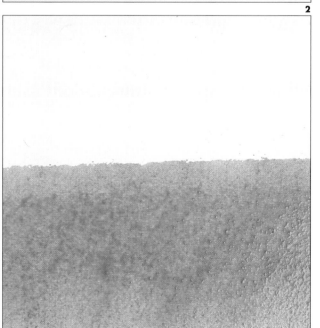

Summer Fields
MASKING FLUID WITH PEN

This subject is interesting in many ways. First of all the artist has taken an apparently daunting tangle of wayside weeds and grasses and produced a delightful painting which is not as complicated as it looks once the techniques he used are understood. What is probably more difficult for the beginner is the analysis of the subject into manageable areas, then the planning of the stages to prevent the painting from getting too dark too early. You will gain confidence by trying the exercise yourself then by finding a similar subject to apply what you have learnt.

Let's look at the composition. The artist has chosen a fairly high horizon but has placed the picture plane quite close to the viewer. We feel as though we are in a sunken lane viewing the landscape over a bank and through the wildflowers that grow so profusely on it.

The idea of the picture plane is interesting as well as helpful to the landscape painter. If you have ever tried to paint in the countryside you will be aware of that feeling of inadequacy as you try to decide where to begin – after all, you can stand on the spot and turn through all 360 degrees! As you turn, not only is a different 'picture' revealed but having chosen your 'view' you can also choose a wide-angled or a relatively narrow field of vision. The painting can include everything from the ground at your feet to the horizon. Think again about the viewfinder we discussed in the previous painting, because the picture plane is a similar idea. Imagine that instead of the viewfinder, you are holding up a vertical sheet of glass – this is the picture plane. Hold it as near to you or as far away as you like and what you see through the glass will be included in the picture. A more practical demonstration is to stand in front of a window. Start at the far side of the room – if you had a really long-handled brush you could trace off the details of the view. Now move nearer the window and see how the image changes until, when you are standing right next to the window, your picture plane includes the window sill outside.

1 The drawing was made with a 4B pencil on Cotman Not 140lb (300gsm), 10¾in ×14¾in (22.5cm×37.5cm).

The artist sketched in the broad outlines of the composition using a soft, 4B, pencil. He wanted to depict light coloured grasses, the white composite heads of cow parsley and delicate white flowers of the wayside weeds.

He uses masking fluid to protect the white of the paper, allowing him to work with greater freedom. In this detail he uses a pen to put in small blobs of masking fluid in the areas which will eventually be the cow parsley. In the bottom left-hand corner, vigorously applied slashed lines of masking fluid will represent the stems of grasses.

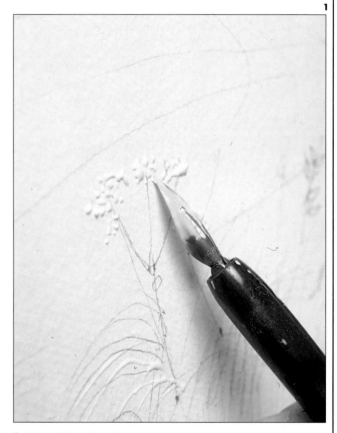

In this painting the rolling countryside provides a backdrop to the colourful wayside flowers. The subject is a rolling landscape with a bank of wild flowers and grasses occupying the foreground. The picture plane is close to the viewer, drawing us into the painting. By deciding what to include and what to leave out, what to emphasize and what to play down, the artist helps us to see a fairly common subject in a new way, through his eyes.

2 In this detail the artist uses the now familiar wet-in-wet technique to create the sky. In this case he has used a cobalt blue to create a more summery effect.

3 The artist wanted to create the sort of white fluffy clouds sometimes seen on a summer's day. To create this effect, he lifts out the wet colour by dabbing it with a small piece of natural sponge. This works particularly well on this Cotman paper for the colour lifts out cleanly and easily revealing the pure white paper.

4 With a mixture of cadmium lemon and cobalt blue, a flat wash is laid in the left foreground area. In this detail, the artist applies loose streaks of the same colour to suggest the tangle of weeds and grasses in the foreground.

5 The artist treats this not as an element of the landscape but as a simple area of colour. In his mind he has planned the way he intends to achieve his final effect. He uses a light wash at this stage so that he can build up the final tone from a series of similar light washes which will give the final painting a special depth and brilliance.

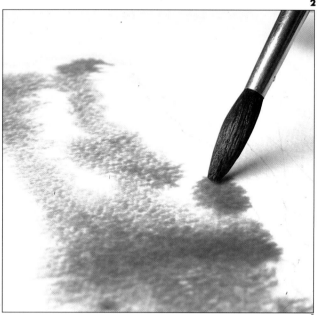

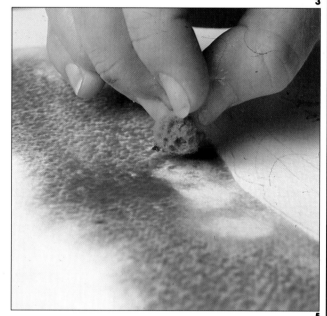

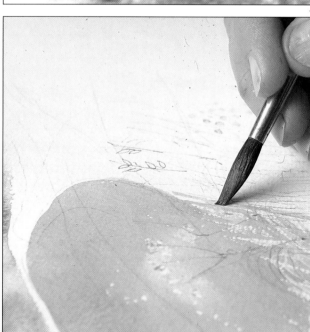

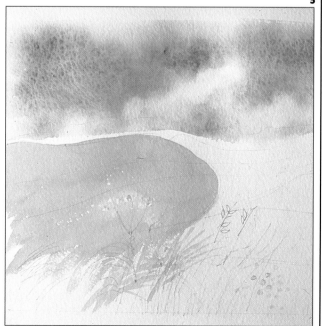

MASKING FLUID WITH PEN/SUMMER FIELDS

6 The field on the right is blocked in with a flat wash mixed from cadmium lemon and yellow ochre. This is laid in wet-on-dry. Again the artist starts by laying a light wash so that he can develop the tones and textures at a later stage. If it gets too dark too early on he limits the possibilities. In this detail, a mixture of sap green and raw umber is laid into the foreground area picking out the darker tones of the vegetation. The paint is wet and therefore looks darker than it will when dry. Notice the way the lines and dots of masking fluid stand out against the dark paint.

7 In the detail below, the artist adds more texture and detail to the foreground by using the handle of his brush to draw in the wet paint. He is moving paint which has already been applied to the surface rather than applying more paint.

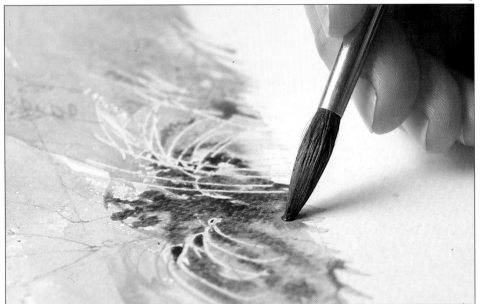

6

7

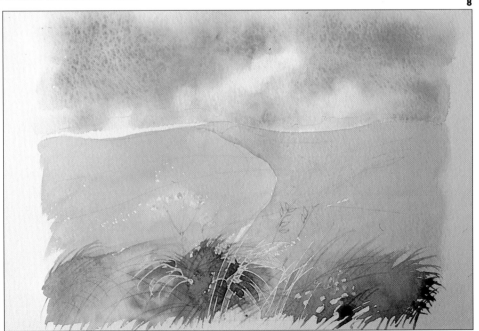

8

8 At this stage the artist stands back and takes a careful look at the painting. He has established all of the main elements of the composition and has started to develop the focal point of the picture – the bank of flowers and grasses in the foreground. He has applied only one layer of colour in this area but nevertheless it is beginning to read accurately. He has used a variety of techniques here, only one of them – masking – is new to you. The others, wet-on-dry, wet-in-wet and drawing into the paint with the tip of the brush are all familiar. This is a very good illustration of the way watercolour allows you to use simple techniques to good effect.

9 The band of trees which defines the horizon is laid in with a mixture of sap green and raw umber. The artist uses a loaded number 3 brush to lay in a sweeping band of colour. He then suggests the outline of the trees by going back over the paint while it is still wet and flicks at the edge of the paint area with the very tip of his brush.

10 The artist adds interest to the foreground area with a broad shadow which runs diagonally from left to right. This is laid in with a mixture of sap green and yellow ochre. At this stage the underlying layers are quite dry and this new wash of colour sits on top without disturbing them. If the first paint layers were not completely dry, this second layer of paint would pick it up and create a lighter area known as a 'backrun'. Below, the artist uses a pen to create linear detail. Because it is difficult to mix sufficient colour to allow the pen to be dipped in it, he applies the colour to the pen with a brush.

11 The artist works into the foreground with a dark sap green/raw umber mixture. He uses a number 3 brush to build up a delicate and complex web of stems and leaf shapes. Sometimes he paints the forms, sometimes the spaces between. A complex subject like this is best handled by 'seeing' it as a pattern of light and dark areas rather than small separate elements.

9

10

11

12 You can learn a lot by comparing this picture with the one at the bottom of the facing page, for they show you very clearly the way the painting is developing. As the artist increases the amount of detail in the foreground, that area of the picture becomes increasingly resolved, creating the illusion that it is very near to the viewer's eye. The background areas are by contrast thrown into the distance, suggesting recession towards the skyline. You can also see the way the artist increases the tonal contrast of the painting, adding darker areas in the foreground and a dark band of trees along the horizon.

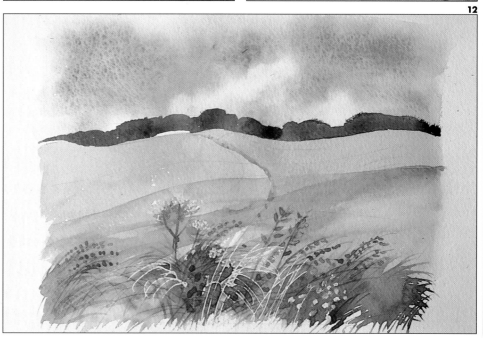

12

13 The artist removes the masking fluid by rubbing the masked areas very gently with his fingers. The rubbery film lifts off revealing the white paper underneath. Notice the crisp edges created by the masking fluid. Always make sure that your painting is dry before you start rubbing the mask off. If not, you will smear wet paint into the newly exposed white paper making a muck of all your efforts. Masking fluid is not only extremely useful, it is extraordinarily satisfying to remove and expose the pristine white of the paper beneath. This detail also shows the crisp edges achieved when wet paint is applied over dried paint – see the little touches of colour used to describe the leaflets.

14 The detail below illustrates yet again the complexity that can be achieved using very simple techniques. The artist hasn't actually painted any realistic details, he has merely interpreted the forms and found an equivalent mark. However, he has the advantage of being familiar with the medium and from experience knows which marks and techniques will allow him to create the effect he requires. He can see into the future in a way that a less experienced painter cannot. Nevertheless you should persevere, for the more paintings you do, the more you will add to your sum of knowledge and to your ability to predict the outcome of the techniques you use.

13
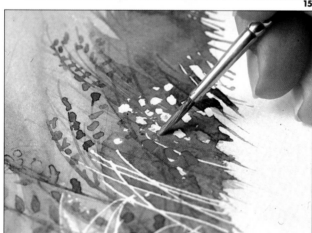

14
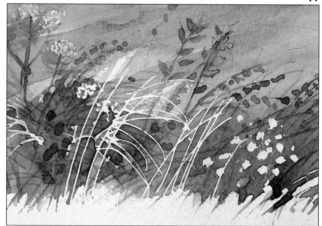

15
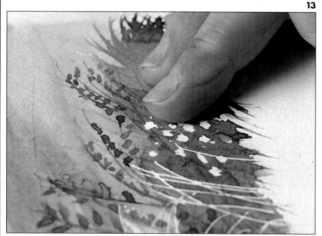

16
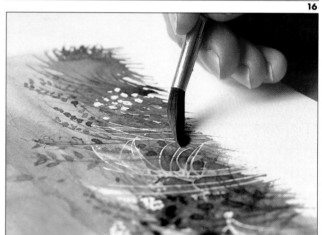

15 Here the artist adds a dash of colour with blobs of cadmium red standing for poppies. This small area of colour will have a disproportionate impact on the final painting. Red is a complimentary of green and this relationship means that when they are seen in combination, they enhance each other making the green look greener and the red look redder. Artists sometimes introduce touches of red into paintings of grass or foliage for just this reason. Look for this in paintings by great masters next time you visit a gallery or museum.

16 In this detail the artist lays a light wash over some of the masked areas so that they stand out as pale rather than white stems of grass. In this instance masking has allowed the artist to add a light tone at quite a late stage.

Detail
Watercolour is a seductive medium which gives pleasure on many levels. There is in all of us a child who likes messing around with water and paint. The materials too have a special quality. Everything about watercolour is neat and compact – from the boxes whose design has changed little in the last hundred years to the pans of colour like brightly coloured sweets. The images too can be enjoyed in their entirety as paintings, but the details are often as rewarding.

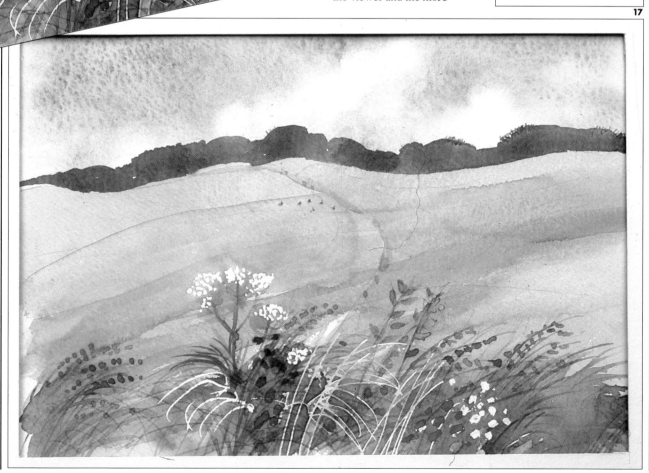

17 The artist completes the painting by adding further light washes across the fields suggesting the undulations of the ground.

The finished painting illustrates several points which we have discussed before. It shows you the freedom that masking fluid can give you. It also illustrates the way in which an apparently complex subject can be treated fairly simply and effectively. I suspect that when you first looked at this painting you thought 'that's far too difficult for me to do' but now I am sure you feel quite confident that you could cope with this, or with a similar subject. The other point we can learn from this painting has more to do with composition. Objects low down in the picture plane are perceived as being nearer to the viewer and the more detailed an object, the nearer it will be assumed to be.

And finally, if you establish the picture plane close to the viewer's eye and suggest a distant horizon, you will create a sense of space and recession within your painting. An effect which is particularly useful in landscape painting.

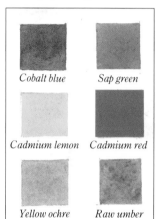

Cobalt blue *Sap green*

Cadmium lemon *Cadmium red*

Yellow ochre *Raw umber*

17

Sailing in the Bay
MASKING DETAILS

The paintings we are showing you are gradually becoming more complex in both the subjects and the techniques involved. The sea is high on the list of subjects considered difficult by beginners. One of the fascinations of the sea is the way it changes mood from a flat calm pond one day to a whipped-up froth of crashing waves and flying foam on another. The colour also changes, because a large body of water has a highly light-reflective surface and tends to mirror the colour of the sky above. Other factors come into the equation. The reflective qualities of the surface can be modified by the depth of the water, the amount of debris and plankton in suspension or whether the water is calm, broken by large rollers or covered in ripples. It also changes from minute to minute as clouds pass across the face of the sun and, just as you've mixed the right wash to depict a particular dark tone, the area is suddenly bright and sparkling. The only way to cope is to concentrate hard and paint what you see. By the time you have finished the painting everything will have changed so often that the final painting will be a summation of all that has occurred in that time.

Another particularly useful technique for the watercolourist working under changeable weather conditions is to work on two or three paintings at a time. The artist in this book used this method and so collected most of the material on which he based the paintings you have been studying. One of the many myths about watercolour is that it is a quick method of recording an image and it can indeed be used for very simple sketches and note-taking. But as you will now know, the process is slow since most watercolours are based on a series of very wet washes which usually need to be dry before the next wash can be applied. If you have two or three paintings on the go at once you can work on each in turn, ensuring that each is dry before you return to it. You can either paint exactly the same view – the differences between each attempt will be as interesting as the similarities. Or, alternatively, you can decide to paint three different views so that you return home with a variety of images.

Study this painting carefully and then work through it yourself. Once again the artist has made things easier for you by sorting out the method of working and by selecting and simplifying the image – nevertheless I hope it will give you the confidence to tackle a similar subject on your own.

Any view which includes a large expanse of water presents special problems – here the artist shows you how he captures the feeling of moving water and the sparkle of ripples.

1 The artist used the following: Cotman 140lb (300gsm), 10³⁄₄in × 14³⁄₄in (22.5cm × 37.5cm); a soft pencil (2B); several brushes – numbers 2, 6, 8 sables and a flat half-inch brush; masking fluid and a dip pen. He started with a simple outline drawing, indicating the broad masses of the hills and the areas where the water changes colour as it changes depth. Here the sky is dampened in preparation for the wet-in-wet wash.

2 The sky is laid in using a loaded brush and a mixture of Payne's grey and cobalt blue. Notice the way the artist introduces colour in some areas but not in others so as to achieve a variegated effect. It is important to work quickly at this stage as the sky must be completed in one go. There is usually no place for hard lines in a sky where the effect depends on soft blended edges.

1

2

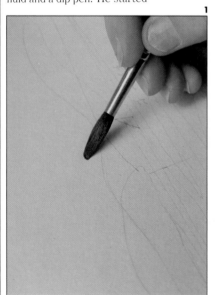

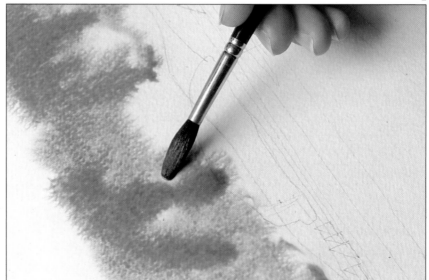

3 In the detail below, we see a wad of tissue being used to blot out the shape of billowing clouds just over the horizon. This must be done before the paint begins to dry and on this particular paper the technique is especially effective.

4 Here the artist uses a small number 3 brush to mask the white triangles of the sails. These are small but important elements of the final painting and a crisp edge is needed if the forms are to read against the blue of the sea. Clean the fluid from your brush immediately, otherwise the rubbery substance will gum the hairs together and once dry it is impossible to remove.

5 Here masking fluid is applied with a dip pen. He stipples in rows of small dots which will suggest the sparkle of reflected light glancing from the broken water. Here the pen is used to put down slightly larger dots suggesting the pebbles on the foreshore. The pen nib being rigid and precise is suitable for small details.

6 Here we see the effect of the finished sky with the body of the clouds now apparent. We can also see the yellow masking fluid used to reserve the white areas of the sails, the gulls, and the ripples breaking the surface of the sea.

3

4

5
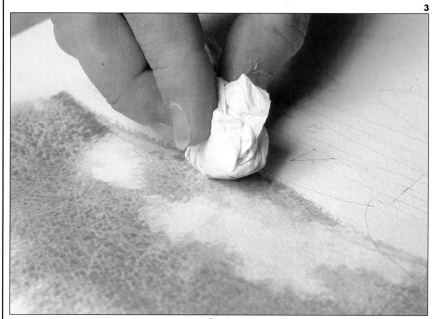

6
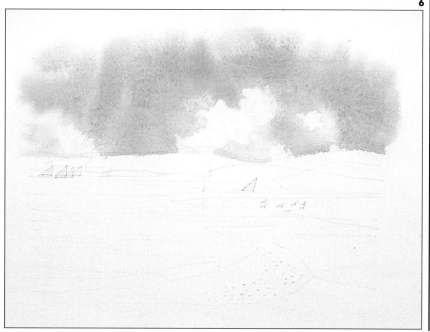

7 With a mixture of alizarin crimson and cobalt blue, the artist washes in the narrow band of the distant hills. Notice the way he has overlapped the edge of the sky, creating a third colour which can be read as shadows on the hills. Don't forget that watercolour is a transparent medium and that one wash can be overlapped with another to create a third colour.

8 Using a number 8 brush and a mixture of Payne's grey and cobalt blue, the artist starts to lay in the water. As you can see, his brush is fairly dry so that the wash breaks on the texture of the paper creating yet more sparkle. He is able to paint straight across the small sailing boat because the white sail is protected by the masking fluid. If you look carefully, you can see that some of the white in the sea area is actually masked while some of it is created by the dry brush technique.

9 The clump of trees on the distant shore is laid in with a rich mixture of Winsor green with a touch of cadmium scarlet. The artist uses the brush to push and pull the wet paint to the outline which will more realistically suggest the coppice. In this detail he uses the tip of the handle of the brush to draw down lines of wet paint which express the trunks of the trees.

10 Here the artist continues to work into the wooded area adding more detail and taking the vegetation down to the sea shore. Watercolour is an expressive and flexible medium which allows him to describe a fairly complex subject with only one colour. Obviously he has simplified the subject so that he sees the wood rather than the trees. He has varied the marks he makes, firstly by using a brush to lay down a pool of colour which describes the canopy of foliage. The brush is then used to push out the colour and break up the edge in a way that implies the individual trees within the wood. Finally he uses the tip of the brush to draw the trunks of the trees taking the lines of paint. In this way he paints not only the outside surface of the wood but also implies its depth and the space it occupies.

7

8

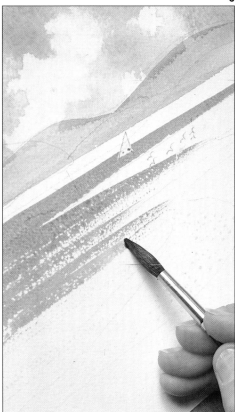

9

10

11 The artist uses a very pale wash of sap green as an underpainting for the coastline. The colour will be developed over this as a series of washes with areas of more detailed texture applied later.

12 In this detail, the artist lays a wash of the same sap green over the spit of land which juts into the sea. Once again we see the way in which the masking fluid allows him to work quickly and freely.
We can also see where a wash of green overlays the purple foothills creating a muted green on the far shore.

13 A wash of yellow ochre is sweeps round in a curve following the line of the beach. It is also laid over the pale green wash. When this is almost dry, the artist draws into it with more sap green and begins to establish the tussocks of marram grass. Here he uses the tip of a half-inch flat brush to touch in stems of grass with raw umber and a little sap green.

14 Here the artist uses the same brush but in an entirely different way. The brush is fairly dry and the colour is applied with broad sweeping strokes of the flat of the brush. The bristles of the brush separate, creating a striated effect. These are all examples of dry-brush work.

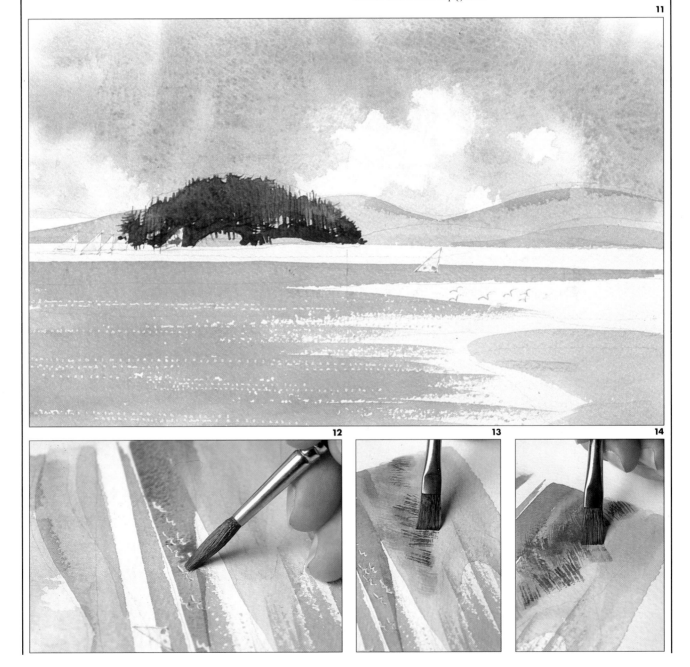

11

12

13

14

103

MASKING DETAILS/SAILING IN THE BAY

15 The artist continues to develop the painting laying washes of varying intensity across the sea. He adds details to the line of low hills which borders the far shore using touches of Payne's grey and sap green. Here he lays a pale blue wash into the shallow seas in the distance.

16 Here the artist uses a number 6 brush and with a mixture of sap green and yellow ochre adds more detail to the vegetation in the lower right-hand part of the picture. Be careful not to overwork this area.

17 When the paint is completely dry, the artist removes the masking fluid by rubbing it gently with his finger. The masking fluid forms small rubbery crumbs as it is rolled off to reveal the virgin white of the paper beneath. There are now two kinds of masking fluid – white and yellow. The yellow stained certain papers so a white version was brought out.

18 Here the artist uses a fine number 3 brush to suggest the hulls of the sailing boats. They are some distance from the viewer and it is important that they should be sketched in impressionistically rather than described in great detail.

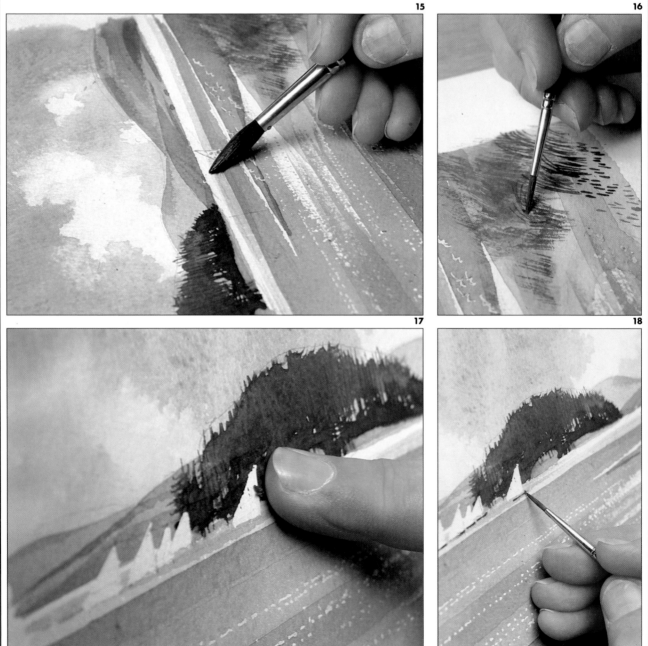

15

16

17

18

104

Detail
In this detail we see the way the artist has used masking fluid and a dry brush technique combined with the texture of the paper to suggest the sparkle of moving water. You can also see the way the crisp white shapes revealed by the masking fluid suggest very convincingly a flock of birds in flight and beyond that the white sail of a small boat.

19 The artist completes the painting by adding a splash of cadmium red for the sail of the leading boat. Notice the way the red sings against its complimentary green. It is interesting that such a small splash of colour draws the eye and, though small, is the focal point of the painting. Again the artist has used a simple compositional device to capture the viewer's attention. The eye is led along the curve of beach which sweeps from the foreground along the spit which projects into the sea. From there, it leaps across to the bright red sail and is brought up short by the line of hills which introduces a strong horizontal element into the painting. A revealing exercize for those of you interested in composition is to lay a piece of tracing-paper over a painting and to draw in the main compositional lines.

In this case it will consist of two main lines: a single sweeping curve from the right foreground to the point where the far shore is cut by the left border of the painting; and a horizontal line defined by the far shore.

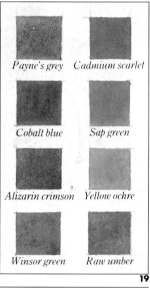

Payne's grey Cadmium scarlet

Cobalt blue Sap green

Alizarin crimson Yellow ochre

Winsor green Raw umber

19

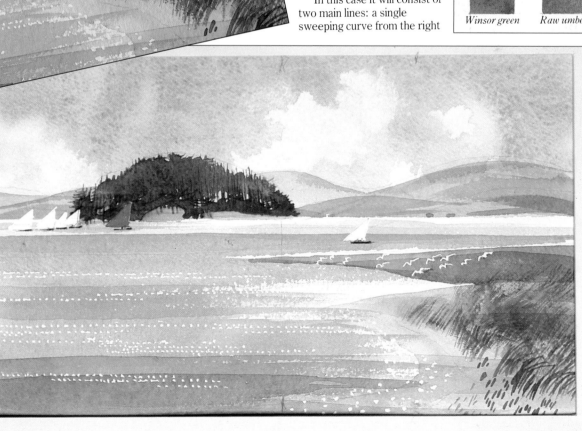

Town Gate
LINEAR PERSPECTIVE

The artist is surrounded by 'pictures' but some subjects are considered more stimulating or appropriate than others. Despite the fact that most of us live in towns or cities watercolour is nearly always associated with landscape painting while the urban scene is neglected. There are many possible explanations for this prejudice. For many of us painting is a leisure pastime and has become associated with country or seaside holidays. This is reinforced by the fact that many of the examples in our museums and galleries date from the great age of watercolour in the eighteenth and nineteenth centuries when topographical subjects predominated. Nevertheless, it is important to realize that the perfect subject for the painter is as elusive as the perfect picnic spot.

There are many reasons why you should paint subjects close to home. First of all there is the availability of subjects. Household objects such as cups and saucers, potted plants, fruit and vegetables, are always near to hand and an interesting still life is assembled in a matter of moments. Similarly the view from your own window is always there, changing with the time of day, with changes in the weather and the seasons. The time that would be spent journeying to the perfect piece of countryside can be spent painting!

In fact the city is a fascinating and challenging subject. The smooth rolling lines of the countryside are replaced by straight lines with the angular geometry of buildings creating an interesting conjunction of surfaces. Planes impinge on planes casting strong and complex shadows. Superimposed on this angular structure are the textures of manmade and quarried materials, of brick, stone and concrete. The greens and earths of the rural palette are supplemented by vivid primaries and the synthetic colours of paintwork and even clothing.

Some of you will be puzzled by the problems of perspective that the subject presents. Linear perspective is a device which can help you analyse, understand and depict what you are seeing. It is based on the fact that when viewed from a particular point, and assuming one eye is closed, parallel lines on the same plane always meet at a point which can be anywhere above or below the horizon. In this street scene the bases of the houses and the line of the eaves are in the same plane – the plane is represented by their facades. A line drawn through the line of the eaves and base of the facade meet at a point just to the left of the archway – this is called the vanishing point. Please don't worry about perspective at this stage, whole tomes have been written on the subject which is hedged about with ifs and buts, just draw what you see and if something looks wrong check that the perspective lines are correct.

In this study we look at an urban scene for the first time. The subject provides us with new challenges – we have to cope with the problem of perspective and use a much broader palette.

1 The artist used a sheet of unstretched Cotman paper, 90 lb (185 gsm), 10¾ in × 14¾ in (22.5 cm × 37.5 cm). The brushes were numbers 3, 6 and 8, and he also used a pen and masking fluid.

He started by making a simple outline drawing with a B pencil. The drawing is more detailed than those he has made so far as the construction of the intricate pattern of streets, houses, roofs and other architectural details needs to be resolved before the paint is applied. The subject lent itself to bright clear colours and a lot of contrast. He therefore establishes his darkest tones first, using black ink applied with a brush. To achieve a really strong black which will not bleed into subsequent colours, the artist has used black ink rather than paint. The darkest areas are the shadow on the inside of the ancient gateway and the shadows within the windows on the upper storeys of the nearby houses. Having established the darkest tone, the artist lays in the mid-tones which he creates by diluting the Indian ink with water.

2 One of the important aspects of this painting is the way the perspective lines lead the eye into the centre of the painting where the town gate frames the view beyond. This must be firmly established in its position in space to avoid any visual ambiguity. So the artist uses a very pale black wash to describe this area. The paler tones contrast with the stronger tones nearer to the viewer and help to reinforce the sense of recession.

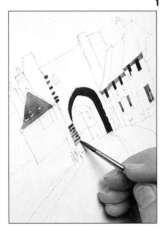

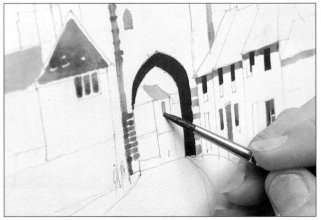

3 The sky is laid in using a wet-in-wet technique and a mixture of Payne's grey and Winsor blue. The artist works quickly and as you can see in the detail below, the wash is very wet at this stage.

4 The clump of small conifers on the left is laid in using a wet-in-wet technique. The colour is Winsor green. The paint is applied with the point of a number 3 sable brush using vigorous graphic marks which describe the skeletal structure of the trees. The outline blurs into the damp paper but here you see crisp details being created as the colour is taken into dry areas.

5 The artist begins to establish the foreground – the street and pavement – with a dilute wash of neutral tint. This area will receive several washes of colour before the painting is finished so it is important that this first wash is fairly pale.

6 So far we have seen masking fluid being used to mask the white of the paper. Here, however, the artist wanted to create a 'cobbled' effect on the pavement. To do this, he masks not the white paper but the first pale grey wash. Here we see him using a pen to stipple in blobs of masking fluid where the cobbles will appear.

3
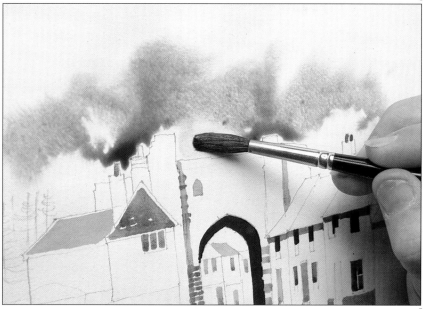

4
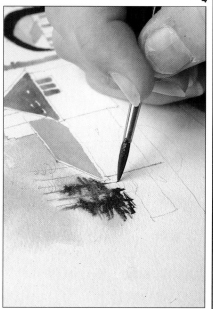

5
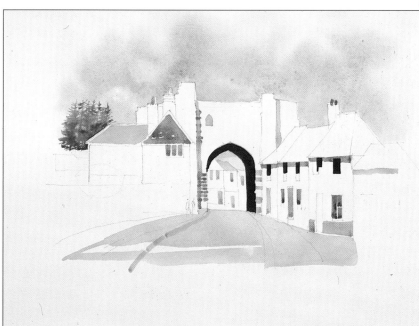

6
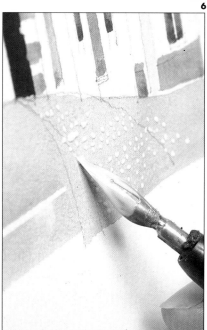

107

7 The artist starts to block in the simple geometric shapes of the buildings. He uses burnt sienna for the roofs, yellow ochre for one of the buildings, a diluted burnt sienna for some of the walls and burnt sienna mixed with Winsor green for the end of the house to the left of the gate. Here we see him using neutral tint for the façade of the nearest house.

8 The artist continues in this way, treating the areas of the buildings as flat areas of colour. At this point the reason for his control of the tone of his washes becomes apparent, for he now needs to lay in the textures and can do so using subtle colours. If he had allowed his first washes to become too dark, the subsequent detailing would have been very dark and crude. Here he uses stripes of neutral tint to describe the weather-boarded façade. On the lower wall, dashed and dotted marks describe the irregular masonry and on the tower he develops the texture of the stonework. He has already begun to build up a series of washes in the foreground, allowing each one to dry before the next is applied.

9 The masking fluid is removed and now we begin to see the point of the earlier masking as the cobbled effect is revealed. Here the artist lays a dark shadow over the foreground in order to give that area more impact. The colour is mixed from alizarin crimson, Winsor blue and burnt sienna.

7

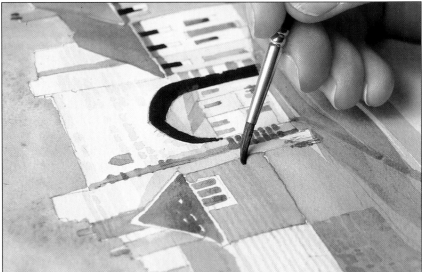

8

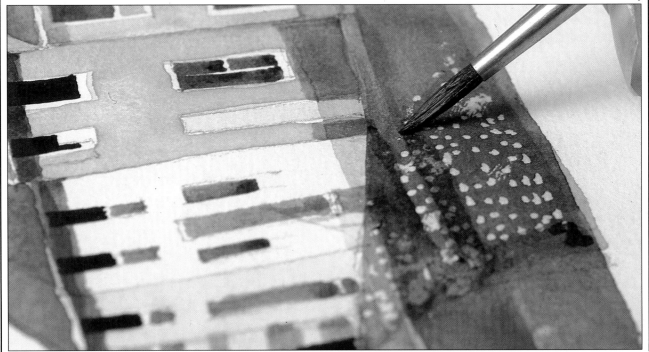

9

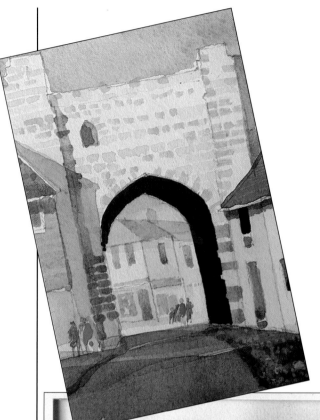

Detail
Here we see the simple and impressionistic way the artist has handled the townscape beyond the arch. There is sometimes a temptation to pay too much attention to the human figure when it is included in a painting such as this. But if the figures depicted here had been rendered more sharply than their surroundings, they would have leapt from the painting rather than harmoniously blending with their surroundings.

10 The picture is completed by working up the textures in the roofs and walls. Stripes of cadmium red with yellow ochre add interest to the rooftops. With the tip of his brush the artist puts in the slightest suggestion of groups of figures, these help to give a sense of scale to the painting.

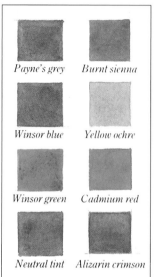

Payne's grey	*Burnt sienna*
Winsor blue	*Yellow ochre*
Winsor green	*Cadmium red*
Neutral tint	*Alizarin crimson*

10

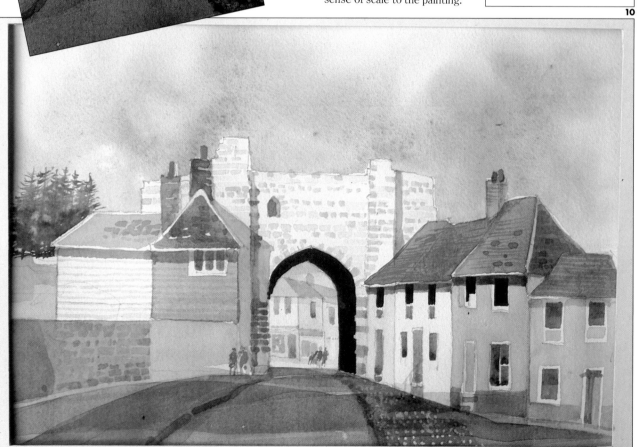

109

Anemones
MASKING LARGE AREAS

Still life provides the artist with an infinite source of inspiration and has exercized all the great artists at one time or another. The material is varied in terms of texture, shape, size and colour and wherever you are there will be elements around you to assemble into an intriguing still life study. A still life also has the advantage that you have control over it. The arrangement is what you choose it to be, the lighting can be adjusted according to your taste and, unlike a model, it won't want paying or feeding, suffer from cramp or boredom. As you can see, many 'artistic' considerations are really terribly pedestrian!

Anything can be the subject of a beautiful or expressive painting but some have a more obvious attraction than others. Flowers are an obviously seductive subject but one, however, fraught with difficulty – there is first the temptation to produce a 'pretty' and possibly unsatisfying image. It takes a stout heart to interpret a subject which is so obviously 'perfect'. But if you don't put something of yourself into the study you run the risk of merely copying, which no artist attempts and in which no amateur succeeds, if you want a photorealistic record, why not take a photograph?

Flowers are exciting subjects, especially for those of you who are colourists at heart. Watercolour is a particularly sympathetic medium given the vibrancy of its colours and the subtle blended effects that can be achieved: approach the subject as you would any other. See it as an integral and integrated part of the whole picture. Plan the composition, is it to be asymmetrical or symmetrical, is the image to fill the area or be placed within a large space? Make thumbnail sketches to help you consider the alternatives. When you have begun to form your ideas, sketch in the broad outlines making decisive rather than tentative marks. The pencil drawing is not an outline to be filled in as a child 'fills in' the colours in a painting book. It is to help you to 'elicit' the painting from the broad compositional structures you have identified.

Next examine the subject and decide where your lights and darks are to go. Studying the subject closely through half-closed eyes will exaggerate the tones. Then you can either build up the tones very carefully by laying down the lightest areas first or you can do as the artist has done here and begin by masking the lightest areas. The advantage of this technique is that you can work very freely without fear of getting too dark too quickly. At first you will have to think very carefully about where you put the masking fluid. Here the artist wants to retain white paper so that the colours of the petals can be laid on in a single wash of colour to which the white of the paper will contribute a brilliant sparkle.

When you have tackled this painting, try it again using the other approach. Lay down the palest tones first then build up the tones laying down the dark background last. Remember that you will have to cut the dark background colour around the flowers which will be very detailed. There is an example of a flower painting created in this way later in the book.

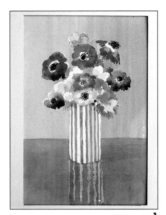

Here the artist used a vase of flowers as the basis of his painting. He has loosely interpreted the subject – simplifying the pattern on the vase and editing certain details. He did this to create a strong composition and also to provide an image which would be easier for you to follow.

1 The materials for this painting were 140 lb (300 gsm) Cotman paper, 10¾ in × 14¾ in (22.5 cm × 37.5 cm); a number 3 and a number 6 sable brush; and masking fluid.

With a soft 2B pencil, the artist draws in the broad outline of the petals, the dark circle of the stamens in the centre and the striped pattern of the vase. The drawing is very loose – avoid the temptation to make a tight, botanically correct drawing. All you want to do at this stage is map out colour areas.

2 There is no fussy detail in the finished drawing, but the artist has established the composition and has enough information to plan the way he will approach the painting. Notice the way the reflections of the striped vase are treated as a continuation of the real thing. Also consider the composition: the artist has placed the vase of flowers firmly in the centre of the picture area and the background is divided at approximately two-thirds of the way down the paper.

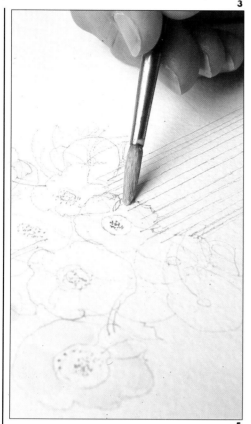

3 The masking fluid is applied to the flower heads. The artist uses an old sable brush and works freely but carefully. He uses the masking fluid to define the shape of each petal. What he is doing is preparing a sort of 'negative' of the subject, the areas he covers with masking fluid will be revealed as white paper at a later stage.

4 The vase is entirely masked and the masking fluid is also taken down into the reflections where it is used to reserve the areas which will eventually show as white against the dark table surface.

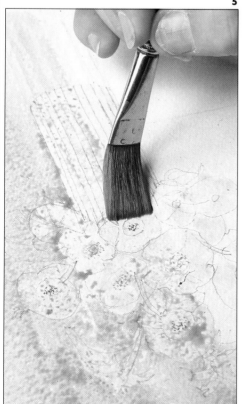

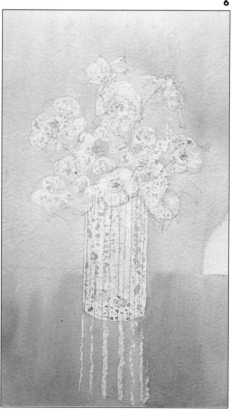

5 The artist has chosen a fairly simple background which provides a neutral foil to the vivid colours and strong pattern of the vase and flowers. This simplicity is an important component of the final image; the artist could have set the flowers against a more complex background – patterned wallpaper, a window or a clutter of other objects. This editing, whether in the selecting of the objects or in the selective drawing, is all part of the process of composing a picture. The artist lays a neutral grey wash over the whole area. The colour is mixed from yellow ochre, Payne's grey and Winsor blue and is laid on with a large flat brush, working quickly from top to bottom.

6 Here we see the masked forms of the vase of flowers as a negative image against the darker background.

7

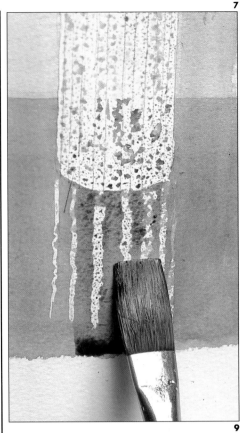

8

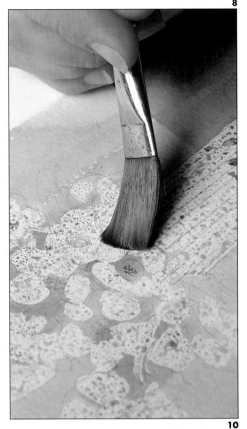

9

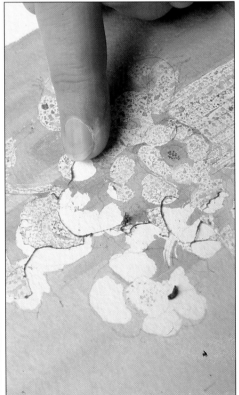

10

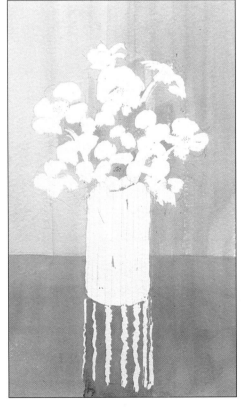

7 The first wash of colour is allowed to dry before a darker tone is applied to the area of the table top. The colour is created by adding more paint to the original wash. Here you can see the value of masking fluid, which allows you to work very freely in an area where there is a lot of pale, intricate detail. The artist can apply several layers of washes until he achieves just the right tone – imagine trying to work several washes around the lines of the reflection!

8 At this stage the artist studied the painting carefully and decided that another wash of colour was required to give the background more punch. He uses the same mixed grey applied with the broad, flat brush to the right hand side of the picture, making the painting darker on this side. Notice the way he has allowed the colour to streak, adding textural interest to an otherwise flat area.

9 The artist removes the dried masking fluid by rubbing it gently with his forefinger. You only need to apply a little pressure since the rubbery film lifts quite easily from most papers. This masking fluid has a yellowish tinge which was found to leave a slight stain on some papers. A new white version is now on the market, though for your purposes either would do.

10 Here all the masking fluid has been removed and the image can be seen as white silhouette against the dark background – a sort of negative of the subject. Notice the special crisp quality of the edges created with masking fluid.

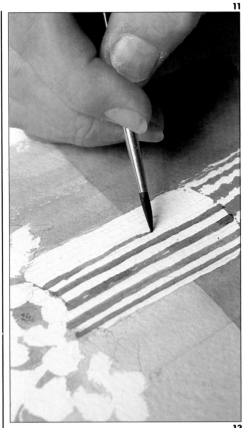

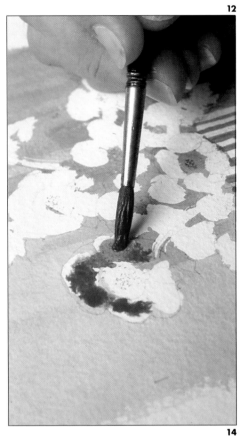

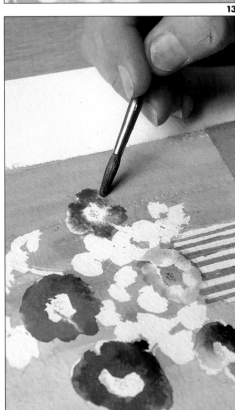

11 Using a number 3 Kolinsky sable and Payne's grey, the artist paints in the dark stripes on the vase making them slightly broader than they actually are. He felt that in the context of the composition broader stripes would have more impact than very fine stripes. As an artist you have considerably more freedom than a photographer – so do not feel that you must slavishly copy what you see. It's your picture and as long as the final painting has conviction and is successful (and only you can decide that) then you can include, discard or modify as you wish.

12 At last, twelve steps into the painting, we can start to introduce some real colour into the picture!

Here the artist has washed in magenta and now drops in a little cadmium scarlet.

13 The flowers are painted in a range of rich colours: cadmium scarlet, magenta, cadmium yellow and Winsor blue. Using a wet-in-wet technique small touches of colour are introduced into the predominant colours, purple is touched into the cadmium scarlet and magenta flowers, for example. Here the artist uses a loaded brush and mauve paint to wash in the furthest flower.

14 At this stage a wash of Payne's grey was used to 'knock back' the white of the reflection. 'Knock back' is a useful term describing the process in which a too-dominant area is harmonized with its surroundings. The artist then uses a very pale wash of Payne's grey to lay a tone on the shadowed side of the vase. This heightens the roundness of the vase, which becomes darker on the side opposite the source of light.

15 The painting is rapidly coming together as colour is applied to each flower in turn. Very dilute cadmium scarlet and magenta are used for the pale flowers. Intense washes of the same colours are used to create darker flowerheads. The subtle blurring of the wet-in-wet technique creates a naturalistic blending of colours which contrasts with the crisp, masked outlines. Notice the free way in which the colour has been applied – yellow ochre washes over the white paper as well as over the grey background, in other places the colour does not fill the outline, leaving a white halo.

16 The dark cluster of stamens in the centre of each flower is stippled in with neutral tint – a warm grey.

17 Here we see a small piece of natural sponge being used to apply colour. The method is quick and achieves the soft, slightly blurred effect which the artist is seeking.

18 The artist continues in this way, washing in touches of colour and taking the colour from one area to another. This allows the picture to develop as a whole rather than one area taking precedence over another. He uses a number 3 brush and sap green paint for the leaves and flower stems treating them very sketchily.

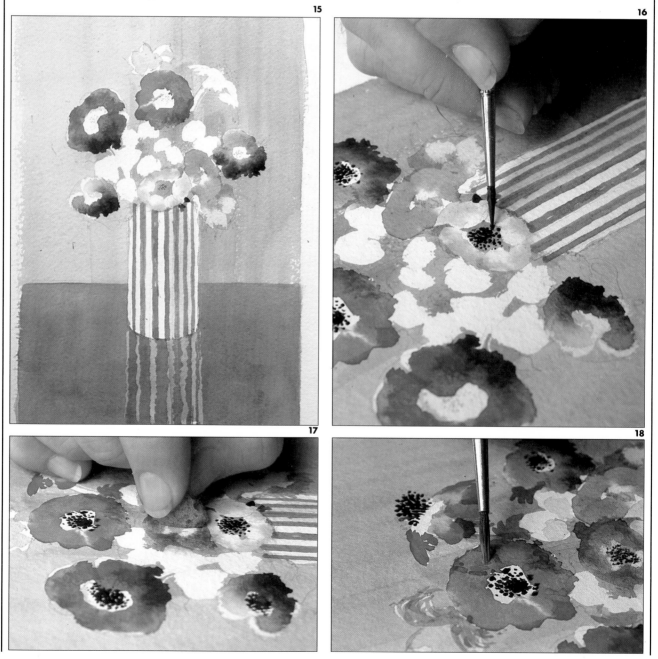

19 Flowers are an obvious and delightful subject for the painter: they are attractive, colourful and their forms are almost infinitely variable. However, a pitfall for the unwary is a tendency to become obsessive about detail, so that what is attempted is a scientifically accurate but sterile image. Here the artist has created a simple but elegant composition. The subject has been treated very freely by applying the paint with a loaded brush and dropping in touches of adjacent colours with a wet-in-wet technique. This is more sympathetic to the subject than a minutely accurate approach. Rather than applying colour in one area only, the artist developed the painting as a whole. Colours are affected by those that surround them and should not be judged in isolation or against a white background.

It is also true that all coloured objects reflect off one another so an object is rarely a single colour but contains traces of adjacent colours. If you paint an area in a single flat local colour the result will be unnatural.

Detail
In this pleasing and realistic image, overlapping layers of transparent colour and subtly blended colours create a softly-focussed effect. Crisp accents of pure colour, touches of darker tones and the clearly defined white edges 'hold' the image so that some areas swim back into focus. The artist implies form rather than describing it.

Cadmium yellow *Cadmium scarlet*

Payne's grey *Magenta*

Winsor blue *Sap green*

Sepia *Neutral tint*

19

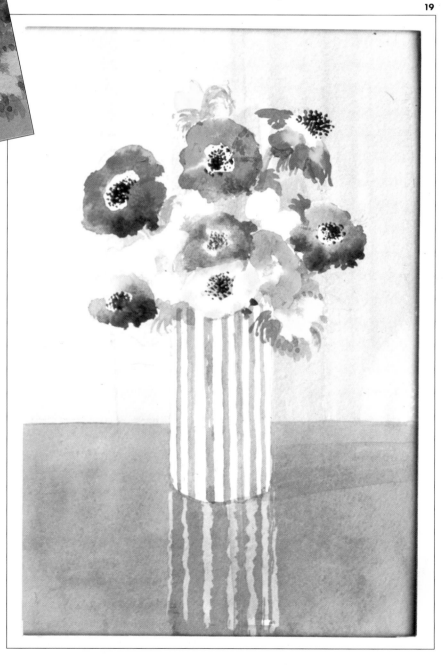

Chapter 6
Approaches

As we said in the introductory chapter there are all sorts of ways of approaching watercolour. In this book we have chosen a particular approach to help you over the initial hurdles, but we are not suggesting that this is the only way to use watercolour. Basically you need to be able to handle paint in order to make it work for you. You also need to improve your observing, recording and drawing skills. But once you have mastered the basic skills you can afford to indulge your personal passions whether they are for colour, texture or realistic representation – but you will continue to learn and improve your skills throughout your painting life. Here we start by looking at texture. Texture can be introduced into a painting for many reasons, to progress the image, to add interest, even to demonstrate your dexterity. Apart from anything else, texture is fun, just like noise is fun, and just as organized noise becomes music so organized textures can become part of the abstract qualities of an image. Try the techniques we have shown here, but take them further. Experiment, make the techniques your own and discover others of your own. The bigger your repertoire the greater and the more ambitious the projects you can undertake. An enlarged vocabulary expands the means you have of expressing yourself, allows you to communicate complex ideas, and enables you to express yourself more quickly.

The projects here are a little more ambitious but well within your reach. Look at the paintings in detail. Try them for yourself or set up similar projects. The still life with shells is particularly interesting and if you have done the flower painting with masking fluid in the previous chapter you may like to try the flowers in this chapter using a entirely different wet-in-wet technique.

Techniques

TEXTURE

Texture is introduced into paintings for a variety of reasons. It can be used in a purely literal way, to describe foliage, cobblestones or a sandy beach, for example, but it can also be used for decorative purposes and to enliven the paint surface. In many paintings the subject matter is secondary to the artist's obvious enjoyment of paint, paper, and the paint surface. As you progress you will evolve ways of describing particular textures, some you will crib from other people, from books like this, or by studying the work of the masters of the medium, past and present. But you will also find your own ways of treating certain subjects, a personal shorthand for describing the visual world, and as long as you have a fresh and enquiring approach you will continue to add to this repertoire, developing new solutions to old problems, and modifying and developing old solutions.

The truth is, that the more you learn about watercolour the more there is to learn. By now you should be handling paint with authority, controlling wet washes, using various masking techniques and introducing simple textures using a dry brush. To succeed with watercolour you need to combine a bold, vigorous approach with an

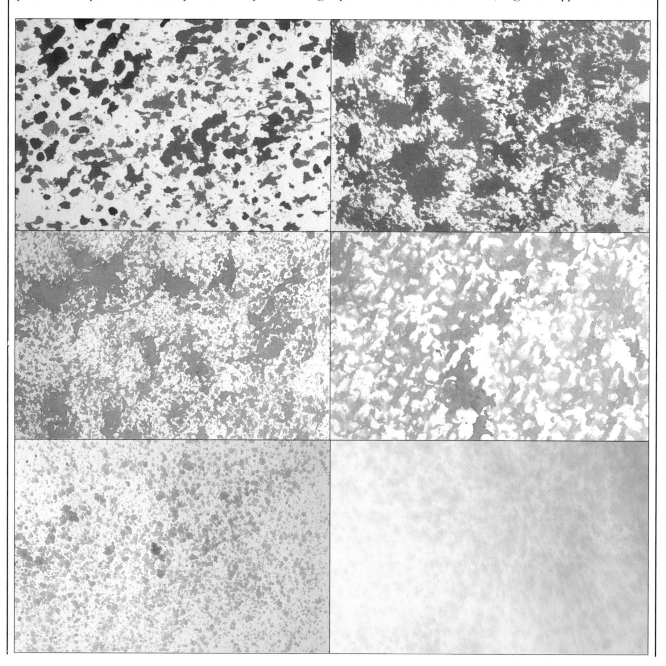

awareness of the medium and a willingness to let it lead you now and then. The happy accident is an important part of all good watercolours, so you need to be alert and decisive, prepared to incorporate an unplanned effect which enhances the painting. Watercolour offers plenty of opportunity for the happy accident, but to provide fertile ground for these you must adopt an investigative and open-minded approach to the medium. The successful painting comes from a balance of control and the unexpected. The more competent you become the more confident you will be, and the happier you will be to let the

materials do some of the work. We have looked at some of the basic techniques and there are obvious ways of achieving particular special effects, but the possibilities are endless and you will be limited only by your own inventiveness.

The techniques described here are very simple. In the first four, texture is applied with different materials – a stencil brush, a small nailbrush and two sponges, one natural and one synthetic. Here we have used a single colour which has been dabbed on to demonstrate the possibilities of the marks – take these same textures

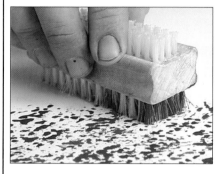

Stippling with a nail-brush
Dip the nailbrush in a paint solution and dab one end on to the paper surface with rapid stabbing movements.

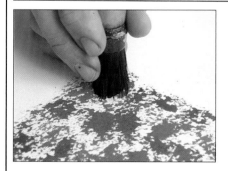

Stippling with a stencil brush
Here the artist dabs the paper with a stiff stencilling brush. The textures created by these two brushes are surprisingly different.

TEXTURE

further by introducing a second colour, or smearing the paint in some areas.

The other technique described here involves spattering paint on to the picture surface, and has a pleasingly unpredictable quality. In one of our projects it is used to create a pebbly effect on a beach but there are innumerable other applications. The paint can be applied with any sort of brush – here we use a decorating brush – and each will create a different effect depending on the stiffness of the bristles. Old toothbrushes are particularly effective. Mix a quantity of paint and dip the brush in the colour. Shake the brush to remove surplus colour – if it is too loaded the colour will drip. Hold the brush over the surface of the paper and draw a stiff instrument, such as a painting knife, through the bristles. This will create a fine spray which can be directed over the painting. The further away from the paper you hold the brush the larger the droplets will be.

Another way of introducing these 'accidental' effects is by flicking colour from a brush on to the paper – this introduces larger splashes which tend to be varied in size. Load your brush with colour and flick it briskly over the

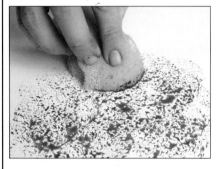

Stippling with a synthetic sponge
Cut a small piece of sponge from larger one and dip it in the paint solution. Now dab the paper surface with the sponge, to create a mottled effect.

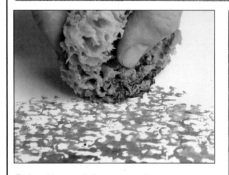

Stippling with natural sponge
Cut a small piece of sponge as before, dip it in water and dab the paper repeatedly with it. The natural sponge has a more open texture, and this is reflected in the pattern it makes.

painting – this technique was used to introduce a variety of tones and textures into the Mediterranean beach scene in this chapter. You can also texture an area by flicking the paint surface with clean water. The water splashes on to the paint and the droplets of water soften and loosen the paint, causing the pigment particles to separate and flow towards the edges, creating lighter areas.

Once you have mastered these techniques and discovered new ones you will begin to incorporate them in your painting. In a tight, realistic painting a small textured area will stand out, making a strong statement. In a more loosely and impressionistically handled work the textures will balance each other and no one area will stand out. However, you can draw attention to an area and 'explain' it by making a few simple marks which sharpen it up and bring it into focus. You are providing a few visual clues – after all, painting is all illusion, a trick of the eye. Different artists have different aims. Some want to describe and interpret the world about them, sharing their unique vision with the viewer. Others want to entertain. Whatever your particular concern you should explore the medium, so that you can use it to produce the images you want.

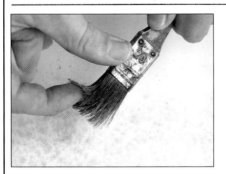

Spattering on to dry paper
Load a stiff brush with paint, hold it over a sheet of dry paper and run a knife through the bristles. This will deposit a fine spray on the paper.

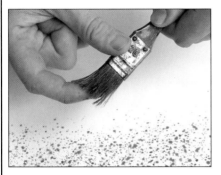

Spattering on to damp paper
Damp a section of your paper and then spatter on to it in the way described above.
The result is a more softly mottled effect, the speckles blurring into one another.

On The Beach
WET-ON-DRY

The figure provides a subject which is infinitely challenging yet wonderfully expressive and it is for this reason that artists throughout the ages have never tired of depicting it. It is not necessary to have a deep knowledge of anatomy to be able to draw the figure well, though as you pursue the subject you will undoubtedly want to increase your knowledge, to look under the skin for explanations of what you can see from the outside. The knowledge gained at second hand from books or classes will never do more than supplement what you learn from your own personal observation. This is why we encourage you, firstly to work through the demonstrations we have shown you here, and then to find similar subjects to which you can apply what you have learnt. We are really trying to give you the basic skills so that you can develop on your own. We are giving you a 'push start' in the hope that you will continue under your own momentum.

There is no substitute for painting and drawing directly from the figure, but you do not need to go to the expense of hiring a model or even going to classes where a model is available. There are free models all around you, beginning with your friends and family who may be persuaded to 'sit' for you or whom you can draw surreptitiously. In parks and bars or as here on the beach, there are people to be drawn. You should get into the habit of carrying a sketchbook in which to make notes no matter how cursory. It will surprise you how much information you will find in a sketch which seemed too thin to be useful. Watercolour is an excellent medium for this sort of notetaking although in this book we do not really discuss its qualities as a sketching medium.

The beach is a wonderful place to people-watch. You can make yourself comfortable in an unobtrusive position from which you can see much without being overlooked. It is important to make the marks recording what you see rather than concerning yourself with the finished image. The images are being imprinted on your mind as you work, in the same way that writing notes helps you to remember things even if you never read the note. Again the rule is to look, make notes, observe and to draw. The practice and the experience cannot be bought.

So far we have not really looked at the figure. Here the artist gives you a gentle introduction.

1 The paper for this painting is Bockingford 140 lb (300 gsm), Not, 15 in × 22 in (37.5 cm × 55 cm). The brushes were a large Dalon (number 18) and sables number 3 and number 8.

The artist mixes a solution of cobalt and ultramarine, and with a large brush (number 18) loaded with colour, washes in the sky, working wet-on-dry.

2 The artist treats the figures very simply, looking for the broad forms rather than the details.

Study the subject carefully through half-closed eyes. Try to reduce it to an abstract pattern of lights and darks and put down what you see, not what you 'know' to be there. The artist started with a light wash of brown madder alizarin and chrome orange. When this was dry he laid in the mid-tones with sepia and brown madder alizarin.

3 The sky was washed in briskly, using a big brush. The artist allows the white of the paper to show through in places to suggest white clouds in a brilliant summer sky. The wet-on-dry technique creates crisp edges. The figures have been established simply, but very effectively, using a light tone and a mid-tone.

4 The bright sunlight casts strong shadows and the painting has more contrast than some of the landscapes we have seen so far. The artist uses Payne's grey for the darkest skin tones then, while this is still wet, he drops in a mixture of brown madder alizarin and sepia to add warmth to the shadows. The sunlight reflected from the sand warms the shadows.

5 Having broadly established the figures, the artist drops in background features such as the beach umbrella. The various elements of the composition then begin to take their place in space. The umbrella is laid in with brown madder alizarin with a touch of Winsor red; cobalt and ultramarine; sap green; and Payne's grey for the dark parts. The artist paints these

details wet-on-dry with a number 3 brush.

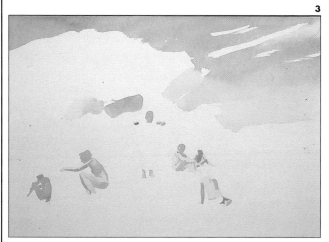

3

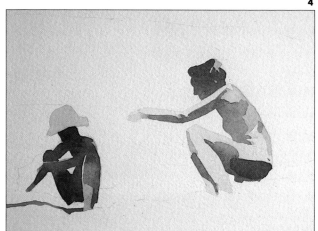

4

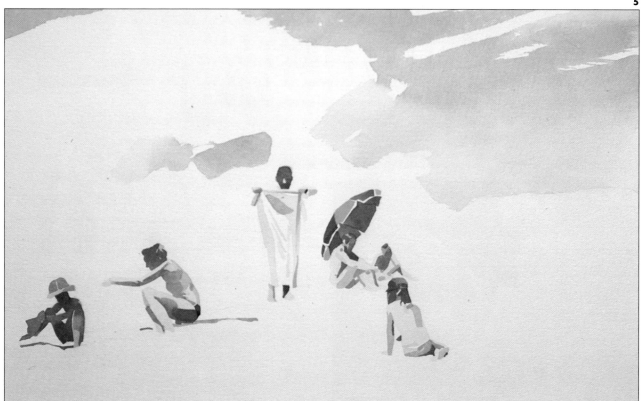

5

6 In this detail we see the way the artist is building up the forms from discrete patches of colour. Seen close to, the painting has an abstract quality – it is divided into small elements of colour like a jigsaw puzzle. However, these resolve themselves into accurately described forms as soon as you increase the viewing distance.

7 The deep green foliage of the pine trees which form a backdrop to the beach is an excellent foil for the warm tones of the sand and flesh, and the occasional brilliant touches of local colour.
The green is mixed from sap green and Payne's grey and is washed in wet-on-dry with a large brush. A smaller brush is used to cut back around the contours of the figures.

8 The background is simple but descriptive. The artist has used the colour to block in large areas for the canopy of the trees, and has also used it to 'draw' the complex tracery of the tree trunks. A dilute wash of sap green is used to trace the silhouettes of the palm trees in the distance – these pale colours help to suggest that the trees are further away.

9 The beach is laid in with a series of overlaid washes mixed from yellow ochre and cadmium yellow. The colour is applied broadly in the open spaces, but around the figures the colour has to be applied more carefully with a number 3 brush.
The shadows beneath the figures are laid in with Payne's grey mixed with a little yellow ochre.

6

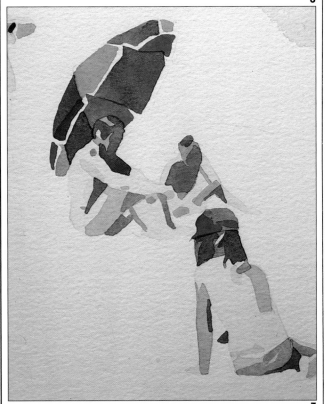

8

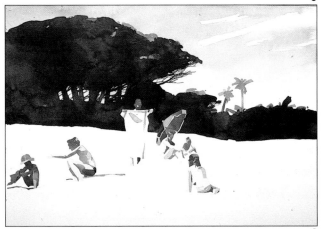

9

7

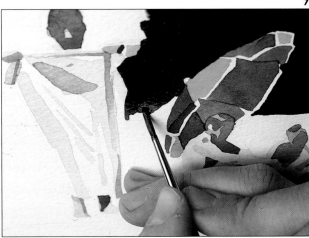

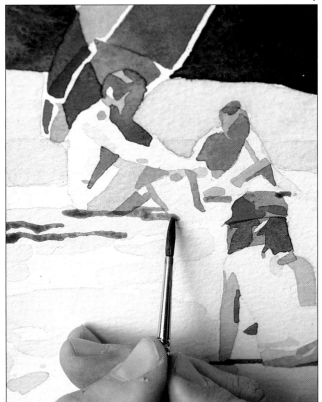

Detail
The crisp layers of fresh colour effectively create the warmth and brightness of a Mediterranean summer.

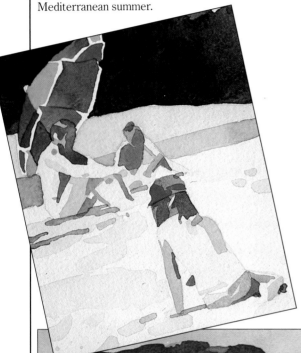

10 To complete the painting, the artist lays a slab of shadow across the beach – adding both compositional interest and form. The sweeping diagonal divides the rather plain rectangle of the beach into two more interesting geometric shapes. Payne's grey and ochre are spattered in the foreground; again it has a dual purpose, describing the pebbles on the beach and the uneven surface of the sand, as well as adding textural interest.

The subject could be considered complicated. Firstly, there are many different elements within the picture: people and their beach paraphenalia, the sandy beach and the background. The figures seen in this way are constantly moving and can adopt an apparently infinite range of poses. The answer is to be direct and decisive, drawing what you see, putting down only the essentials and risking making a mistake. Deal with the subject as a whole rather than becoming too concerned with one element. The artist has simplified the forms, but the painting is nevertheless an accurate and easily read representation of the scene.

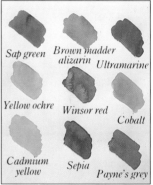

Sap green Brown madder alizarin Ultramarine

Yellow ochre Winsor red Cobalt

Cadmium yellow Sepia Payne's grey

10

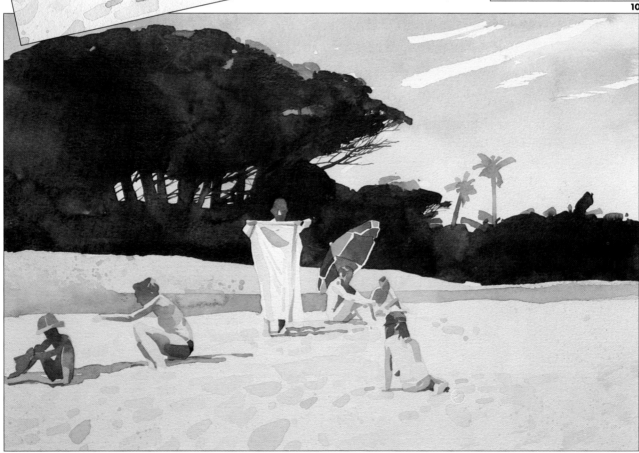

Boats – Low Tide

SPATTERING

This composition may appear more complex than some of those we have encountered, but when analysed, it consists of a few simple elements. The boats occupy the central area and, with the repeated curves of their hulls and their exhilarating colours, undoubtedly dominate the painting. Nevertheless the foreground is an important part of the composition, balancing the bright primary colours of the boats. These two visually busy areas are set against the more subtle colours and textures of the background. The textures in the foreground are built up gradually – so be careful not to let this area get too dark too quickly, or subsequent layers of pattern and texture will not 'tell'. For this project the artist uses very simple techniques but the exciting results demonstrate the way that these basic techniques can be extended almost infinitely. The artist used pencil to apply small areas of texture to the cliff-face – this combining of media is often frowned upon but it is effective and does not compromise the essential qualities of watercolour – its freshness, spontaneity, and that luminosity which is unequalled in any other medium.

1 For this painting the artist used a sheet of 90 lb Cotman paper with a Not surface. The paper measured 10¾in × 14¾ (22.5 cm × 37.5 cm). The brushes were a number 3, number 6 and number 8 sable. The artist also used a soft B pencil.

The first step is to make an outline drawing – for this the artist used a soft B pencil to block in the main elements of the subject. He made only sufficient marks to help him identify and organize the main colour areas but not enough to confuse the drawing. It is important that the drawing is kept as simple as possible since watercolour depends for its effect on bright, clean colours. When he has blocked-in the main areas of the drawing the artist stipples in masking fluid to represent the shingle. The blobs of fluid are varied in size so that those nearer the viewer at the bottom of the page are larger and those further up the page – further from the viewer – are smaller. He also masks the circle of the sun and a flock of gulls swirling in front of the cliff-face.

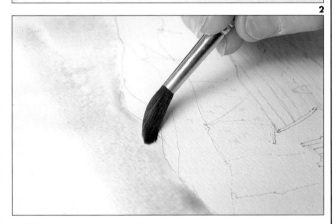

These sketches were made on location – the artist was drawn to the simple curved shapes of the hulls of the beached boats. He used these as the basis of this study of texture.

2 The sky is washed in with a pale blue – a dilute mixture of cobalt into which a little raw sienna and Payne's grey has been introduced to create a rather watery sky. This pale first wash will be overlain at a later stage with further washes to create a hazy effect. To achieve subtle effects such as this you must develop the tones gradually. If you allow the colour to get too dark at an early stage you will limit your possibilities later. If, on the other hand, you are after dramatic effects, do not be afraid to make a bold statement.

3 The beach in the foreground is washed in with a mixture of raw umber into which the artist has introduced a little yellow ochre. Occupied areas of space are rarely the colour you believe them to be. A beach, for example, is expected to be a golden yellow but the colour of the sand or pebbles will depend on the geological structure of the coastline. The rocks which back the beach are not necessarily those which will supply the material of which the beach is made. Often the longshore currents move quantities of material down the coast, resulting in the shingle being comprised of material from an outcrop further up the coast. Other factors in the equation are the weather, the light and, as here, a covering of seaweed giving a green cast.

4 The first wash is allowed to dry then the artist adds more yellow ochre to the original mixture. This creates an olive green which is washed over the foreground, covering part of the original wash but leaving some parts exposed. Here the artist introduces Payne's grey plus a little lamp black into the wet wash to create a dramatic darker tone in the foreground.

5 One of the important elements in this painting is the texture of the shingle. He started by masking the larger pebbles, taking care to make sure those in the foreground are larger than those in the distance to aid the sense of recession. Dots of Payne's grey mixed with lamp black are being stippled in here to create another level of texture.

6 The beach can be seen to be a series of overlapping washes edged with deliberate undulations and not simply random shapes. Dark stipples of the Payne's grey/lamp black mixture extend in lines from the foreground into the background – creating a linear perspective and at the same time defining the bases of the troughs.

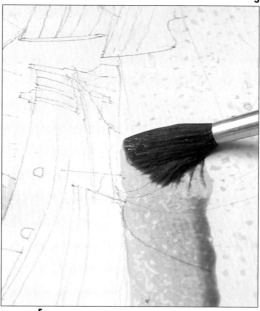

3

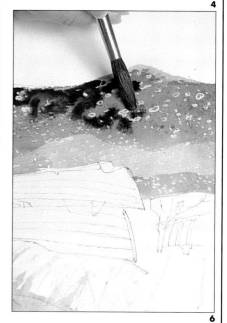

4

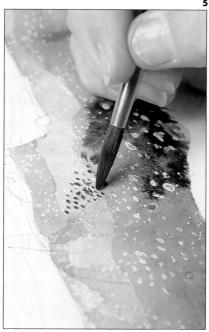

5

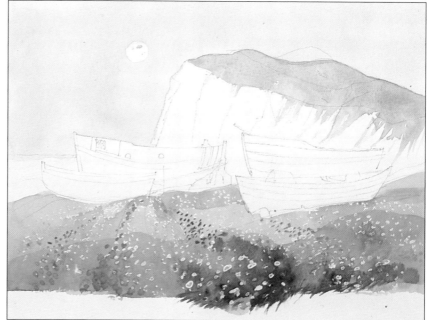

6

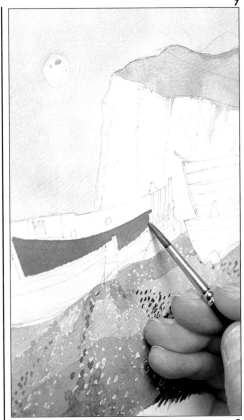

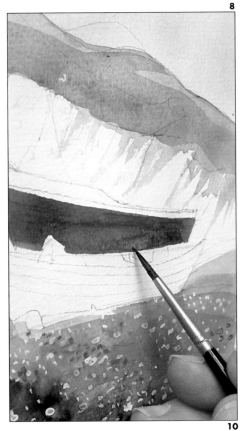

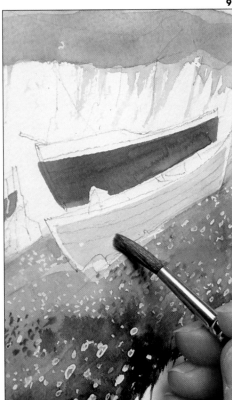

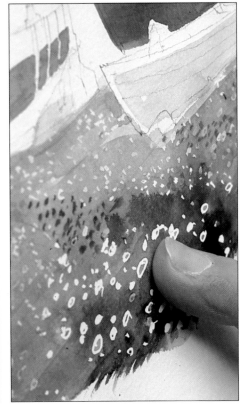

7 The vivid paintwork of the fishing boats provides the artist with a wonderful opportunity to use pure primaries – red, blue and yellow. Here he uses cadmium scarlet. The paint is laid on with a number 3 sable brush using a stroking movement to create a relatively smooth paint finish. The brushstrokes follow the line of the planks of the clinker-built hull so that any streaking in the paint will follow and help describe form.

8 For the second boat the artist uses cobalt blue, a particularly vivid blue. Study the painting carefully at this stage. You have established the colour of two of the boats but, despite the fact that you have probably matched the paintwork exactly, the effect is likely to be unconvincing. This is because the pure unmodified colours which you have used are actually 'the local colour' and not the colour you would see. At a later stage various tones of red and blue will help to define the form and create a more realistic image.

9 Here the artist uses a cadmium lemon to describe the local colour of the nearest boat. Notice the transparency of the yellow and compare it with the cadmium scarlet, which is a very opaque colour.

10 The artist mixes a large quantity of yellow ochre and, using a loaded number 8 brush, applies this colour across the foreground, working briskly to create vigorous gestural marks. In this detail, the artist removes some of the masking fluid by rubbing it very gently with his finger making sure that the paint is quite dry. He leaves some of the masking fluid because its creamy yellow makes a useful contribution to the texture of the shingle.

11 Here the artist creates a spattered effect in the foreground. The technique is very simple – he first mixes a quantity of raw umber and raw sienna in a large dish.
A toothbrush is dipped in the colour and held over the painting. The artist then takes a palette knife and runs it across the bristles, depositing a very fine spray of colour on the surface.

12 Payne's grey mixed with lamp black is used to develop the detailed structures of the boat such as the rudder, the keel, and the propellor.
Few brush strokes are used to describe the simplified shapes – it is the general forms that are required, not a lot of detail. Here the artist uses the tip of a number 3 brush to paint the blackened timbers propping up the boat.

13 At this stage we can review the progress of the painting once again, and it might be useful if you glanced back at picture number 6. As you can see, the artist has laid a tonal wash across the top of the cliffs so that the clifftop can now be read as a hummocky area covered in grass. The sea has been washed in with a very pale wash of Payne's grey.

Cadmium yellow, with a little Payne's grey, has been washed over the original lemon yellow of the nearest boat. The shingle beach is richly textured and convincing but the rest of the painting needs a considerable amount of work before it will be complete.

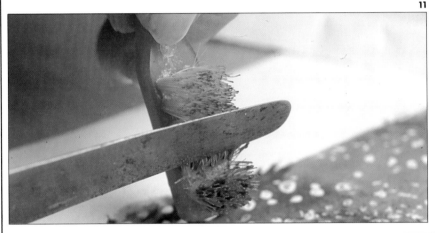

11

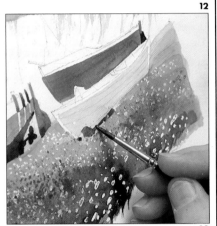

12

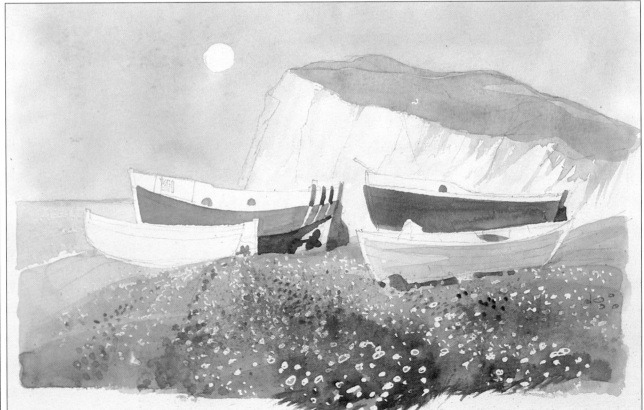

13

14 The artist continues to develop the details of the boats. A very pale wash of Payne's grey is used on the red boat to 'knock back' the bright red and suggest the way the boat curves along its length. The white boat is rendered with a wash of Payne's grey. Details are added over this with a strong Payne's grey tint applied wet-on-dry, creating the crisp lines of the timbers and other details. Here the artist uses the tip of a number 3 brush and lamp black to paint the lettering on the prow of the boat. He deliberately leaves the letters undefined since sharp edges would leap from the painting rather than taking their proper place in space. Details at that distance would not be clearly defined.

15 In this detail we see the artist using an ordinary lead pencil to sharpen up some of the detail on the boat. People often recoil from the notion of 'mixing media' but it can be useful. The pencil is appropriate because it has a very fine and rigid drawing point that can be handled with great accuracy and its sutble grey tones well with the watercolour.

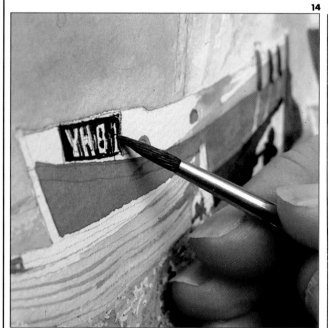

14

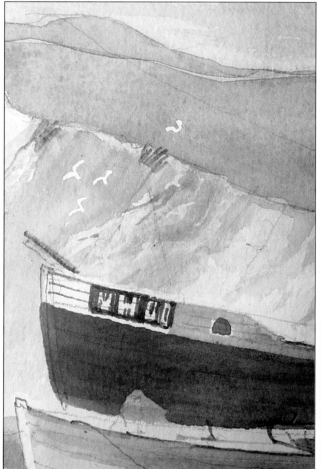

16

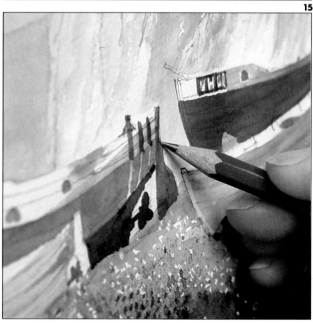

15

16 The artist works into the cliffs with a pale Payne's grey, using the brush to create marks which suggest faceting and fissuring of the rock. When this is dry he applies more texture using a dry brush technique. The texture of the rock-face builds up as a series of thin and very pale applications of colour, some applied wet-in-wet, others applied wet-on-dry. When the artist was satisfied with this area of the painting he removed the masking fluid, revealing the gulls. Here you can see the way in which he has added more texture using a fairly blunt lead pencil.

17 The painting is completed by laying a light wash across the sky. The artist uses the original mixture of cobalt, raw sienna and Payne's grey in a very dilute solution. He drags the colour across the sky area to create the impression of thin veils of cloud which drift across the sun. The colour is laid on with a fairly dry number 8 brush as he wants to create streaks of thin colour rather than a wet wash which might lift the underlying colour.

The artist has created a pleasing composition which relies for its impact on the simplicity of the forms, the contrast between the strongly textured foreground and textures of the sea, sky and chalky cliffs, and finally on the vivid complementary colours which dominate the centre of the painting.

Detail
In this detail you can see just how richly textural watercolour can be. These effects are created optically, for the paint surface is entirely flat – contrast this with oil painting where it is possible to build up thick encrustations of paint which extend the surface of the painting to almost three-dimensional proportions.

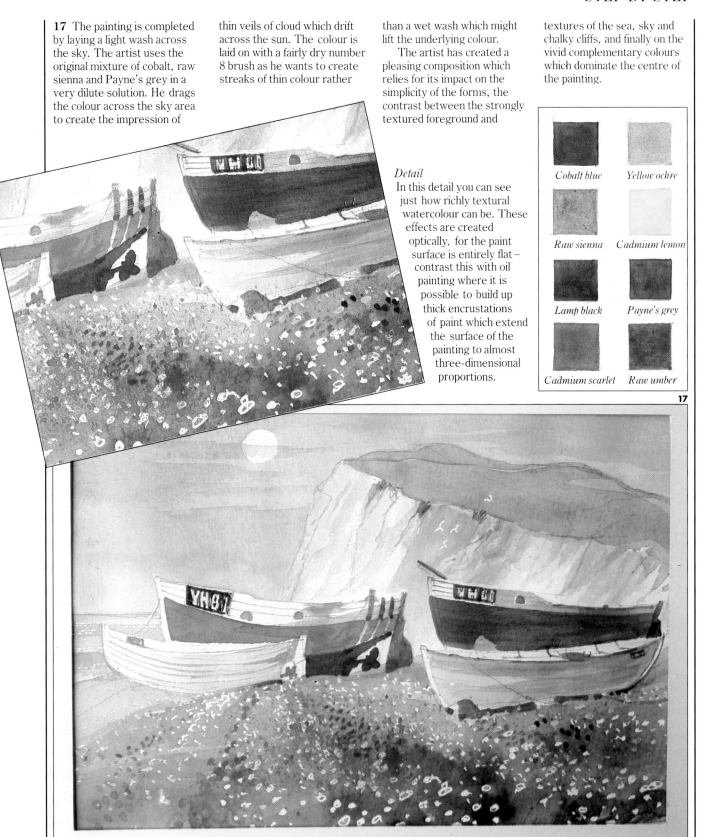

Cobalt blue	*Yellow ochre*
Raw sienna	*Cadmium lemon*
Lamp black	*Payne's grey*
Cadmium scarlet	*Raw umber*

17

Still Life – Shells
WAX RESIST

Objets trouvés provide the artist with a never-ending source of inspiration and the sort of material that automatically finds its way into your home is very revealing. For example, a wildlife artist who specializes in bird paintings has a large collection of skins, skulls and feathers, gathered on walks in the countryside. This is supplemented by material brought to him by friends who know of his interest. His collection is a valuable source of information and inspiration to which the artist constantly refers. In his field accuracy is important.

In the same way an artist interested in texture will automatically gather bits of bark, fabric and anything which has an interesting surface. A colourist, on the other hand, will gravitate towards objects that feed his particular imagination. So hang on to that collection which everyone else thinks of as junk – it is an essential part of your visual library and you will never be without something to paint.

Here the artist has taken four familiar objects from his collection and has created a simple but effective composition. It doesn't matter how often you paint a subject as long as you treat each painting as an entirely new experience, make no assumptions and look at the subject as if seeing it for the first time. For the artist every visual experience is a new one.

1 For this painting the artist used a sheet of heavy paper (Bockingford 200 lb) which he stretched on a drawing board. The dimensions were 15in×22in (37.5cm×55cm). He used four brushes, three sables – a number 3, a number 5 and a number 8 – plus a one-inch, decorating brush for spattering texture. The wax resist was applied with a white candle.

In this painting there is no underdrawing. The artist works directly onto the paper using a number 8 sable brush loaded with a dilute wash of yellow ochre and ivory black. Working quickly and observing the subject carefully, he blocks in the largest shell.

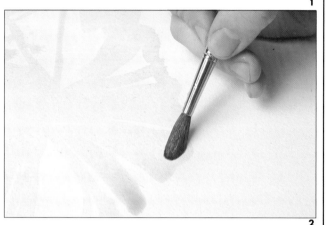

These shells were selected from a large collection in the artist's possession. Most artists are magpies, saving bits and pieces that catch their eye – it may be the colour, the shape or the texture which attracts them. These 'found' objects become part of their visual library and the same objects may appear again and again in their work.

2 The smaller shells are sketched in using the same pale grey wash, a large brush and brisk, decisive gestures. This method of starting a painting demands a slightly different approach, for the artist is looking for broad forms rather than outlines. You may feel unhappy about abandoning the initial pencil drawing, but the sense of security which it gives you may be a false one. There is a tendency to assume that the drawing is correct and so forget about it once you start to apply the paint. But a good artist constantly checks his drawing, takes nothing for granted, and is prepared to make quite radical changes even at a late stage. Try this exercise – it may feel a little like walking a tightrope at first, but you'll find it exhilarating and your work will become more direct and vigorous.

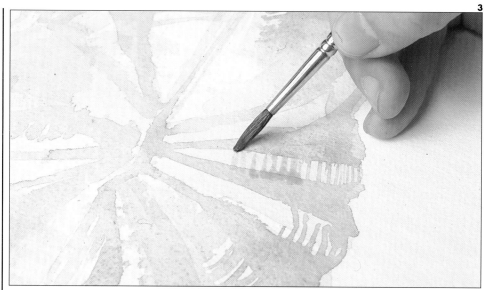

3 The artist allowed the first wash of colour to dry, helping the process along by standing the painting near a fan heater. He then introduced some Payne's grey to the original wash and used this to add more detail. He studied the shells carefully through half-closed eyes to identify the lights and darks, touching-in the darker tones with a number 5 brush. The main ridges have been drawn using a wet-on-dry technique – notice the way these colour areas have dried with crisp edges which will enhance the grittiness of the shell's surface.

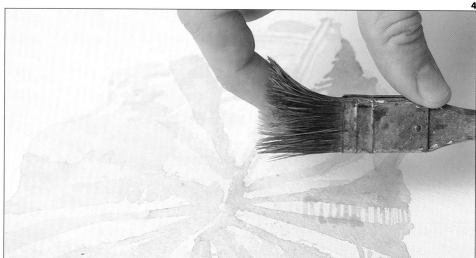

4 Shape, texture and pattern are the main concerns of this painting. On the left we have the solid symmetry of the largest shell – the stony fan of the top half mirrored in the lower part. On the right, the spiny silhouette of the larger shell contrasts with the smooth, compact shapes of the pair of small shells. Now look at the surfaces – chalky, grainy textures on the one hand and a polish as smooth as glass on the other; a creamy matt colour contrasting with rich brown spots and speckles. Here the artist spatters on colour to create a softer effect.

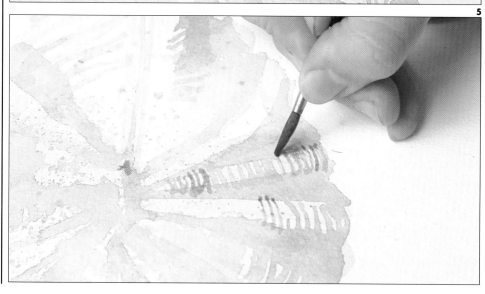

5 The artist attacks the subject boldly, taking risks to avoid the painting looking overworked. In the previous picture we saw him spattering on texture, here he tightens up the drawing by adding detail with a fine, number 3, sable brush. This method of working is ideally suited to the subject. It allows the artist to work loosely and respond to the textural aspects of the subject without losing its linear qualities.

6 Here the artist works into the spiny shell on the right. One of the possibilities which watercolour offers you is the gestural mark – the mark which is an important statement in its own right. The artist uses broad, bold descriptive marks for this shell, and carefully drawn, organized lines to describe the delicate tracery of the large shell. He adds more texture by flicking on heavy droplets of colour. Then, using the same technique as in picture 4, he spatters on colour with a one-inch brush, but in this case the brush is heavily loaded and deposits a coarse spray of colour.

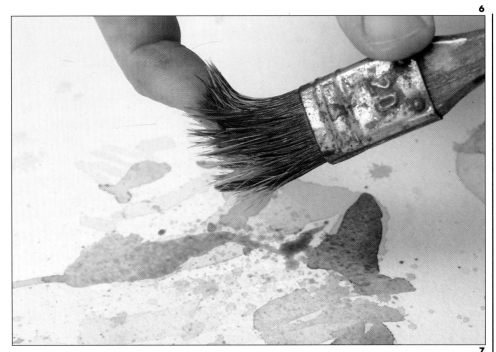

7 The artist uses a number 3 sable brush to add fine details. Again he alternates between a bold, broad approach, applying the colour freely with sweeping gestures as in the previous picture, then tightening up the image by adding details using a number 3 sable brush. Here we can see some of the repertoire of marks available to the watercolour painter. At this scale the painting has a pleasing, abstract quality which relies for its impact on the contrast between blurred edges and sharply defined colour areas, on paint which is spattered and splashed, and on a limited palette and fairly close tones.

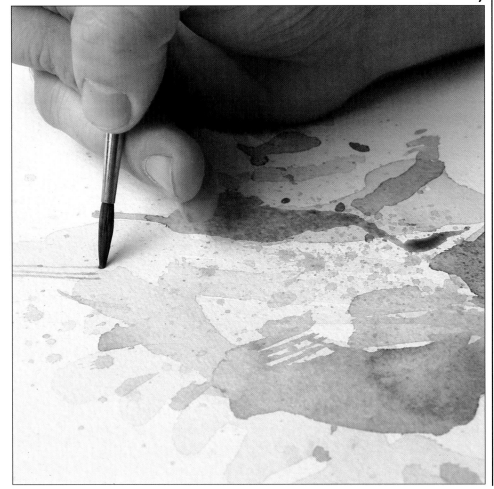

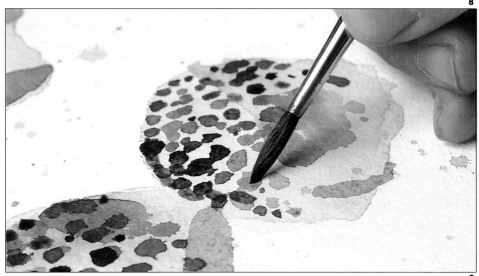

8 The cowrie shells are established very simply. Payne's grey is used to paint in the darker tones. It is fairly easy to see the tones in a subject which is a single colour; as soon as pattern is introduced the forms are broken up, confusing the eye. This is a concept which is exploited in nature by animals with a dappled coat that acts as a camouflage. The best way to see the tones is to exaggerate them by half closing your eyes. Here the artist speckles the shell with brown madder alizarin, the darker spots are sepia.

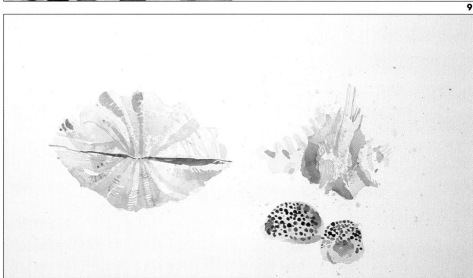

9 In this painting, the artist uses cool colours and a limited palette. This allows the quality of the brushmarks and the textural element of the composition to show to advantage. The painting is bold, the paint freely applied but the subtle pearly greys and the warmer pinky browns create a soothing, harmonious effect. A simple subject such as this allows you to explore the special qualities of watercolour – the brighter pigments are so seductive that there is a temptation to rely on colour and neglect the marks and the effects of overlaid colours.

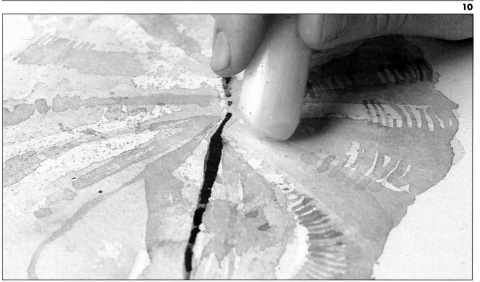

10 There is a pleasing tension in watercolour which may result from its apparent randomness and the need to control that. This random element can be explored and exploited and when it is successfully channelled the result is that special freshness and immediacy which is almost irresistible. Here the artist lays on a wax resist. Watercolour will be repelled in the waxy areas, resulting in an unevenly applied colour which is exciting.

11 Payne's grey is washed over the waxed area. A greasy surface repels water, so the colour breaks up into droplets which either run off or dry on top of the wax. As the candlewax was not evenly applied, the wax resist is not continuous and colour runs off and collects in areas where the paper is exposed. This effect is even more obvious on rough paper as the wax tends to rub off on the high spots causing the colour to run into the recesses, exaggerating the paper texture. An artist searches for ways of implying what he sees, of sharing with the viewer his vision of the world. Some adopt a photorealistic approach, describing the subject in minute detail. In this painting, however, he has found equivalents for what he sees.

12 If you turn back to the painting of anemones you will see that the artist masked his subject so as to lay in the background area first. Here, however, the artist has worked up the details of the shells first, only applying the background at the very end. In this case the artist was dealing with four simple shapes; the bunch of anemones on the other hand presented a more complicated outline and applying the background last would have been slow and complicated. Here the artist deliberately uses the background colour to firm up the outlines of the objects. Using a number 8 brush he takes the Payne's grey and ultramarine wash around the objects, using the wash to define the outline.

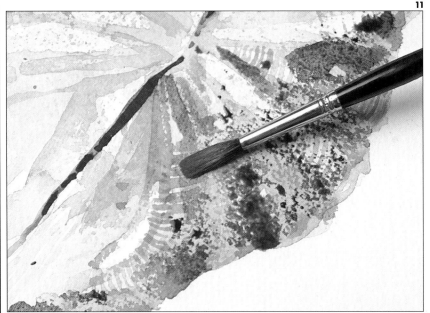

11

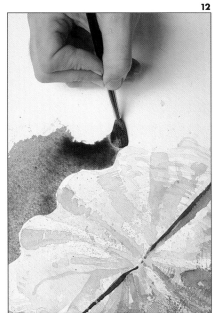

12

13 The flat, monochrome background gives you very little information about the spatial relationships so that in the previous picture the objects appear to be suspended in space. To rectify this, the artist mixes a dark wash of ivory black and ultramarine and uses this to lay in shadows around and under the objects. This immediately sits them firmly on the flat surface on which the shadows are cast. The shape of the shadows reinforces the illusion of three-dimensionality, for two-dimensional objects lit in this way would throw different shadows.

In this detail the artist lays a final wash of brown madder alizarin over the top of the cowries.

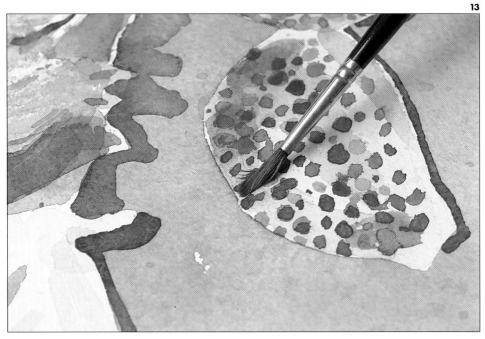

13

14 It was the simplicity of this subject which attracted the artist. The small, simple shapes of the shells are close in tone yet not without interest. They could have been incorporated as subsidiary items in a much larger composition, but by making them the subject of the painting the artist is able to study them carefully, concentrating on their subtle colouring and the slight differences in texture. In the process he allows us to see quite ordinary objects with new eyes. He shares his visual experience with us.

This simple still life illustrates the range and flexibility of watercolour. The artist makes clear simple statements using straight-forward techniques. He puts down patches of colour, allowing the mark of the brush to contribute to the web of colour which creates the illusion of form, local colour and texture. The approach is controlled for the artist is a skilled exponent of the medium, yet the final image is fresh and direct.

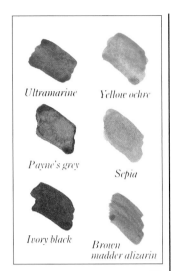

Ultramarine *Yellow ochre*

Payne's grey *Sepia*

Ivory black *Brown madder alizarin*

14

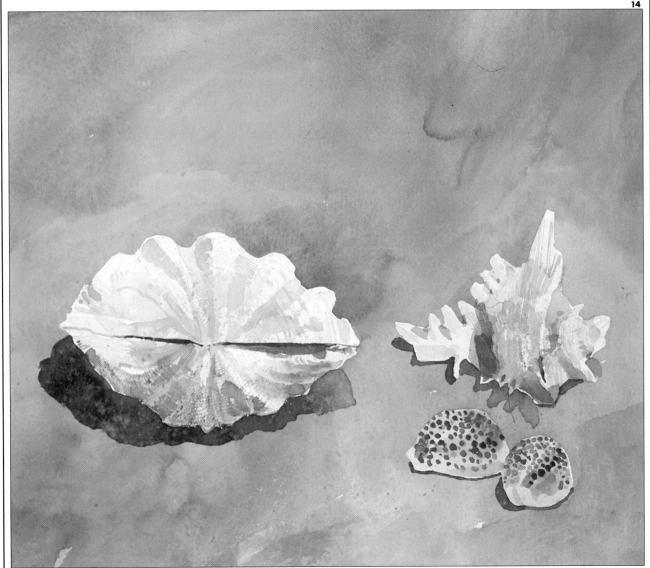

Rocky Headland
WAX RESIST

One of the joys of watercolour is that you can make of it exactly what you want. If you look at the paintings in the introduction you will see that the approach varies from artist to artist and that each artist has their own particular concerns. One artist is a colourist, another is more interested in subtle tone, whilst another may be particularly concerned with structure and space within a painting. These concerns may remain the same for a lifetime or may change from painting to painting or over a period of time. The beginner is generally too busy grappling with the technical difficulties of the medium to find where his or her real interests lie. At first the subject seems restricting and hedged about with dos and don'ts, but none of these rules are immutable, and eventually you will be able to choose whether to abide by them or ignore them. Thus some purists never mix any other media with watercolour, while other artists happily combine it with gouache, pencil, ink or anything that comes to hand. Some of the great masters have been quite cavalier in their use of media. However, the more disciplined you are at first the more freedom you will have in the end. By practising the techniques, exploring and understanding the way paint reacts to paper under different conditions, by getting to really know the materials you use, you will gain a mastery of the medium which will allow you to handle it with confidence. You will then be in a position to exploit the considerable freedom that watercolour offers.

In this painting the artist has handled the paint with great freedom and inventiveness. He has deliberately chosen a subject which provides him with opportunities to explore the textural qualities of watercolour. The composition consists of a few interlocking curved shapes:

the sweeping line of the track which bisects the foreground, the wedges of sea, cliff and headland. The main areas of interest are the crumbling cliff-face and the hummocky foreground. These provide the artist with the starting point for the study, but eventually the image and the materials start to make their own contribution. Thus the artist looks for the dark tones among the rocks on the rocky cliff, he wets these areas and lets the ink flow in. Now, the artist is a particularly accomplished exponent of the medium, and from his experience knows the sort of effects that can be achieved using this technique; nevertheless, he cannot be quite sure exactly how much the ink will flow or what it will look like when dry. This element of surprise adds spice to watercolour.

This tumbling coastal scene gave the artist plenty of opportunity to demonstrate the textural qualities of watercolour.

2 The artist wanted to create an area of broken colour on the cliff-face, to suggest faulted and weathered rock and scree. He works over these areas with a white candle. The wax will act as a resist, protecting the paper from the wet colour. However, that protection is not as complete as masking fluid, for example, for the wax adheres unevenly, allowing the paint to penetrate in some parts. The wax is also applied in the foreground, using vigorously scribbled marks and dots. This technique demands a bold approach – if you are tentative the work will lack conviction.

1 For this painting the artist used a sheet of Cotman, 140lb (300gsm) watercolour paper. The paper had a Not surface and measured 10¾in×14¾in (22.5cm×37.5cm).
The brushes were sables numbers 5 and 8, and the artist used black Indian ink as well as pan watercolours.

The artist started by sketching in the main areas of the composition with a B pencil. The sky is washed in with a mixture of cobalt blue and Payne's grey. He works wet-in-wet, dotting in the colour and allowing it to spread. He applies very little colour as he wants a light sky with a lot of the paper showing through.

1
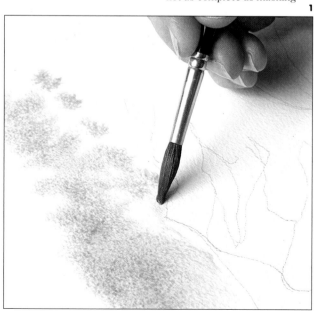

2
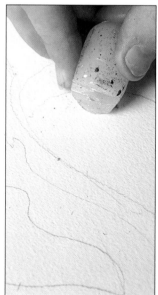

3 A little yellow ochre is added to sap green and the mixture is washed into the foreground with a loaded number 8 sable – you can see that the wash is quite wet. White paper shows through where wax was previously applied to the paper.

4 The artist allows black ink to bleed into the wet paper. Ink is used because it is a denser and more opaque black than watercolour and therefore has more impact. The ink floods into the wet area – the artist is taking a controlled risk, for he cannot know exactly what the final effect will be. But this element of chance is one of the pleasures of watercolour.

5 The artist draws down strands of black from the pool of ink, using the tip of the handle of his brush – you have seen this technique in earlier projects. Here he uses a pen and ink to draw blades of grass. Compare the different qualities of these lines.

6 The drawing consists of a few energetic lines, freely laid in and giving a very sketchy notion of where the different elements will be. The sky has been established simply but effectively – by now you too should be handling these wet-in-wet washes confidently. The foreground is also beginning to take shape and promises to be exciting.

3

4

5

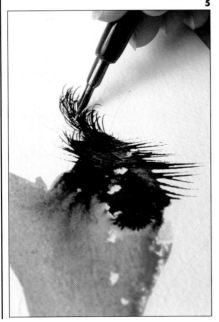

6

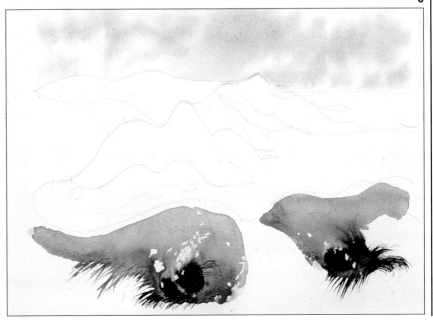

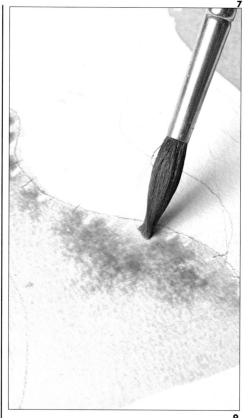

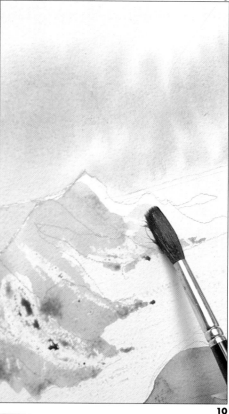

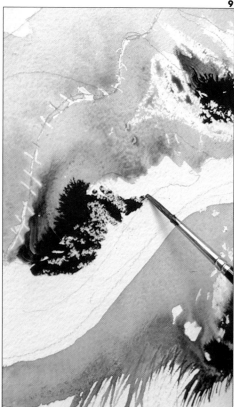

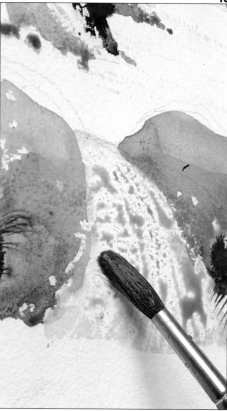

7 The clifftops are washed in with the sap green and a loaded number 8 brush. He works quickly, interested in achieving a direct, expressive image, rather than smooth, carefully graded washes. Here we see Payne's grey being bled in wet-in-wet.

8 The artist stippled masking fluid across the surface of the sea where the white paper will eventually capture the effect of sunlight glinting on the surface of the broken water. He also stipples masking fluid along the pathway which plunges from the foreground down to the sea. Gulls swirling along the cliff-face are masked, as is the fence which runs along the cliff-top. Payne's grey and cobalt blue are washed on to the cliff-face where the strata are exposed. The colour is repelled by the waxy resist – though in places the colour actually forms droplets on top of the wax.

9 Here the artist bleeds black ink into the wet wash. The rich, velvety black gradually spreads, the fine, blurred tentacles reaching out into the wet paper. The ink is also repelled by the wax, though less thoroughly so than the paint. With watercolour you have to allow for changes of tone as the paint dries – the paint looks lighter when dry than when wet. The ink however is different, and will retain this dense, rich velvety quality even when dry.

10 A mixture of yellow ochre with a little Payne's grey is lightly washed over the path. Again the wax resist repels the paint, causing it to coagulate in droplets. This area was fairly thoroughly covered with wax, the artist using the candle to 'draw' the ruts and potholes in the path. The same colour is washed across the hummocky foreground to build up the colour in that area.

11

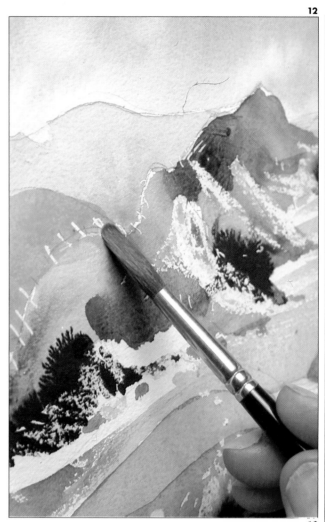

12

11 With a painting like this the artist starts off with an idea, but many of the techniques are employed because they introduce the possibility of the 'creative accident'. The artist has a 'let's see what will happen attitude' which allows him to be prepared for the happy accident which may reveal possibilities he had not considered. There is an element of this in all watercolour painting, which is why it's such an exciting medium – certainly not for the faint hearted!

12 The artist mixes a bright grass green by adding cadmium yellow to sap green and this is washed over the near slope of the headland. This bright colour adds impact to the area and helps the sense of recession by bringing it forward, at the same time pushing the distant slope back.

13

13 At this stage the artist stands back from the painting to study it carefully, and decides that the foreground needs further development.
He applies another layer of candle wax, over the first washes, working carefully so as not to damage the paint or overwork the surface.
He then washes a mixture of cadmium yellow and sap green over this area, adding tonal and textural interest which also helps to describe the hummocky nature of the ground.

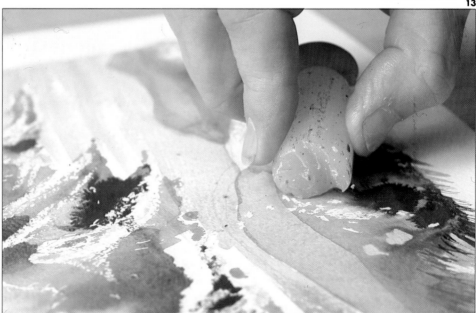

WAX RESIST / ROCKY HEADLAND

14 The sea is washed in with a mixture of Payne's grey and cobalt blue. When this is dry, another wash is applied to describe the shadows on the sea. The crisp edges of the wet-on-dry technique emphasize the areas of light and dark within the painting, capturing the way the light on the sea changes as scudding clouds pass across the sun.

15 The artist continues to work over the picture surface, adding colour here and there, looking for the tones which describe the forms, but at the same time aware of the textural possibilities.
The painting is descriptive but the decorative element is also very important.

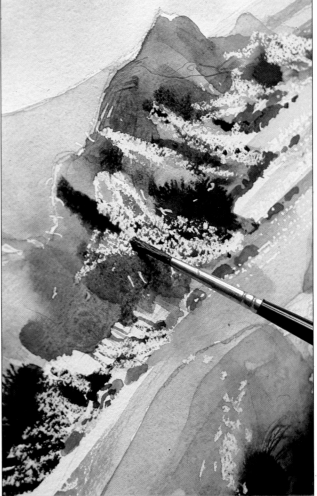

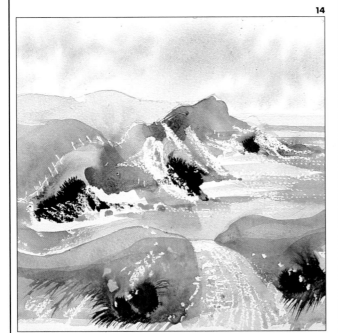

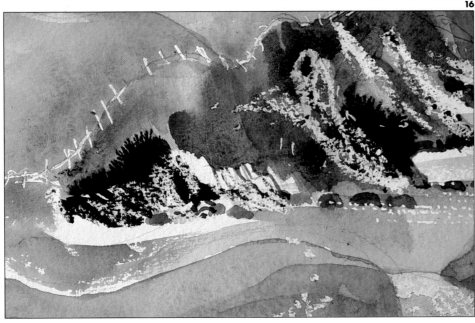

16 In this detail we see some of the exciting effects which can be achieved using this combination of wax resist, ink and watercolour. The artist has handled the paint freely, working with the medium rather than imposing his notion of the final image upon it. Each stage dictates the next, unlike previous projects in which the progress of the work was planned in advance. However, watercolour is an unpredictable medium and you can never be quite sure what will happen – the good artist merely harnesses its unpredictability.

Detail
In this detail we see the descriptive qualities of the resist technique – here the rutted surface of the track is realistically represented.

17 This painting displays all the exuberance and spontaneity which is such a pleasing quality of good watercolour. More than any other medium, watercolour suffers from being overworked. This is why we have suggested you work through the exercises and projects, so as to get the confidence to handle the paint with the freedom tempered with control which produces the very best watercolours. There is no substitute for 'hands on' experience.

Here the artist has created an image which works on several levels; it is an effective and engaging description of a stretch of coastline, it is also an interesting exploration of the qualities of paper, paint and ink. The picture surface is an essay in contrasts, the soft, velvety black of the ink is set against the transparency of the paint, crisp masked edges lie alongside softly blurred areas of wet-in-wet colour. The viewer is presented with an attractive stretch of coastal scenery to admire, but at the same time he is invited to enjoy the quality of the surface, texture and pattern, paint, ink, colour and line.

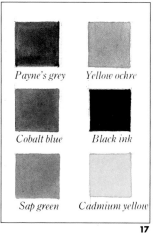

Payne's grey Yellow ochre

Cobalt blue Black ink

Sap green Cadmium yellow

17

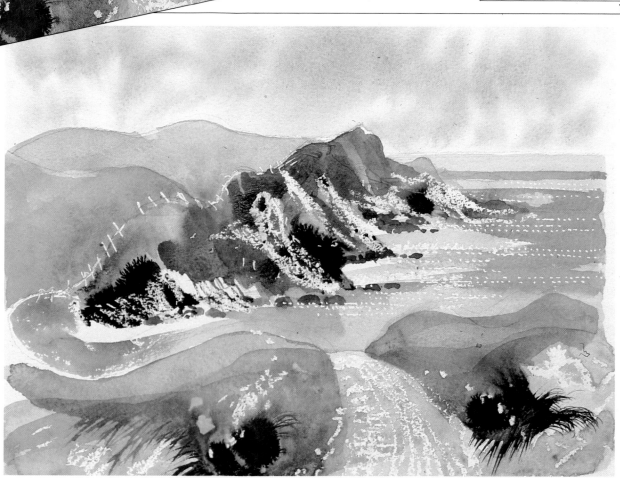

Daffodils
WET-IN-WET

Watercolour is capable of almost infinite variety and in the last two projects in this book we illustrate two entirely different approaches to very similar subjects. In this lively painting of daffodils the artist has used a spontaneous, vigorous approach, working almost entirely wet-in-wet. In the painting of buttercups which follows the artist is using a mainly wet-on-dry technique, planning the application of colour carefully and working slowly and meticulously.

Here the artist dispenses with the initial pencil drawing and starts by defining the broad forms of the subject with a wash of clean water – she is actually drawing with water. She then begins to lay-in the paint, allowing it to flow onto the damp paper. The wet area confines the flow of the paint and she imposes shapes and tones by pushing and pulling the colour with a brush, so that it builds up in some areas, leaving a very thin veil of colour in others, revealing the white of the paper in yet others. She works fast, for the technique relies on the immediacy of her response and on keeping the paper damp. She concentrates on the subject, looking for the broad forms of the bunched flowers heads, and for the lights and darks which describe the form and create a sense of volume. She continues in this way, alternatively wetting and drying the paper, touching in colour, standing back to see how it flows, moving it with the brush or dabbing it with tissue.

Described like this the technique sounds difficult, but as long as you are prepared to be bold and risk making a mistake it is no more difficult than any other method of working, and it is certainly exciting.

These delightful spring flowers were the inspiration for this painting. The colours are simple yellows and greens rendered more vivid by the sunlight streaming through the window. Flowers are a demanding but particularly rewarding subject for the watercolourist.

1

2

1 The support is Bockingford 140lb (300gsm), unstretched and the brushes are numbers 5 and 6 sables. Using a number 6 brush loaded with water, the artist starts to lay-in the broad forms of the subject. She then applies the colour: cadmium yellow, cadmium lemon and cadmium orange middle for the flowers, sap green for the flowers and stems. The colour is allowed to flow into the wet area, and is then manipulated with the brush.

2 Here you can see the way the artist is working – the paper is still wet and the paint spreads through it. The darker areas are where the artist has used the brush to push and pull the paint, gathering the colour to form darker tones. The ghostly form of the subject can be seen shimmering through the wet paint. The artist is searching for the shapes, rather than drawing them, building them from within rather than outlining them.

3 Using a wet-in-wet technique, the artist develops a range of subtle tones, from delicate veils of colour which barely tint the paper to rich, deeply saturated passages. She introduces more water on to the paper, then floods a vibrant Indian yellow into the centre of the daffodils. In this picture we see that colour being lifted with a brush to create highlights and impose a shape on to the colour area. To do this, the artist dries the brush and then presses it down on the paper surface so that the colour is sucked up by the hairs. Notice the softly blurred colours, the crisp dried edges, and the way the texture of the paper shows through and influences the paint layer.

4 The artist mixes a wash of lemon yellow and Prussian blue and, using the tip of a fairly dry number 5 brush, draws the stalks of the flowers, the neck and shoulder of the jar. The brushmarks are clearly defined, but not harsh, softened slightly by the wet ground. Here she works back into the stems with lemon yellow.

3

4

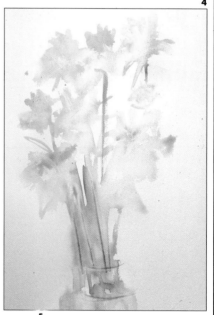

5

5 The artist's method of working demands that she works quickly, keeping the colour wet, moving the paint, touching-in more colour, lifting colour, judging the progress of the work, constantly assessing the work. All the time she refers back to the subject, looking for the tones that will describe the forms, but nevertheless working with the paint, rather than imposing upon it. It is a risky way of working for a painting is easily lost, or overworked. Her approach depends on the directness and immediacy of her response to the subject.

6 In this detail you can see the way the painting is beginning to build up. The first wet-in-wet washes have dried and she now works over them wet-on-dry. This creates crisper edges, and as the layers of colour build up the forms begin to emerge. Here the artist lays cadmium orange into the trumpets of the flowers. She constantly refers to the subject, and whilst she is concerned to establish the individual flowers in a credible way, she also wants to capture the feeling of a bunch of daffodils.

7 Here sap green is applied to the stems, to give them more intensity and form, and to imply the bunched effect. A cool Prussian blue is then used to establish the shadows within the foliage.

8 The centres of the daffodils are painted in with the tip of a very dry brush. The artist uses the paint straight from the paint, so as to get a rich, opaque colour which contrasts and heightens the transparency of the other passages.

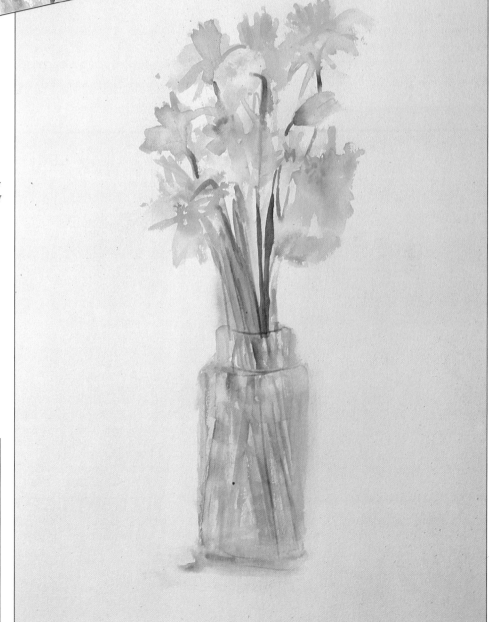

9 Watercolour is an unpredictable but expressive medium. When this unpredictability is harnessed the results can be astonishingly beautiful. The wet-in-wet technique demonstrated here shows watercolour at its most unpredictable, but the artist deliberately courts this element of risk. She explores and exploits the controlled accident which can destroy a painting but which can also produce startling and pleasing effects and images, to surprise even the person who holds the brush. Here she has created pale, delicate veils of colour which describe the most fragile petals, while the trumpets are vivid splashes of orange.

9

Detail
In this detail we see the way the artist has explored and exploited the qualities of watercolour. The colour is fresh and true, with that special vibrant transparency which is peculiar to watercolour. The techniques used work on two levels. They describe the subject accurately – there is no doubt that the subject is a bunch of daffodils. They also create a picture surface which is interesting and pleasing when viewed as an abstract pattern of shapes and colours, lines and edges.

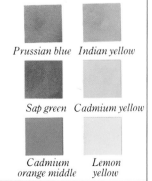

Prussian blue Indian yellow

Sap green Cadmium yellow

*Cadmium
orange middle Lemon
yellow*

Buttercups in a Blue Vase
CUTTING BACK WITH THE BACKGROUND

Simplicity is the key to this pleasing and satisfying study of a bunch of wild flowers. The artist's approach is careful and painstaking, but he sacrifices none of the freshness and immediacy of true watercolour. Part of the success of the study relates to the composition. The vase of flowers is placed off-centre with its base on the bottom quarter of the picture area. The shadow links to the vase, so that the object and its shadow form one continuous shape which occupies two-thirds of the picture. The background too is divided on a one-third, two-thirds basis, the boundary between the table top and the background occurring at this point. The colour scheme is simple but effective. The buttercups are placed against a cool grey background which enhances their bright, fresh yellows. The contrasts between the cool and warm colours is also seen in the dark blue vase which is set against the ochres of the table.

The artist has described the flowers accurately, but not with strict botanical detail – this is a painting rather than a botanical illustration. He has studied the forms carefully and found a shorthand to express each element. Thus he uses only two yellow tones, light and dark, to capture the form and character of the flowers. He goes from bloom to bloom painting in flat shapes with a pale yellow, using the colour to draw the shapes, following the underdrawing only loosely. The shadow areas were then blobbed in with a darker, more intense yellow. This same formula is repeated for the leaves – light green flat shapes, with shadows added in a darker tone. He paints what he sees, and what he sees is a pattern of light and dark areas, rather than 'a stem', 'a flower' or 'a leaf'.

The background is laid-in at a late stage, and the artist has to 'cut back' around the flowers, buds and leaves. This is a difficult task, requiring a steady hand, but it allows the artist to redefine and refine the outlines of the flowers, giving them a crisp clarity.

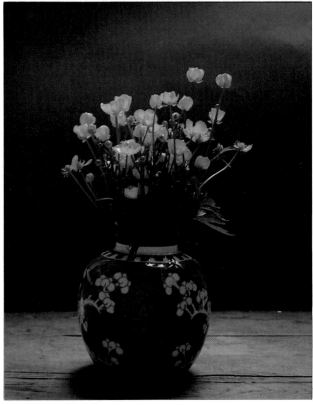

The tiny flowers and the mesh of stems and leaves provide a challenging subject, for this our last project. The artist was attracted by the strongly contrasting colours, the yellows of the petals, the rich, dark greens of the stems and leaves and the dark blue of the vase. A further contrast is provided by the busy, detailed outline of the flowers and leaves, and the smooth, uninterrupted curves of the vase.

1 The artist used two brushes: a number 18 wash brush and a number 2 sable. The paper was a sheet of stretched Bockingford measuring 24in×18in (61cm×46cm). The artist starts by making a light outline drawing with a graphite stick.

2 The basic forms of the flower heads are laid in with a weak solution of lemon yellow. The colour is dropped in with a small, number 2, sable brush, and with controlled gestures the colour is then pushed and pulled into shapes which describe the flower heads. However, if you look at the next picture you will see that the artist does not stick too closely to the pencil outlines.

3 Moving on to the foliage, the artist blocks in the leaves and stems with a pale sap green and lemon yellow mixture. For this detailed work you should use a number 2 brush and keep the paint moving to avoid tidemarks which would interrupt the forms. Hold the brush in a relaxed manner, using smooth movements from the wrist to obtain natural, flowing lines. Use the tip of the brush to make the pointed leaf shapes.

Here the artist adds the dark tones on the buttercups with a mixture of lemon yellow and cadmium orange – he does not create a very dilute wash for he wants the colour here to be as deep and dense as possible.

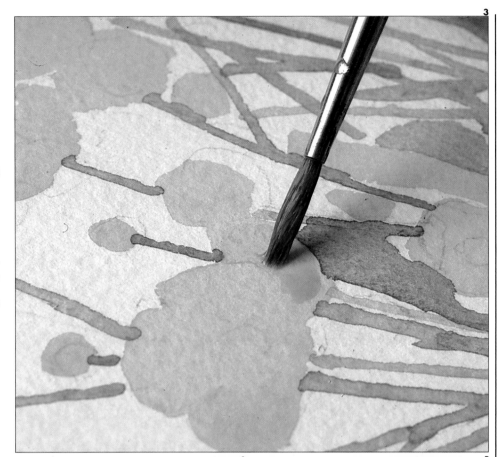

4 When the first wash of colour in the foliage is completely dry, the artist develops the darker tones with a mixture of sap green and a little black. By painting wet-on-dry he ensures clean, crisp edges. By painting the spaces between the leaves and stems he implies a sense of depth. This also helps to describe the forms of the foliage and stems, for the light areas stand out against the darker areas. He implies the positive shapes by painting the negative shapes.

5 The artist continues in this way, allowing the paint to dry between applications of colour. The complexities of the stems and foliage are resolved into an overlapping tracery of colour. A touch of dilute sap green is dropped into the centre of the flowers to describe the stamens.

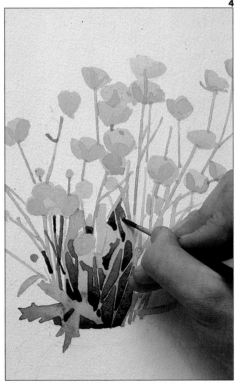

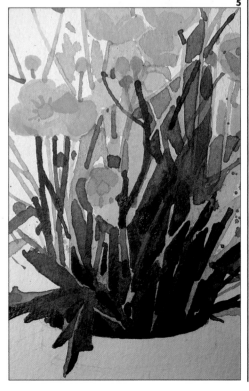

6 Finishing touches are added to the flowers – some of the dark tones have been strengthened to harmonize with the foliage. However, try not to overwork the buttercups for you risk losing the freshness. It is important to know when to stop. So leave the flowers, even though they may not be as 'finished' as you would wish.

Here the artist works into the background with a very dilute mixture of Payne's grey and neutral tint. Neutral tint is a useful addition to your palette, for it tones down other colours without deadening them.

8 The background is completed with lively directional brushstrokes. This places the subject in a real setting – a grey wall replaces the flat, white paper and establishes a sense of space between the vase of flowers and its background. A completely flat colour would be harsh and uninteresting, and would be an unsuitable foil for such a fresh and natural subject. The artist introduces a textural element into the wash, creating a lively surface, which enhances the composition and suggests a realistic setting. Notice the way he has used the background colour to redefine the flowers and leaves, taking the grey right up to the fragile, irregular outlines with a number 2 brush, redrawing the shapes where necessary.

6

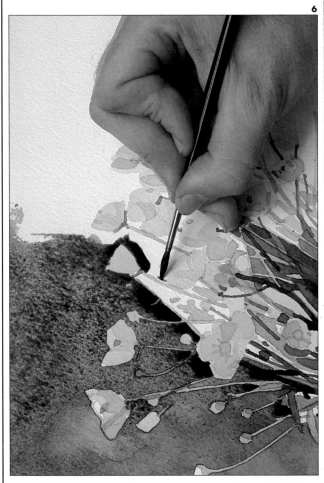

8

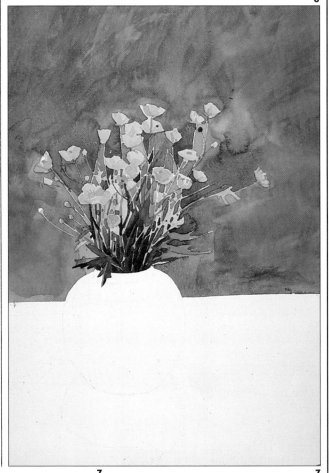

7 A number 18 wash brush is used to fill in the large background areas *far right,* and a number 2 sable for the delicate task of taking the background colour up to the outlines of the flowers *right.* Keep the paint moving, working clean water into the unfinished edges as you paint, to prevent the colour from drying unevenly.

7

7

9 The vase is built up gradually in a series of simple stages. The artist started by mixing ultramarine blue and indigo, applying this as a flat wash with a number 2 sable brush. The artist works carefully, leaving white paper to stand for the toothed pattern around the shoulder of the vase and the rim of the vase. The first wash is allowed to dry and then the artist applies another wash of the same colour, this time taking it over the pattern on the front of the vase, and carefully painting the reflection of the window, creating a bright highlight on that side. A third wash is applied while the second is still wet, this time the colour is applied across the lower part of the vase to suggest the shadow in that area, which helps to establish the curve of the vase. The wet-in-wet technique creates a blurred effect which suggests the roundness of the form. Contrast this with the crisp edges of the bright highlight.

9

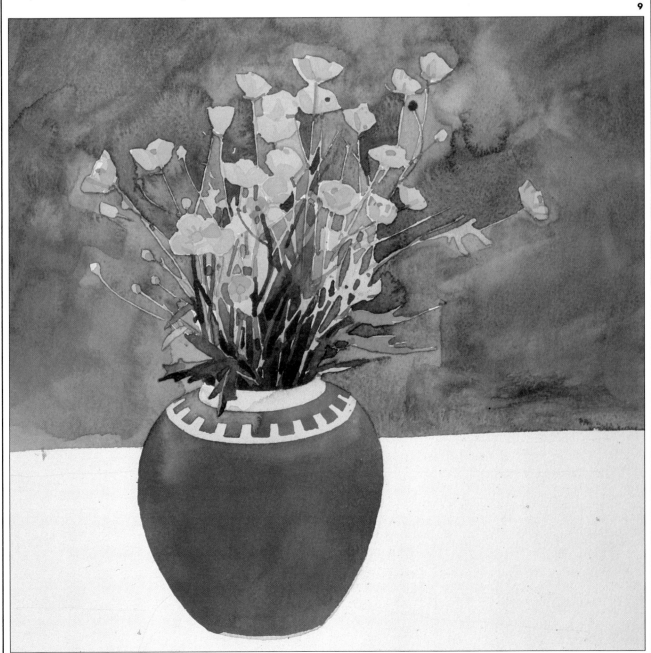

10 The shadows are blocked in with a dilute mixture of burnt sienna, ultramarine and indigo. The artist uses a large brush and working wet-on-dry carefully describes the irregular shape of the shadow. The crisper the edge and the greater the contrast, the brighter the light source will appear. Shadows should not be neglected, they are not an unimportant part of the background, but a significant positive shape within the composition. They also help to relate the subject to the environment. Here, for example, the shape of the shadow helps to establish the horizontality of the table top, and also reinforces the perceived roundness of the vase.

12 Next the artist mixes a wash of raw umber and burnt sienna and working broadly lays in the table surface. The colour is applied with a number 18 brush, working the colour carefully around the contours of the vase, but taking it right across the shadow, giving the shadow a rich colour which integrates it with its surroundings. To make sure that the dark tones of the shadow did not lift and contaminate the wash, the artist made sure that the area was completely dry, and applied the colour with a single stroke. The artist builds up the tone and texture of the wooden table with a series of washes.

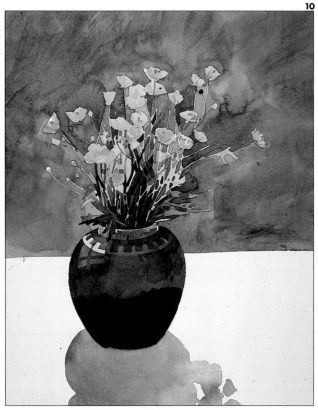

10

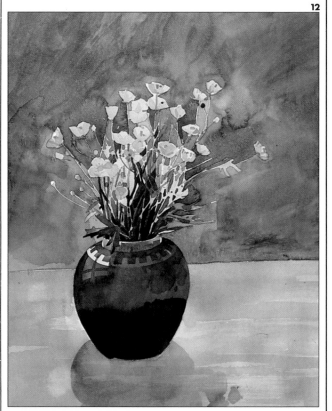

12

11

13

11 Do not make the mistake of thinking that shadows are grey, they vary in tone but unless there is very little light they usually contain a trace of the local colour of the object throwing the shadow – in this case the blue vase. A cool colour like this blue is often warmed with a touch of a warmer tone – here the artist uses the burnt sienna to obtain a neutral tone.

13 The final details are added to the table surface with a fine sable brush. The artist uses the same raw umber, burnt sienna mixture and paints a series of horizontal lines to suggest the grain of the wood.

14 In this painting, the artist has used a few very simple techniques to achieve a rich and satisfying image. The subject was complicated, and his approach was painstaking. The flowers and foliage were built up with layers of colour applied wet-on-dry. The crisp edges achieved in this way are used to describe the edges of the petals, leaves and stems. At first sight the stems and foliage might have appeared difficult, but by working from light to dark, using the darker tones to describe the gaps between the stems, the artist has resolved the problem. Nevertheless, the artist worked slowly and carefully, allowing one stage to dry before proceeding to the next. The painting has several richly textured passages: the complex web of the foliage; the loosely brushed background and the simple but realistical table top.

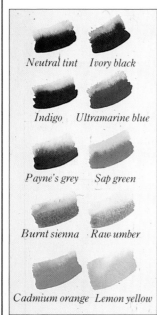

Neutral tint *Ivory black*

Indigo *Ultramarine blue*

Payne's grey *Sap green*

Burnt sienna *Raw umber*

Cadmium orange *Lemon yellow*

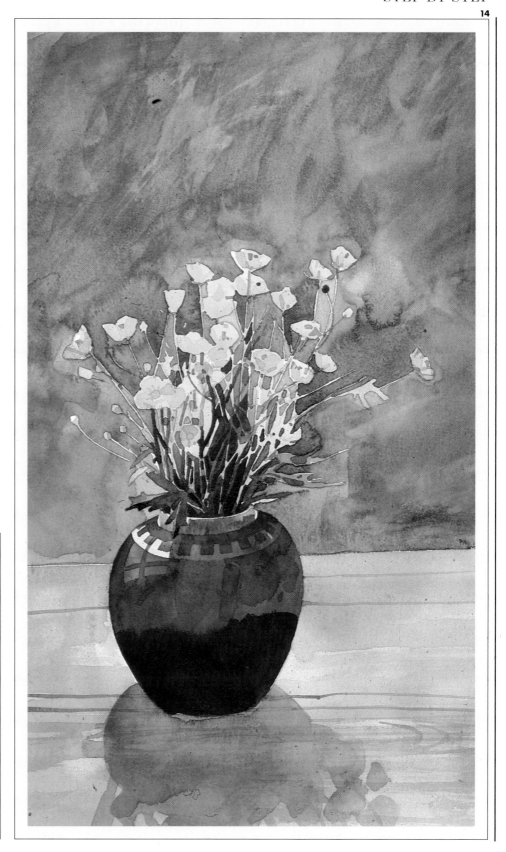

Glossary

Aerial perspective A means of creating an illusion of space in a painting using colour and tone. Also called **Atmospheric perspective.**

Binder or **Binding medium** This is the substance which binds pigments together to form a paint. In watercolour and gouache the binding medium is gum arabic, in oil paint it is oil.

Blocking In The application of broad areas of paint in the early stages of some paintings. Working very freely the artist lays in the masses of light and dark, and areas of local colour so that he or she can organize and assess the composition.

Cold Pressed and **Not**

Complementary colours Pairs of colours which are found on opposite sides of the colours circle: red and green; yellow and violet; blue and orange. When juxtaposed they enhance each other, so red looks redder and green looks greener.

Composition This is the design of a picture: the way the elements such as areas of colour, masses of light and shade, and lines and stresses are arranged within the picture area in order to form a coherent and pleasing effect.

Dry brush A feathery texture achieved with a dryish brush.

Earth colours Colours made from naturally occurring clays or minerals.

Ferrule The metal collar of a brush by which the hair or bristles are attached to the handle.

Fugitive Pigments or dyes which are impermanent.

Gouache An opaque waterbased paint. It can be used like watercolour to lay washes but, unlike watercolour, it is possible to paint light colours over dark.

Gum arabic A naturally occuring watersoluble substance made from the sap of certain species of acacia tree. Used as a binder for watercolour paint.

H.P. Hot pressed – the smoothest watercolour paper which is passed through heated rollers in the production process.

Linear perspective A means of creating the illusion of depth and space in a painting by the use of converging lines and vanishing points.

Local colour The colour of an object, unmodified by light, shade, atmospheric conditions or surrounding colours – the yellow of a daffodil, the green of grass.

Medium This term has several meanings. It can be used to describe the material used for a painting or drawing – watercolour, pencil and pastel are all media. It also describes the material with which the pigments are held together see **Binding medium.** It can also be used to describe any material which is added to paint to change the way it behaves. There are many mediums which can be used with watercolour, for example: gum arabic; gum water; and Winsor & Newton's Water Colour Medium.

Mask Anything which is used to protect areas of a painting while you apply paint to other areas. Masks can be made from paper, masking tape or masking fluid, for example.

Masking fluid A white or yellow fluid which can be painted over an area to reserve the virgin paper or to protect the existing layers of paint. It dries to a rubbery film, and can be removed by gently rubbing with the fingertips.

Masking tape A low-tack tape which can be used for masking or to fix paper to a board as it peels off without damaging the paper surface.

Monochrome A painting or drawing in tones of one colour. In watercolour the whites of the support gives the lightest tones.

Negative spaces The spaces between objects. These are seen as positive abstract shapes in a composition.

Not Paper which is smoother than Rough, but more textured than H.P.

Opaque Not transparent medium, gouache is opaque.

Optical colour mixing The application of paint in small patches of pure colour, so that when seen from a distance it forms another colour. The mixing of colour in the eye rather than on the picture surface.

Palette This term has two distinct meanings. It describes the dish or surface on which a painter sets out, mixes and dilutes his paint. It is also a range of colours. When we talk of an artist's palette we usually mean the colours he or she uses rather than the object he mixes his paint on.

Perspective A device by which we create an illusion of three dimensional space on a two-dimensional surface. See **Linear Perspective** and **Aerial perspective**.

Picture plane An imaginary vertical plane which delimits the front surface of the area to be included in a picture.

Pigment Any coloured substance which can be combined with a binder to produce a paint or a drawing material.

Primary colours The paint primaries are red, yellow and blue. They cannot be mixed from other colours can be mixed from the primaries. In reality the colours you can mix from the primaries is limited because it is impossible to produce really pure pigments.

Resist Waxy materials such as candle or wax crayon repel or 'resist' water. This quality is sometimes used by watercolourists to create textures or linear effects – only the non-waxed areas accept the paint.

Rough Papers with a highly textured surface.

Scumbling This is really an oil painting term which describes the application of dryish, opaque paint so that the support or underlying colours show through in places. It can also be applied rather loosely to watercolour.

Secondary colours The three colours produced by mixing pairs of primaries: yellow and blue gives green; red and yellow gives orange; red and blue gives violet.

Size A gelatinous substance which is applied to painting surfaces to reduce their absorbency.

Spattering A mottled textures. Paint can be flicked onto the support from a loaded brush, or a stiff brush such as a toothbrush can be loaded with colour and ruler or a finger drawn across the bristles so that colour is flicked onto the support.

Stippling A mass of small dots applied with the tip of a brush, or with a large stiff-bristled brush.

Support The surfaces on which you paint. In watercolour this is generally paper.

Tertiary colours Colours created by adding a primary colour to a secondary colour.

Tone The lightness or darkness of a colour.

Tooth The ability of a surface to hold paint or any other medium. It usually relates to its texture.

Vanishing point In perspective the point at which parallel lines appear to meet at the horizon. A painting or drawing may have several vanishing points.

Wash An application of thinly diluted paint.

Watermark A manufacturer's name or symbol which is sometimes incorporated into sheets of paper, especially the more expensive papers. It is visible when the paper is held to the light, and is right-reading from the top surface.

Wet-in-wet Paint applied to a support which is already wet with paint or water.

Wet-on-dry The application of paint to a dry support which may already have a layer of dry paint.

Index

Credits

The author would like to thank all those who
have helped in the preparation of this book.
Special thanks to Ronald Maddox for his expert
and helpful advice, and for the use of his studio;
to Winsor & Newton for advice and for
providing material and equipment; and to the
staff of the Winsor & Newton shop in Rathbone
Place, London.

Contributing artists
Ronald Maddox: pp36-37, 43, 48-53, 54-57,
68-73, 74-77, 82-87, 94-99, 100-105, 106-109,
110-115, 126-129, 138-143. Ronald Maddox is
vice president of the Royal Institute of Painters
in Water Colours and exhibits both in Britain
and abroad. He has had several one man shows
and his paintings have been purchased for
public and private collections in Britain,
Germany, the United States and Canada.
He trained at art colleges in Hertfordshire and
London and practises as a freelance artist,
illustrator and designer. He has been
commissioned by many national and
multinational corporations and his work varies
from postage stamp design to illustrations for
books, calendars, cards, prints and murals.

Sue Shorvon: pp144-147.
Sue Shorvon studied fine art at Camberwell
School of Art and Crafts, London. Her work
has been shown in numerous mixed and one
woman exhibitions.

Ian Sidaway: pp12-13, 16, 38-39, 40-41, 42,
44-45, 46- 47, 60-61, 62-63, 64-65, 66-67,
78-81, 90-91, 118-121, 122-125, 132-137,
148-153.
Ian Sidaway studied at Nuneaton School of Art
and at Richmond college. He worked as a
graphic designer but in 1971 left advertising to
become a professional portrait painter.
His commissioned portraits are in collections
throughout the world and he has also shown in
several mixed and one man exhibitions.

Photography
35mm by Ian Howes.
Studio photography by Mac Campeanu.

Layout and Artwork
Giorgio Moltoni